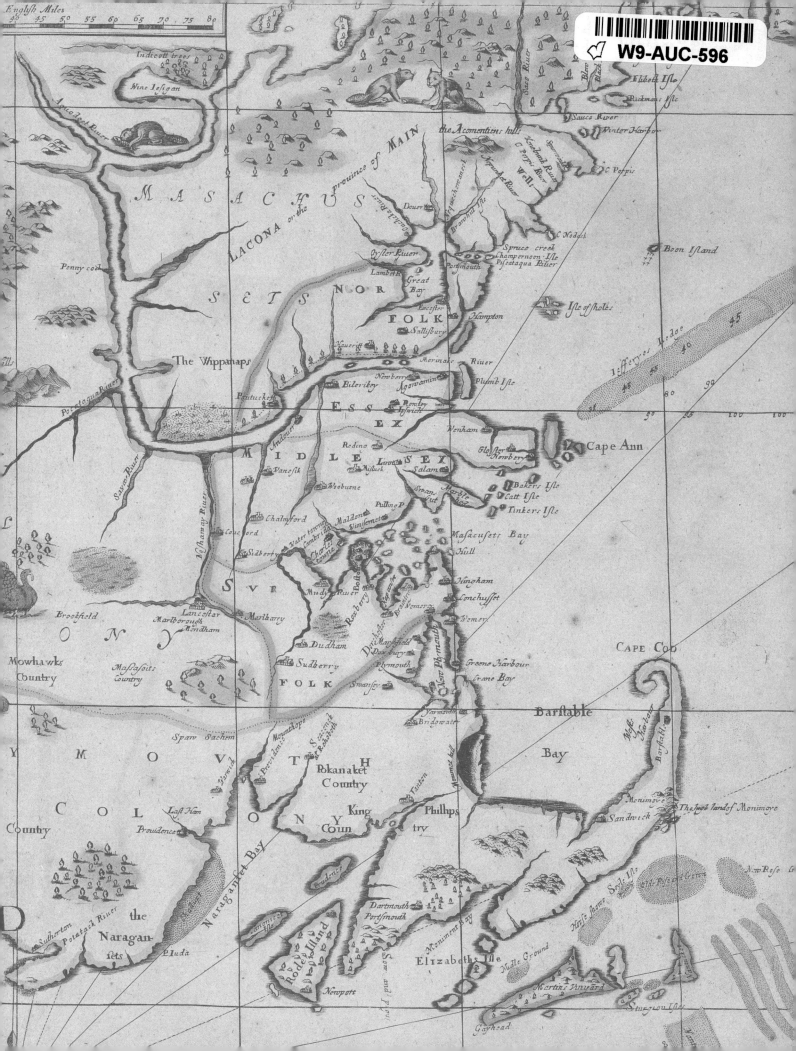

HISTORIC AMERICA
New England

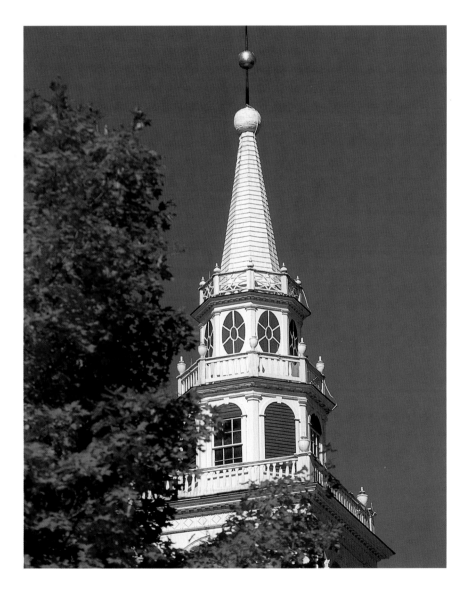

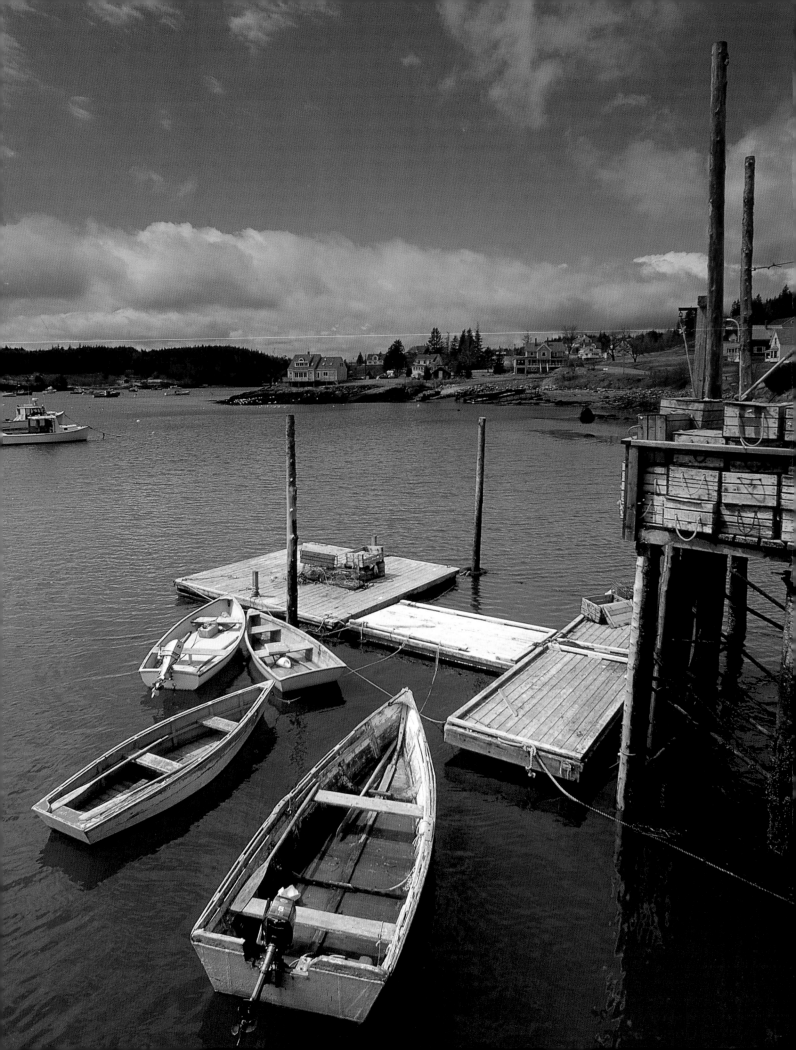

HISTORIC AMERICA

New England

Jim Kaplan

THUNDER BAY
P·R·E·S·S

SAN DIEGO, CALIFORNIA

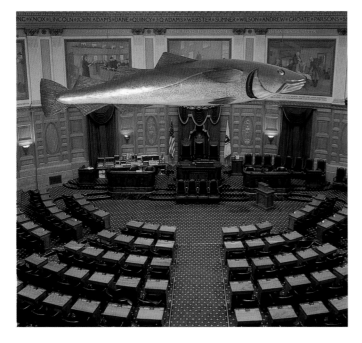

Acknowledgments and Photo Credits

The publisher would like to thank all who assisted in the production of this book, including those listed below and: Deborah Hayes, for compiling the gazetteer; Lone Nerup Sorensen, for the index; Sue Frankenbach of the Norwich Free Academy Slater Memorial Museum; Kerry Buckley of Historic Northampton; Charles Derby; and Lawrence Lowenthal. All color photographs in this volume are the copyright of **Kindra Clineff,** unless otherwise noted in the list below, noted by page number. Grateful acknowledgment is made to the individuals and institutions listed below for permission to reproduce illustrations and photographs: © **Mary Liz Austin**: 10–11, 37; Courtesy, **Boston Red Sox**: 30; Collection of the **Connecticut Historical Society**: 110, 111; © **Ed Cooper**: 41; Courtesy, **Jones Library, Inc,** Amherst, MA: 25; © **Balthazar Korab**: 83, 92b; **Library of Congress**, Historic American Buildings Survey/Historic American Engineering Record Collections: 82 (HABS, MASS, 13-BOST, 1-8, photographed by Frank O. Branzetti), 107 (HAER, MASS, 9-LOW, 7-1); Prints and Photographs Division: 50, 52, 54, 55, 58–59, 62, 63, 67, 86, 87, 90 (both), 94, 95, 99, 115; © **Lorraine B. Myers**: 47b; **National Archives and Records Administration**: 70, 71, 74, 75, 78 (both), 79, 91, 98, 102, 103 (both), 118, 119, 122, 123, 126; **Yale University Map Collection** (photograph © Josef Szaszfai): 42–43, 56–57; © **Charles J. Ziga**: 22

SERIES EDITOR: John S. Bowman
EDITOR: Sara Hunt
PHOTOGRAPHY: Kindra Clineff
ART DIRECTOR: Nikki L. Fesak
PRODUCTION EDITOR: Deborah Hayes

Thunder Bay Press
An imprint of the Advantage Publishers Group
5880 Oberlin Drive, San Diego, CA 92121-4794
www.thunderbaybooks.com

All notations of errors or omissions should be addressed to Thunder Bay Press, editorial department, at the above address. All other correspondence (author inquiries, permissions) concerning the content of this book should be addressed to Saraband, The Arthouse, 752–756 Argyle Street, Glasgow G3 8UJ, Scotland, hermes@saraband.net.

ISBN 1-57145-857-3

Library of Congress Cataloging-in-Publication Data available upon request.

Printed in China

1 2 3 4 5 06 05 04 03 02

Above: *The Chamber of the House of Representatives in the Massachusetts State House, Boston, featuring the "Sacred Cod," a five-foot-long carving dating from 1784 that represents the importance of the fishing industry in the early history of the state.*

Page 1: *Fall colors against the spire of the historic Hancock Congregational Church, Hancock, New Hampshire.*

Page 2: *Cutler, Maine, boasts one of the best natural harbors on the Atlantic coast.*

TABLE OF CONTENTS

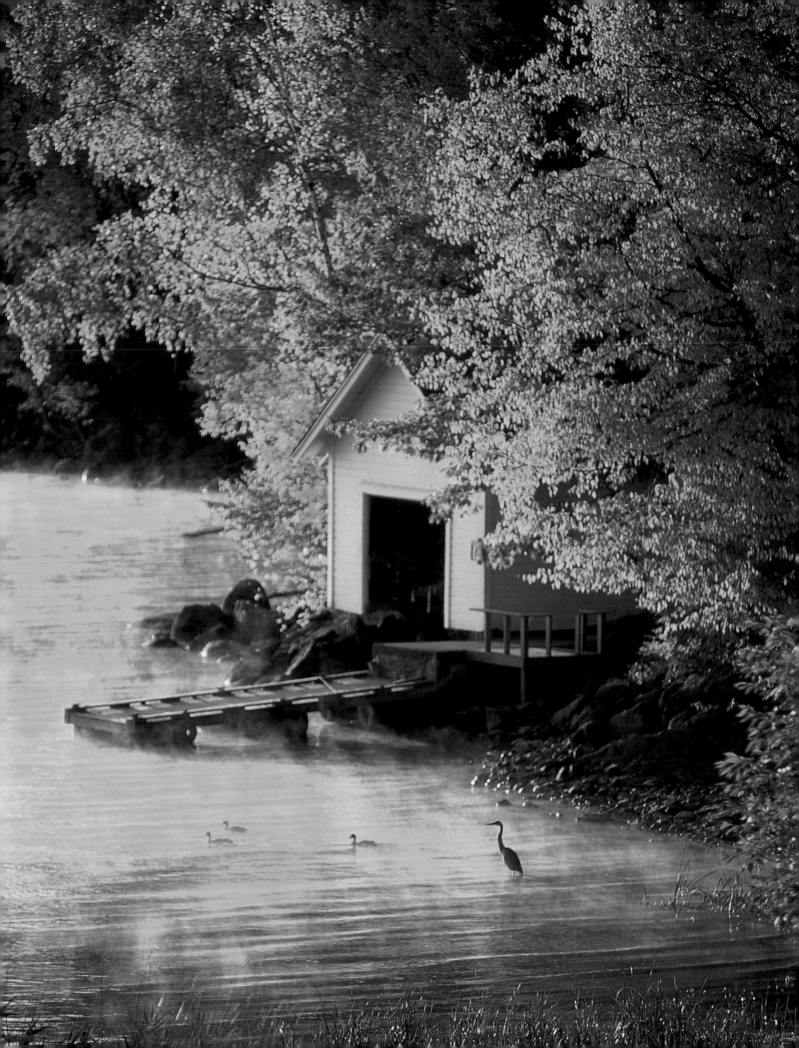

INTRODUCTION

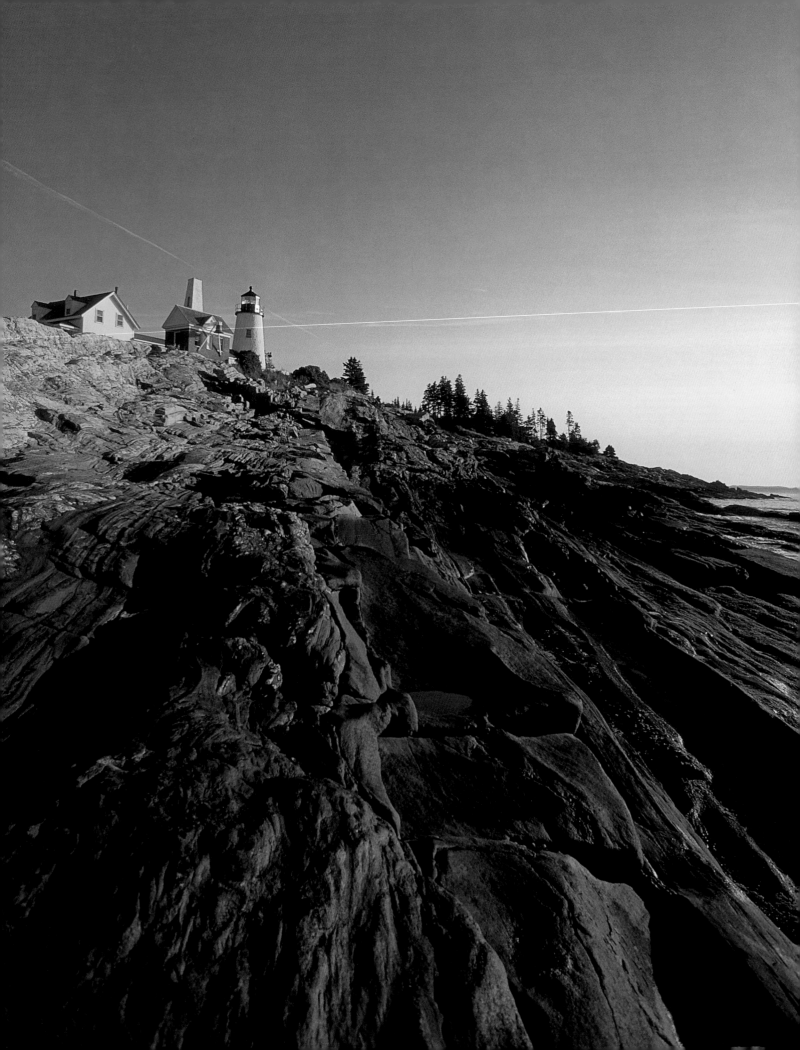

When we think about the six states comprising New England, comforting images dance in our minds: fishing villages in Maine, covered bridges in New Hampshire, syrup flowing off maple trees in Vermont, small towns with colonial buildings and church steeples in Connecticut, sailors on Rhode Island's Narragansett Bay, the Freedom Trail in Massachusetts. Most of all, we conjure up the fall foliage that for two or three weeks a year makes New England seem to many the most desirable place on earth.

To be sure, several discomforting images surface as well, especially the Salem witch trials and the disapproving looks on the faces of Puritan elders. In this volume, what you know about New England will not be turned on its ear but fleshed out. Many familiar stories will be told, but with more detail than you may have read before. Some long-standing assumptions will be modified and long-ignored events given more prominence. If we succeed, you will put the book down with substantially more information—and some trivia questions with which to stump your friends.

In fact, here are some right now. Quick—where was Utah's founding father, Brigham Young, born? Why, in Whitingham, Vermont, back in 1801. What's special about Vermont's statehood? Vermont was an independent republic before joining the Union in 1791. What was the first state to declare independence from Great Britain? New Hampshire, on January 5, 1776. (It only follows that the Granite State should have the first-in-the-nation presidential primary every four years.) What's the third largest city in New England? After Boston and Providence, it's Worcester,

Massachusetts (pop: 172,648 in 2000), home of wire-making, the carpet loom, the diner, the Valentine card, the birth-control pill, the nation's first park, the first national woman's suffrage convention, Robert Goddard, Robert Benchley, and Abbie Hoffman. How about that?

To understand New England history, you must first understand its geography and environment. Every state except Vermont fronts on the Atlantic Ocean—with Maine's 3,500 miles of coastline topping the list. Martha's Vineyard and Nantucket became islands when the last glacier melted about 10,000 years ago and the ocean level rose, covering part of the moraine they were perched on. Inevitably, fishing and other maritime industries have figured prominently in the region's history. Carrying on more overseas commerce than other regions, New Englanders were quite naturally the most incensed by the restrictive Coercive Acts imposed by their rulers in Great Britain. No wonder they led the fight for independence. After the war, New Englanders began trading with ports as distant as Shanghai. Quite

Page 6: *Lake Memphremagog, Newport, Vermont, once a haven for Loyalist refugees from the American Revolution.*

Page 7: *Tools from Hancock Shaker Village in Massachusetts. The Shakers made major contributions to American life for more than 170 years.*

Opposite: *Pemaquid Point Lighthouse, Maine (1826).*

Below: *A whale off Cape Cod. The great mammal created a thriving nineteenth-century industry for Massachusetts ports like New Bedford and Nantucket.*

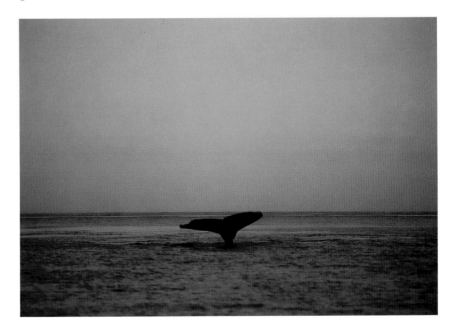

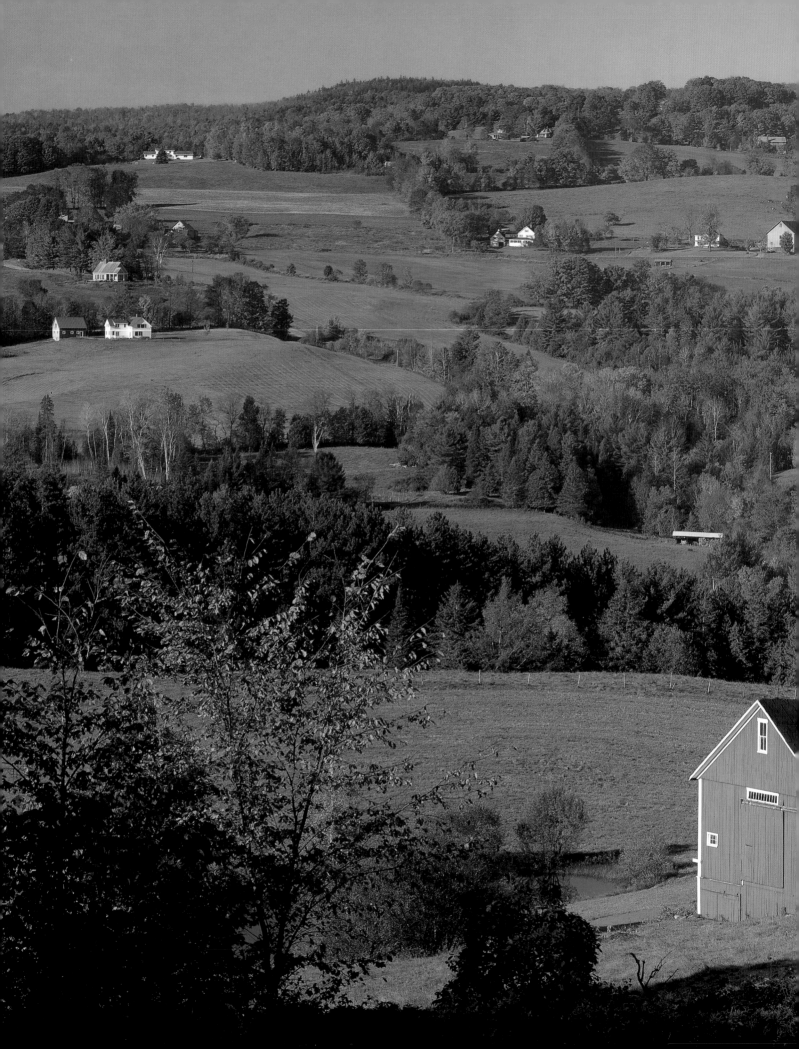

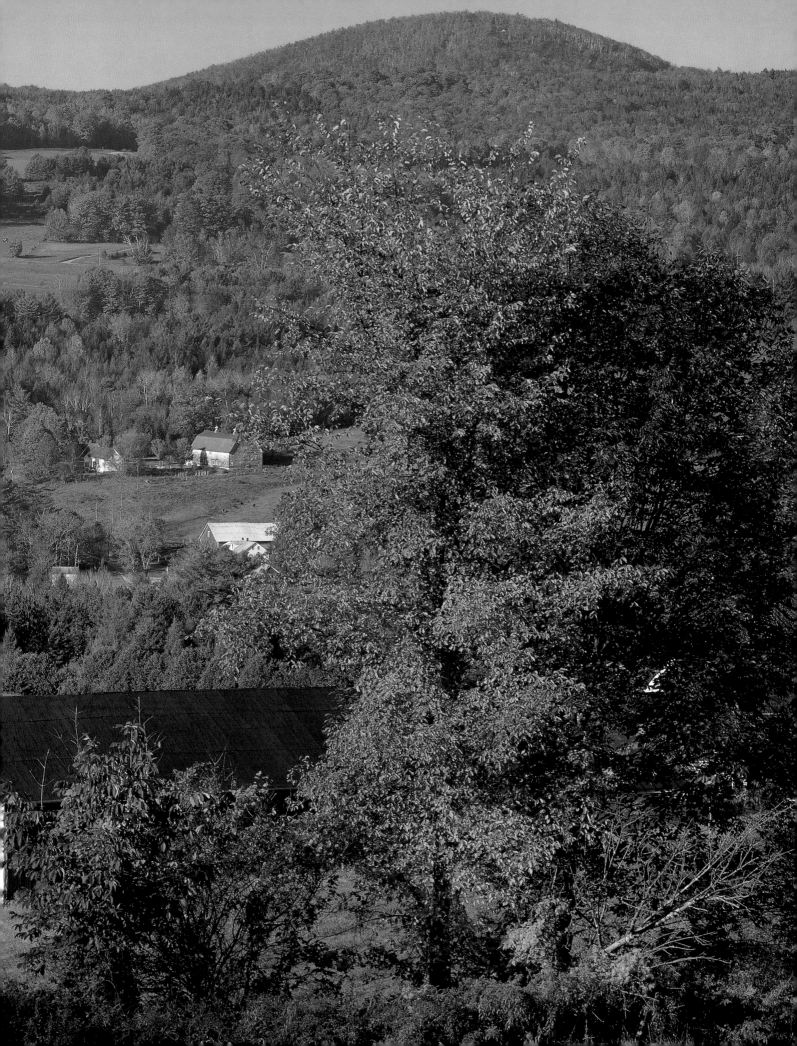

Above: *Harvest time at Northland Cranberries, on Nantucket Island, Massachusetts. Along with blueberries and Concord grapes, cranberries are one of only three fruits native to North America.*

Previous page:
A farmstead near Peacham, Vermont. Surviving the nineteenth-century exodus to the West, the Green Mountain State has maintained its dairy industry to this day.

naturally, they objected to the U.S. Embargo Acts limiting commerce before the War of 1812. No wonder the erstwhile patriots almost voted to secede!

New England's 66,672 square-mile land mass also has figured significantly in its history. The mountains and valleys generally run in a north-south direction reflecting continental collisions and separations. Originally rivaling the Alps in size, the high peaks wore down to low and rounded mountains called the Taconic Range, Berkshire Hills, Green Mountains and White Mountains. Valleys filled with red sedimentary rock (some of which contain dinosaur tracks) and basalt, a form of lava. Glaciers began forming about one million years ago—and would many years later contribute to class divisions: Farmers lucky enough to settle in the Connecticut Valley and similar areas thrived on rich, rock-free soil deposited by glacial lakes and rivers. Their neigh-

bors on surrounding hills faced glacially derived boulders. They were not called "hardscrabble" farmers for nothing.

Many factors—among them heavy rainfall, complex watersheds, and water-filled glacial depressions—have created rivers and lakes all over the region. Short, mostly swift-running rivers—only the Connecticut River could be described as long—especially predominate. As a result, mills and other water-based industries have abounded in New England.

The general harshness of the climate—long, hard winters, hot summers, and short spring and harvest seasons—have, at least in part, produced tough, proud, resourceful, and independent citizens. New Englanders are sometimes characterized as "unfriendly." Well, farmers dug up so many rocks that they just naturally created stone walls and the privacy that came with them— "Good fences make good neighbors," in Robert Frost's words.

In some respects, the six states are simple enough to understand. New England's economic history—from agriculture to industry to office—is as clearly delineated as any other region's. New England's political history follows its settlement, with leadership passing from the Puritans to the radical revolutionaries to the Brahmin Republicans to the immigrant Democrats.

Yet contradictions abound in New England history. Take the Puritans. "[They] nobly fled from a land of despotism to a land of freedom, where they could not only enjoy their own freedom, but prevent everybody else from enjoying his," wrote Artemus Ward, a Revolutionary War general and social satirist. In another contradiction, local Indians, especially the Algonquins, or Abenaki ("people of the dawn"), helped the settlers and were slapped down for their efforts. The Pilgrims and their Indian friends enjoyed half a century of peace, the settlers learning much from the natives, including how to survive. Then hideous conflicts—most notably, King Philip's War and the French and Indian wars—decimated or neutralized the tribes. After 1763, while other regions were conquering frontiers and their native inhabitants, New Englanders got a head start on creating a culture. They led the nation in education, arts, literature, architecture, and fomenting the American revolution.

Contradictions continued. Boston, the so-called "cradle of democracy," has arguably nurtured it less in recent years than almost anyplace in New England. Indeed, the farther one travels from the State House, the more open societies generally become, Vermont being the quintessential example. Known for

Below: A cow in front of a barn in Greensboro, Vermont. Chartered in 1781, the town may have been named after Timothy Green, a printer who was acquitted of producing counterfeit bills of credit.

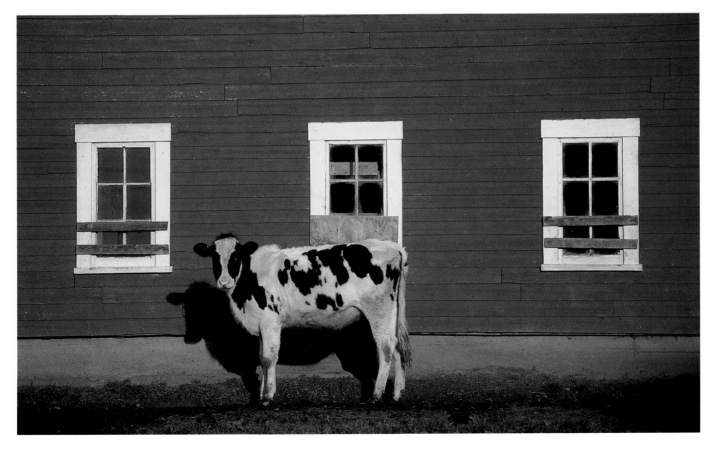

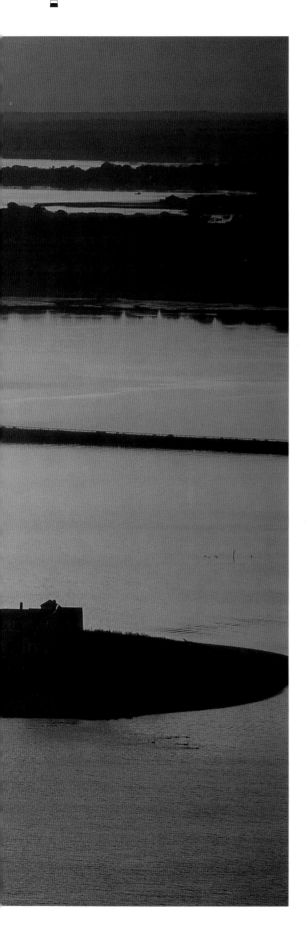

enlightening ideas like abolitionism— Samuel Sewell, a former Salem witch-craft judge, wrote the first antislavery pamphlet in 1700—New England also harbored a frightening number of slavemasters and racists. Nine of Yale's residential colleges were named after men who owned slaves or supported that peculiar institution. Rhode Island was incorporated as a "plantation" and not only employed large numbers of slaves but provided ports where even more were imported for other colonies. Even John Adams, whose racial views were advanced for their time, could be faulted. He described the Boston massacre protestors as "a motley rabble of saucy boys, negroes and mulattoes, Irish teagues and outlandish Jack tars."

Much is misunderstood about New England. We might start with that arche-typal New England legend, the midnight ride of Paul Revere. Emblazoned across American history by the Longfellow poem, "Paul Revere's Ride," Revere sup-posedly rode directly to Lexington and Concord on the night of April 18–19, 1775, with the words "The British are coming!" Actually, he wasn't the only rider, he alerted town leaders on the way, he never reached Concord, and he entered the Lexington house where John Hancock and Samuel Adams were staying with the words, "The Regulars [British troops] are coming out!"

A superb revolutionary organizer, Revere had already taken a less-noted ride to Portsmouth, New Hampshire, on December 13, 1774, to warn citizens that the British were about to seize gun-powder, cannon, and small arms at nearby Fort William and Mary. As a result, the next day some 400 New Hampshire militiamen successfully

Left: Lyme, Connecticut, and the tidelands area of the Connecticut River as it reaches the Long Island Sound. The longest and most prominent river in New England, it rises in northern New Hampshire, forms part of the border between that state and Vermont, and passes down through Massachusetts and Connecticut.

15

Opposite: Great Point Lighthouse, Nantucket. Originally built in 1784 and destroyed by storm and fire, the wooden tower was replaced in stone and has seen numerous modernizations since.

Below: Characteristically charming cottages and gardens in Siasconset, Nantucket. Young David Sarnoff, who later founded RCA, followed the Titanic *disaster by operating a wireless telegraphy station from Siasconset in April of 1912.*

assaulted the fort—which was defended by six invalided soldiers—while braving what were truly the first shots of the Revolution. Even most New Englanders remain oblivious to this episode.

Equally misunderstood were the Puritans, whose influence was said to be universal throughout New England. In truth, Vermont developed independent of them and Connecticut and Rhode Island were founded by refugees from Puritan abuse. Even in their area of maximum control, Massachusetts, there was occasionally hearty dissent.

The case of Hannah Lyman is instructive. Following King Philip's War of 1675–6, the bloodiest per-capita conflict in American history, the courts began zealously enforcing sumptuary laws restricting dress. Lyman, a teenager from Northampton, Massachusetts, was pros-

ecuted for wearing silk on Sundays and fast days "when ye people of god were falling before ye Lord in publique Humeliation in Respect of ye heavy Judgements & Callamities yt were threating to Come upon us." Even as they were trying her case, Lyman appeared before the judges in silk! For her remarkable display of independence and feminist courage, she was fined ten shillings.

Puritans are variously pictured as black-hatted bigots who banned Christmas until 1820, frowned on most games, spied on their neighbors, and punished transgressors with fines, whipping, and time in the stocks. They could be all that—as you'll be reading on these pages—but if Puritans introduced the less likable traits of New England character, they also laid the foundations for the best manifestations of New England

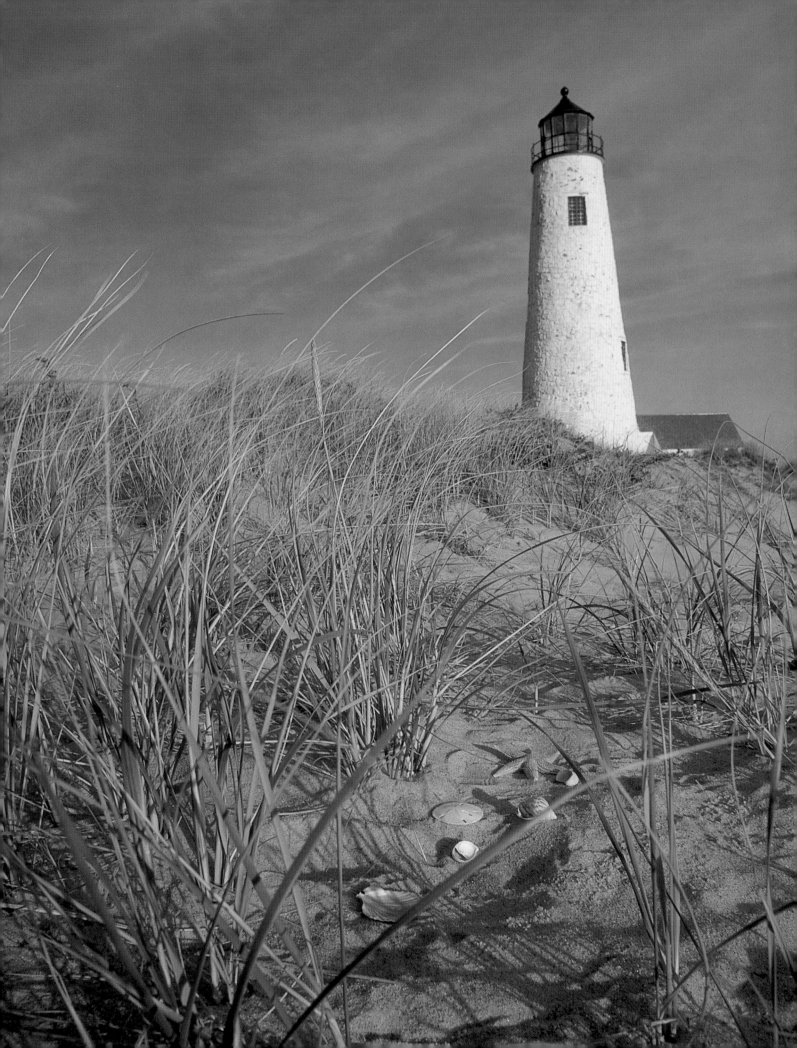

Below: *Farm buildings in Hartland, Vermont. Chartered as Hertford in 1761, the town's name was changed twenty-one years later to distinguish it from nearby Hartford because it was "difficult for strangers to distinguish which of said towns might be meant…and many other inconveniences do attend the having two towns so near of one name in the state."*

achievement, such as the great universities. Four of their early leaders—John Winthrop, Sir Richard Saltonstall, Isaac Johnson and John Humphrey—had attended Cambridge University in England and saw education as a way to train clergy. Another inducement for study was social status. Only educated men earned the status of "master."

The Massachusetts Bay Company authorized Puritan settlement for commercial purposes. Whether equating worldly success with godliness spoke well for them is debatable, but there was no arguing their success. "What the Puritans gave the world was not thought, but action," said Horace Greeley.

The 95-point Massachusetts "Body of Liberties" (1641) granted a speedy trial by jury, the right to appeal, even the right to sit out wars that weren't "defensive." "The Puritans condemned democracy but were the most democratic of non-primitive people on Earth," said Frank Heston, a retired history teacher at Frontier High School in South Deerfield, Massachusetts. "Their society was based on five democratic principles. First, the churches were run by their congregations whose ministers were hired and fired and had far less power than people suppose today. Second, the core of governance was town meeting. Third, the army was a militia of able-bodied men

16 to 60. Fourth, the community would bear the cost of public education for all. And fifth, the commonwealth was a pact of citizen to citizen pledging mutual support." True—these rights did not apply to women, servants and slaves. But citizens who still revered the founders (Samuel Adams's pen name was "Puritan") signed the 1780 Massachusetts constitution, the world's oldest functioning charter, which began, "All men are created free and equal" and banned slavery before any other state did.

Puritanical? That's overrated. The Puritans enjoyed their fair share of sex, alcohol, bowling, shooting, and even wrestling (the real Puritans were the Victorians). Even the worst of Puritanism must be understood in context.

Four years before the famous Salem witch trials of 1692, a thirteen-year-old girl named Martha Goodwin began behaving strangely after an argument with laundress Goody Glover. Soon her younger brother and two sisters exhibited similar behavior, leading to the trial and execution of "witch" Glover. Prompted by concern for the welfare of children, the notorious 1692 events were further influenced by an outbreak of smallpox and fears of attack by local tribes that fostered already rampant paranoia. All of which explains, if not excuses, the worst excesses of the Puritan era.

Overleaf: *Gouldsboro Point, Maine. At 35,387 square miles, the Pine Tree State is nearly as large as its five New England neighbors combined and has more than 1,600 lakes.*

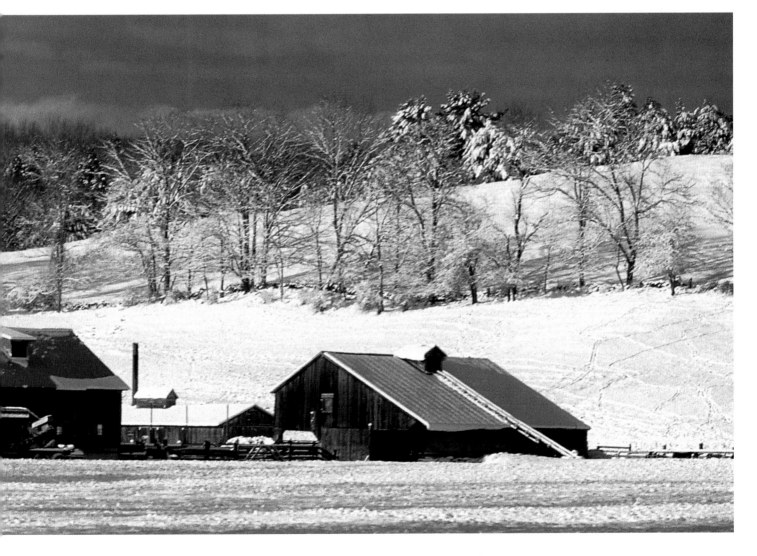

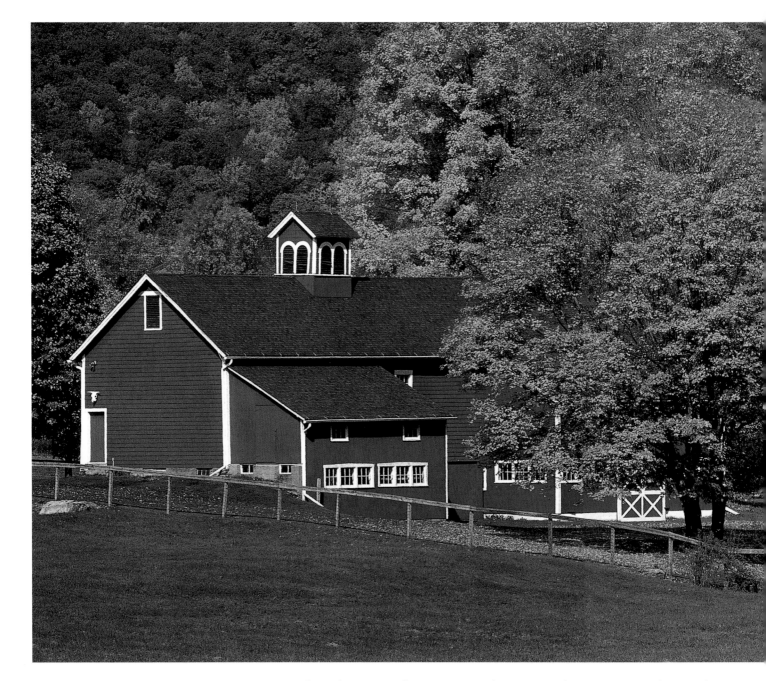

In any case, when the Massachusetts charter of 1692 changed the colony's base from theocratic to political and secular, it was no longer necessary to worship in order to vote. Indeed, "the idea of congregational democratic church government was carried into a political life of the state as the source of modern democracy," according to the *Columbia Encyclopedia.* Granted, Puritanism continued to affect society. Puritans believed in Calvinist predestination and saw the world as a gloomy dress-rehearsal for the hereafter. Yet their example of self-reliance, energy, and industry molded America for the better as well. One might say that New England's Puritan character gradually morphed into the Yankee character: thrifty, resourceful, and finally generous.

Not that the Puritan ethic now permeates the entire region. New England was first settled by Protestants from

Rebellion. Generally footnoted as a 1787 clash between angry farmers from western Massachusetts and their antagonists in the eastern part of the state, the rebellion was actually a class war that changed America forever.

It began during that difficult post-Revolution period during which Americans were governed by the Articles of Confederation—if a document that provided no chief executive, standing army or taxing power could be called government. As a result of the revolutionary war, debt was widespread. In Massachusetts, the state government was desperately trying to pay off its wartime bills. The burden was felt down the line. Boston merchants, denied credit by British associates, pressured country retailers and shopkeepers to pay them in hard coin, wartime scrip having become worthless. The country businessmen in turn told farmers they could no longer pay with produce. That left the farmers in an impossible position. They had returned from war with nothing but scrip and crops to their names. One by one, they lost their lands to foreclosures and filled debtors' prisons.

Enter Daniel Shays. Born to an Scots-Irish farming family in Hopkinton (today the starting point for the Boston Marathon), Shays fought at Bunker Hill, advanced from private to captain, and served under the Marquis de Lafayette during the Revolutionary War. Forced by financial need to sell a ceremonial sword Lafayette had given him, Shays was no longer considered "an officer and a gentleman" by his fellow officers. When they ostracized him, he resigned and in 1780 returned to his farm in Pelham, in the western part of the state. In the mid-1780s, Shays began drilling

Left: Cobble Brook Farm in Kent, Connecticut. Known as both the Constitution State and the Nutmeg State, Connecticut is densely populated along the shoreline and mostly woodland and forest in the interior.

England. Its next great wave of immigrants were overwhelmingly Catholics, and in more recent decades the new immigrants come from all over the world. Defining New England attitudes is as easy as catching lightning in a bottle. But it's worth a try. If you're looking for a consistent thread in the New England character, you could start with the word "independence." Nowhere was this better illustrated than in Shays'

23

Right: A church in Concord, Massachusetts. One of the most historic sites in New England, Concord was home to authors Louisa May Alcott, Ralph Waldo Emerson, Nathaniel Hawthorne, and Henry David Thoreau, and the scene of an early Revolutionary War battle on April 19, 1775.

troops at local Conkey's Tavern, and recruits joined the movement across the state. They called themselves "regulators," because they wanted to regulate rather than destroy government. Strictly nonviolent at first, they went to the legislature and courts with two primary requests: issue paper money and pass laws allowing them to pay in produce. Getting no relief, they stormed into Northampton's Court of Common Pleas and closed it briefly on August 29, 1786, rather than allowing debtors' cases to be heard. Similar actions by Shays and other regulators followed in other Massachusetts cities—Worcester, Concord, Taunton, Springfield, and Great Barrington. In November, when a regulator named Job Shattuck was slashed across the knee by government soldiers, public sentiment quickly turned toward the protestors.

By now lines had been drawn. "I believe this country would flourish faster if there were less white shirts and more black frocks," a farmer wrote the

Hampshire Gazette. "Let us oblige the merchants to shut up their shops and get their living by following the plough." In the pages of the same newspaper, which was founded to present the anti-Shays position, others rained denunciations upon the protestors.

Still believing a peaceful solution was possible, the regulators passed up a December 1786 chance to occupy the Springfield arsenal and seize its 7,000 bayoneted muskets, 1,300 barrels of powder, and untold quantities of shot and shell. Then the government forced them to fight. On January 4, 1787, Governor William Bowdoin assigned General Benjamin Lincoln to command a 4,400-man force to crush the rebellion. Because the government lacked public funds to pay them, the army was funded by the "first characters of Boston," merchants like Samuel Breck, Thomas Russell, Caleb Davis, and Joseph Barrell who lent some £5,000 in a single week.

The rebels, now fueled with class resentment, decided to plunder the arsenal and march on Boston to "destroy the nest of evil." While General William Shepard and 1,100 largely well-heeled volunteers filled the arsenal, up to 2,000 farmers prepared to attack: 1,200 under Shays from Pelham, 400 under Luke Day from West Springfield, and another 400 under Eli Parsons from Berkshire County. As it happened, a message from Day to delay the attack until January 26 was intercepted—by Shepard's men, according to some accounts—before it could reach Shays and Parsons.

At 4 p.m. on January 25, somewhere between 1,100 and 1,500 men advanced through snow to a point 250 yards from the arsenal. Many were dressed in their old Revolutionary War uniforms, with hemlock in their hats, and armed with old guns and wooden clubs. Advancing from before the arsenal, Northampton retailers William Lyman and Samuel Buffington galloped up to them and told the rebels that if they continued advancing, they would "inevitably be fired on" by "men they had been accustomed to obey" during the Revolution. "That is all we want," replied Adam Wheeler.

Buffington came upon Shays and said, "I am here in defense of that country you are endeavoring to destroy." With his drawn sword in his left hand and a pistol in his right, Shays replied, "We are both defending the same cause." The insurgents huddled briefly. Then Shays issued an order, "March, damn you, march!" Warning blasts from arsenal cannon landed behind them. They kept advancing through ankle-deep snow, in platoons of twelve men apiece. "Aim at their center and the Lord have mercy on them!" Shepard commanded. Another blast tore into their ranks, killing four and wounding perhaps twenty more. Outnumbered, the insurgents retreated in

Below: *Conkey's Tavern in Pelham, Massachusetts. At this location Daniel Shays and his followers planned a march on the Springfield arsenal—a critical event in Shays' Rebellion of 1786–7.*

panic. After regrouping in Pelham, they marched north, raiding stores and capturing retailers and tradesmen.

On the freezing winter morning of February 4, 1787, the regulators were cooking breakfast in the northern Massachusetts town of Petersham. To their utter shock, an army of 3,000 men led by the 300-pound General Lincoln, having marched 30 miles through wind and snow while suffering from frostbite and pneumonia, descended on them, scattering their ranks. Shays escaped to the Free and Independent Republic of Vermont and later moved to upstate New York, where he lived out his days in obscurity before dying in 1825. Other regulators continued fighting in Berkshire County until June of 1787. Many Bay Staters remained sympathetic. In the general elections, Bowdoin was defeated by a three-to-one majority, and the ranks of senators and House members were scattered like geese by buckshot.

In time, Massachusetts farmers got relief. The tax laws were overhauled, the insurgents were pardoned (some at the foot of the gallows), and debtors' prisons were abolished. The effect of Shays' Rebellion on the country was more dramatic. Fearing everything from anarchy to a general redistribution of wealth, merchants, planters, and professionals met in Philadelphia. In a classic example of unintended consequences, the anti-Federalist Shaysites prompted a movement for a stronger central government. "Shays' Rebellion was the catalyst for the Constitutional Convention," said historian Larry Lowenthal.

Not to mention that convention's outcome. Listen to the rhetoric. Charles Pettit, a merchant and legislator from Pennsylvania, warned of "a total abolition of debts both public and private and even a general distribution of property." With no means of arming troops against insurrectionists, Foreign Secretary John Jay said, "the inefficiency of the Federal government becomes more and more manifest." As a result, the Constitution provided a strong government with protections against domestic unrest, and gave voting rights only to white male property holders. The subsequent *Federalist Papers*, which helped get the Constitution ratified, were also motivated in part by the fear of insurrection. In short, Shays' Rebellion was instrumental in the existence of both the Constitution and the Bill of Rights.

It should now be established that the New Englander is an independent cuss. And yet, the conformist Puritans never totally deserted the region. They lived on in Nathaniel Hawthorne's gloomy novels (after all, he was descended from another Salem witchcraft judge) and certain secular manifestations of the twentieth century. Surely, Puritan thinking was behind the Blue Laws that still ban liquor sales on Sunday and the shameful practice of banning books—two landmarks of Massachusetts history.

The ultimate manifestation of surviving Puritanism—we are absolutely serious here—is New Englanders' attitude toward the Boston Red Sox. It is doubtful any team is more closely followed than the Olde Towne Team is by New Englanders. In a popular movie *In the Bedroom* (2001), Maine villagers listen to radio rebroadcasts of the games well after midnight. The Red Sox are firmly woven into the region's culture.

At first, the association with Puritan gloom may seem strange, because there is much joyousness about New England's

Opposite: A scenic view in early fall in Warren, Vermont, in the Green Mountains, which run north-south through the center of the state. Before roads were improved, the expression "going over the mountain" described a difficult trek between the state's isolated eastern and western regions.

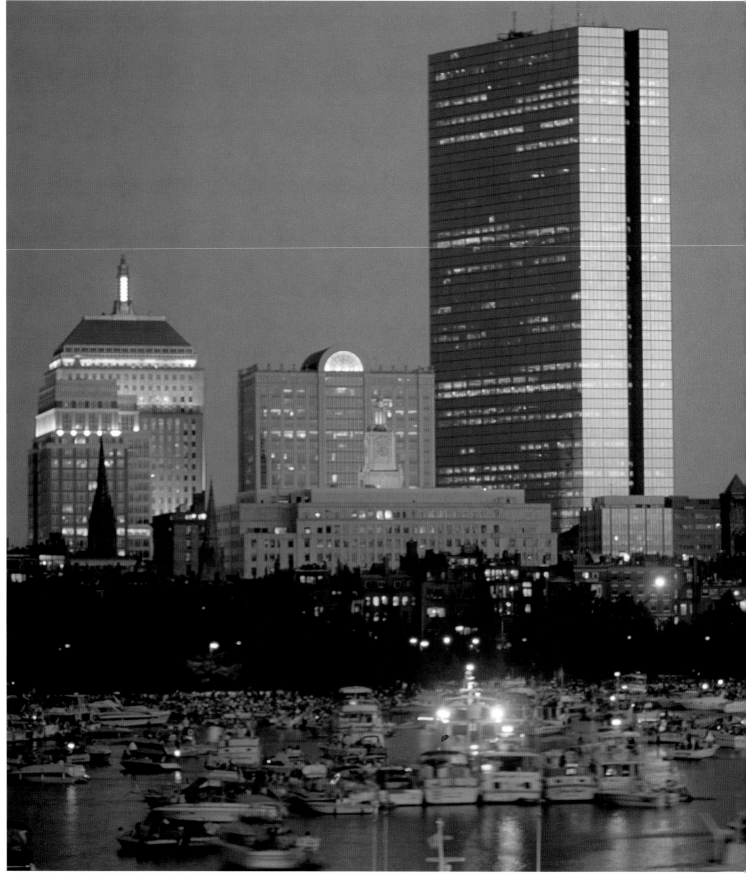

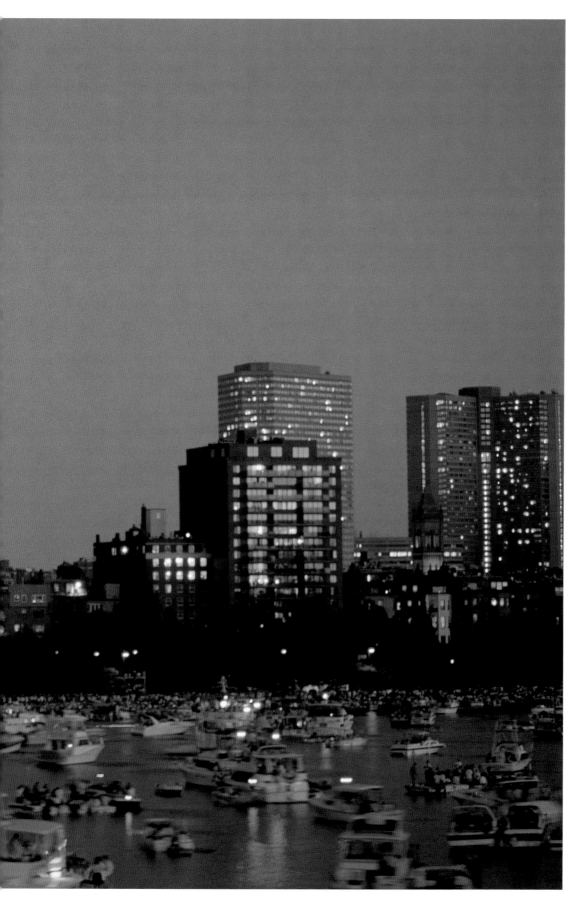

Left: *The Fourth of July Harborfest on Boston's Charles River. During the week-long festival, which New Englanders claim is the nation's premier Fourth of July celebration, visitors can enjoy dazzling fireworks, concerts, and re-enactments of key events in the American Revolution.*

Opposite: The Old State House in Boston. Built in 1713, Boston's oldest public building became a showcase of government in action when a gallery was unveiled in 1766.

baseball team. The game's best club over the first two decades of the 1900s, the Red Sox won five World Series. They have sported many of the game's top individual players, including the best hitter (Ted Williams), best pitcher (Lefty Grove), and best combined pitcher, hitter, and gate attraction (Babe Ruth). Their home field, Fenway Park—"a lyric little bandox of a ballpark," in the words of the novelist John Updike—has been a Boston tourist mecca on a par with the Old North Church and the USS *Constitution*, "Old Ironsides." Finally, at this writing, the Sox have played in four World Series and numerous other postseason playoffs since their glory days.

No, the problem with the Red Sox has not been failure, but something only a miserable Puritan or a musing New Englander could appreciate. It is the feeling of having the brass ring in one's fingers, only to feel it slip away. The very mention of the team sets off head-

shaking from Eastport to Block Island and Boston to Burlington. "Yes, the Red Sox," the muttering begins. "They will never win it all in our lifetimes. The fates are against us. Life is predestined to gloom and misery."

This New England state of mind is all very well and bad, but it may be outdated. In January of 2002, the New England Patriots, with more derring-do and good fortune than any Red Sox team ever, won the National Football League's Super Bowl. They are America's only major sports team named after a region, and, uncharacteristically, New Englanders found something to rejoice about. Could this surly, pessimistic crowd have morphed into a happy, even optimistic populace? In any case, they will never give up on the Red Sox. Indeed, New Englanders have never given up on themselves. And readers of this book will certainly appreciate why they never give up on their region.

Right: Boston's Fenway Park, a scene of regional pride and despair. Its "Green Monster" left-field fence is both the park's most celebrated architectural feature and worst flaw.

Overleaf: Menemsha on the island of Martha's Vineyard. Though destroyed by a 1938 hurricane, it was rebuilt as a fishing village and served as a location for the popular movie Jaws.

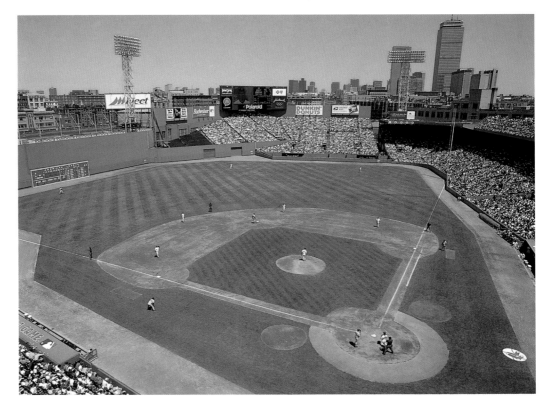

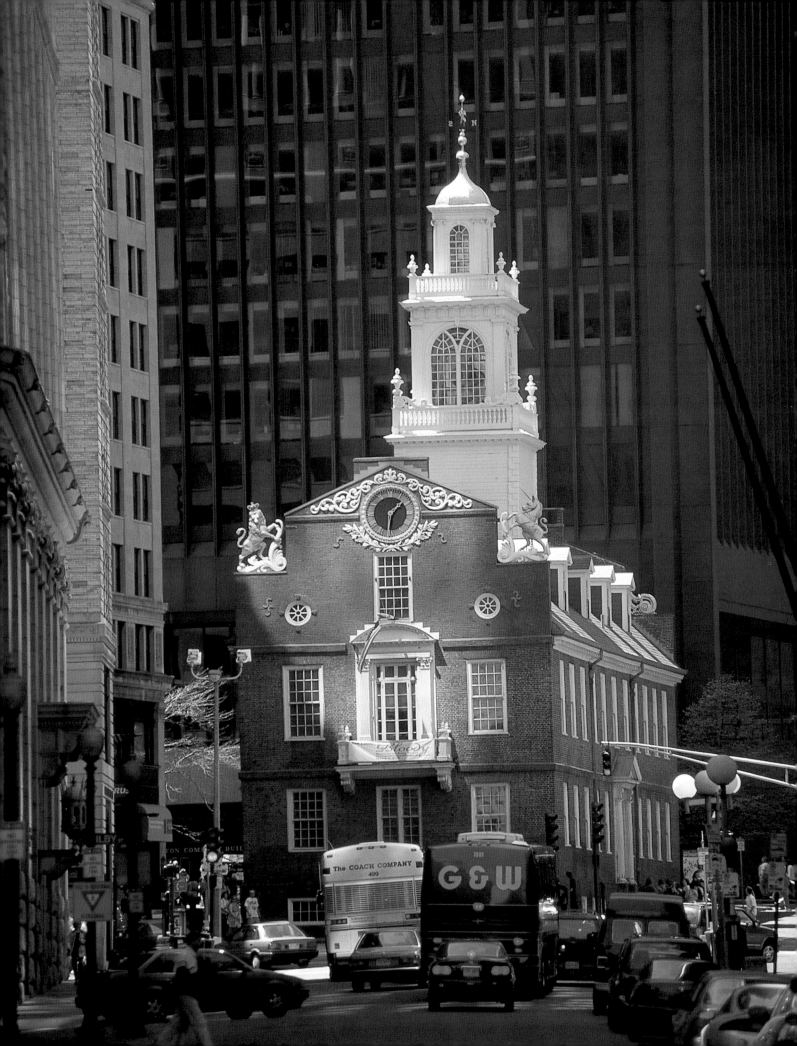

THE
FIRST
INHABITANTS

Previous page: Seen in the mist are the lower slopes of Mount Greylock, the highest point in Massachusetts at 3,491 feet. The mountain is reputed to have been named for a seventeenth-century Mohawk chief.

For all their justifiable pride in their history, most New Englanders are unaware of just how long ago human beings first appeared in the region. In part this is due to the fact that there are few notable sites associated with these first New Englanders—and these sites offer little of interest to the lay person, though they have provided useful evidence of early human settlement for archaeologists and anthropologists. The artifacts discovered at these sites include basic stone tools and animal bones but no human skeletons. In recent decades, the specialists have been piecing together such finds and other evidence to construct a fairly clear scenario for the settlement of the region of North America that we now know as New England.

The exact date of the first human beings in this region, of course, cannot be pinned down. Even assuming that the earliest humans to enter North America moved across Beringia—the land bridge linking Siberia to Alaska—as early as 25,000 BC, it is now believed that their descendants did not make their way over to New England until about 9000 BC. But whenever these first humans appeared in New England, it was a far different environment—in terms of both terrain and climate—from that familiar to the Native Americans whom the first Europeans would encounter. The great glaciers of the last Ice Age had extended all the way down across New England as late as 13,000 BC, so they had been receding only relatively recently as these first so-called Paleo-Indians ("Old Indians") made their way eastward across North America. The land they encountered in New England was both boggy and rocky, the vegetation much like that of

subarctic tundra today, and the weather was cool and damp at best. The environment, in short, has been aptly described as "harsh and unforgiving."

The first humans in New England are believed to have been seasonal visitors, hunters who chased the mastodons, wooly mammoths, caribou, deer, beaver, and other small animals during the warmer months, then returned south for the winter. Their campsites are identified primarily by the fluted points of their spearheads and tools made from chipping flint, carried from outcroppings in present-day New York state. Some of the early Paleo-Indian sites can be found in the following locales: in Connecticut, at Glastonbury, Ledyard, and Templeton; in Massachusetts, at Chicopee, Deerfield, Hampden, Ipswich, Middleboro, Montague, Nantucket, and Plymouth; in Vermont, at Franklin and Highgate; in New Hampshire, at Colebrook, Intervale, Israel River Valley, Manchester, Swanzey, and Whipple; and in Maine, at Brassua Lake, Ellsworth, Lewiston, and Vail. What many of these sites have in common is their location on rivers or ocean shores, indicating that the Paleo-Indians had boats, almost certainly crude dugouts, and were capable of traveling across quite challenging waters.

By about 7500 BC, a distinct change emerged in the lives of the continent's inhabitants due to a significant warming of the climate. In New England this led to an evolution toward more temperate vegetation and thicker forest, which in turn led to a more diverse fauna population—including white-tailed deer, turkey, and black bear. (The mastodon and mammoth both appear to have been wiped out; the caribou moved gradually into Canada as the

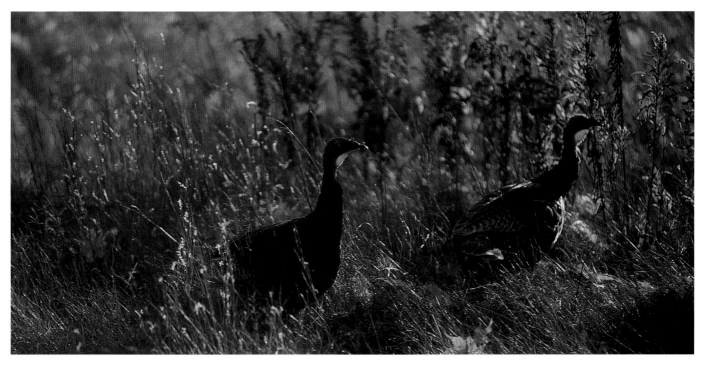

melting glaciers produced the tundra.) The people who now moved into the region—many from the Great Lakes region—were relatives of the Paleo-Indians, but new elements of their life-ways has led to their being classified as Archaic Indians. The term "archaic" is applied to the period from about 7500 BC to about 1000 BC (a period further divided into Early, Middle, and Late Archaic), and the Archaic Indians lived throughout much of North America.

Inevitably, development was uneven and there were many variations during the thousands of years and across the vast areas characterized by the Archaic Period. But by the end of this period, the people of New England were living quite different lives from those of their forebears. Having at first moved about seasonally to take advantage of the more diverse flora and fauna, gradually they began to settle more permanently. By the end of the Archaic period, some were making sophisticated wooden shelters and structures. A circular wooden ceremonial lodge

at Assuwumpsett Lake, in Middleboro, Massachusetts, had a diameter of 66 feet.

The Archaic Indians gathered many varieties of seeds, nuts, berries, fruits, and roots. They also fished from rivers and lakes and the ocean, using hooks, trapping with weirs, harpooning for seals, and digging for shellfish. They had a more diverse material culture: they made more varied stone tools, birch-bark containers, and soapstone (steatite) bowls and nut mortars. Wood was worked into a variety of utensils. They kept domesticated wolf-dogs and used spears and spear launchers (known as atlatls), which gave them an added advantage in hunting game. Larger animals like deer provided not just food but skins for all manner of uses—clothing, shelter, thongs for lashing. They maintained relatively wide-ranging exchange or trade networks: copper was introduced from the Lake Superior region and other objects can be traced as far north as the Arctic and as far south as the Gulf of Mexico.

Above: Wild turkey, for thousands of years a source of food for the Indians of New England, were close to extinction by the mid-1900s. Breeding flocks were introduced and protected and now the birds are again plentiful.

Opposite: This marshy terrain in Maine's Acadia National Park is typical of what New England's Archaic Indians would have known.

Below: Mount Monadnock, New Hampshire, from the Abenaki word meaning "one who stands alone."

And at least by the end of the Late Archaic phase, some of the New England Indians were practicing ceremonial burials of their dead. This involved drying out the body in a lodge, cremating it, then transferring the remains to a burial pit. Various tools needed for survival in the afterworld were often added to the cremation fire; in the final burial, red ocher powder might be sprinkled on the ashes to provide the "blood" for the afterlife. Presiding over all this was a shaman, or priest, who also functioned as the medicine man to treat accidents and ailments.

By about 1000 BC, with the Late Archaic period having come to its climax, the next period across much of the Northeast is known as the Woodland, or Woodland-Ceramic culture. This is the name assigned to the culture that characterized the New England Indians until the coming of Europeans, even to the late 1600s. In turn, the Woodland period is often divided into two phases: the Early/Middle extended to about AD 800; and the Late Woodland, to the contact with Europeans. Again, there were no clean dividing lines and there were

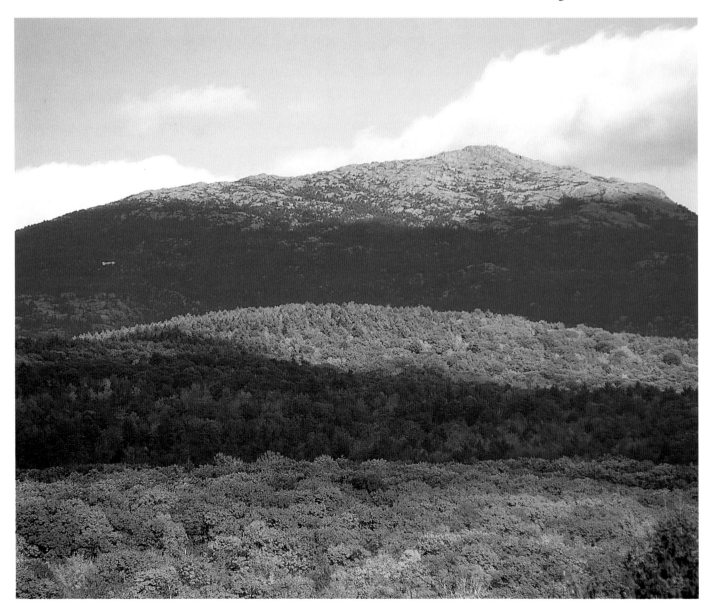

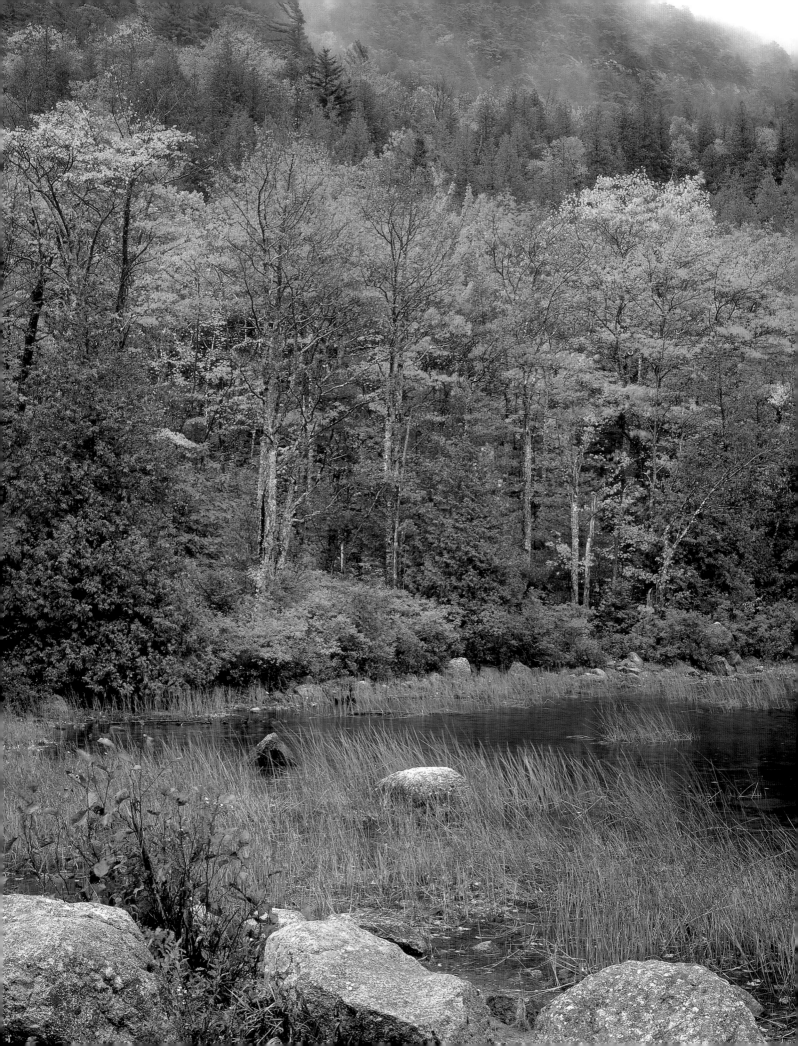

Above: From about AD 1000, corn was not only grown as a staple food but was considered sacred by pre-contact New England peoples.

countless variations in the practices of people moving and living throughout New England during this long period. But from the outset of the period, certain constants emerged. These Indians began to settle in villages located conveniently for food sources. They even cultivated wild plants like pigweed (lamb's quarters) and jerusalem artichokes. They smoked tobacco in soapstone pipes. This more settled existence seems to have led to social ranking, a generally more complex society, and a significant increase in the population.

It is generally recognized that some of the major cultural developments among New England Indians by about the year AD 100 had been introduced by the so-called Adena people, who moved into the New England region from the Ohio River Valley carrying with them a more advanced material culture (some of which had been borrowed from Indians

living well to the south and west). The use of ceremonial pipes, for instance, or the wearing of gorges, or pendants, around the neck may have been introduced by these Adena people.

In particular the Adena people had been making ceramic pots and utensils for some time and they were cultivating three vegetables—squash, beans, and maize (although maize would not be cultivated in New England until about AD 1000). Both these innovations—ceramics and crop cultivation—would have a profound impact on the New England Indians' way of life. By making containers and utensils from clay, they were freed from visiting often distant quarries for stone; instead they had to master the new technology of firing kilns. Cultivating crops allowed them to produce a surplus for the winter months but also required a more settled village-based life. It is also believed that as

women were assigned the tasks of making pottery and tending crops, the men began to spend their time guarding the planted fields and the adjacent villages. As tribes began to identify a need to defend their "territory," more aggressive behavior developed, leading eventually to frequent raids and skirmishes.

By the year AD 1000, most New England peoples are considered to have belonged to the large Algonquian-language group. The names these tribes would be assigned by the Europeans were not always the ones that the Indians themselves used, but they entered our recorded history. In northern Maine were the Eastern Abenaki, which included tribes such as the Kennebec, Passamaquoddy, and Penobscot. The Western Abenaki lived in northern New Hampshire and Vermont; they included tribes such as the Penacook and Winnipesaukee. The Pawtucket Indians inhabited the coastal areas of southern Maine and New Hampshire. The Massachusett Indians lived in northeastern Massachusetts; the Wampanoag lived in the southeast, including Cape Cod and the offshore islands. Central Massachusetts was inhabited by the Nipmuck, while the western edge of the state was inhabited by the Mahican and Pocumtuck. The Narragansett dominated Rhode Island, while Connecticut was dominated by the Pequot and the closely related Mohegan.

Naturally there was some diversity in their lifestyles: those who lived along the coast or rivers depended upon aquatic

Below: At Plimouth Plantation, the replica of the original settlement at Plymouth, Massachusetts, this individual re-enacts the Wampanoag method of planting crops.

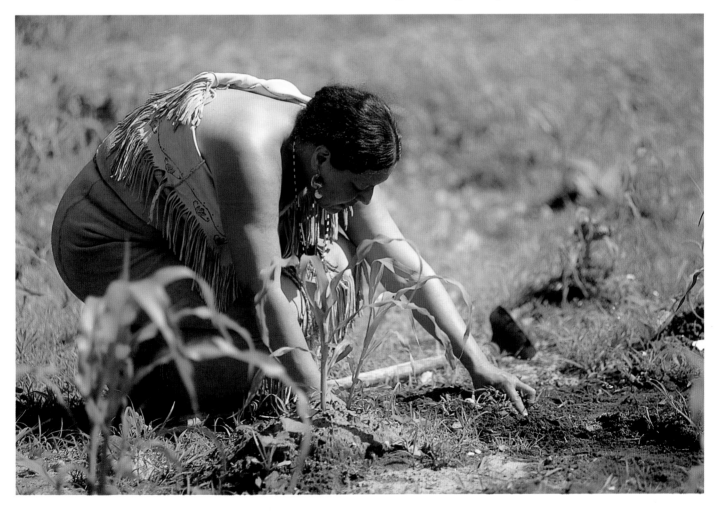

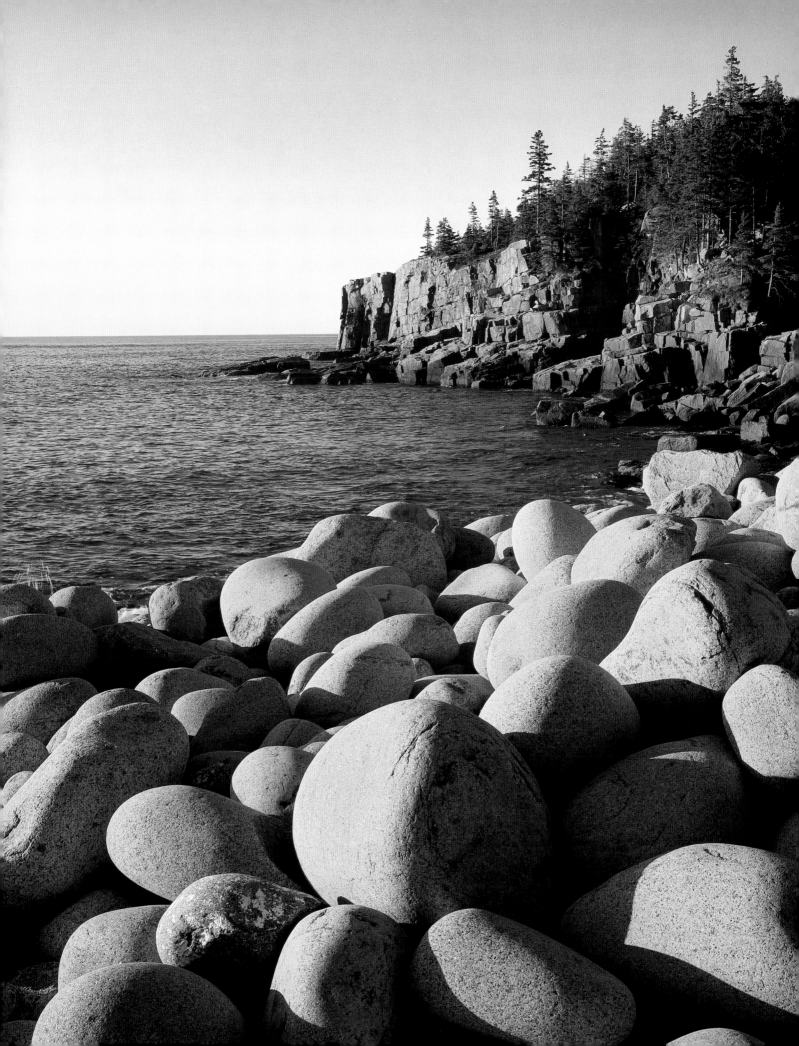

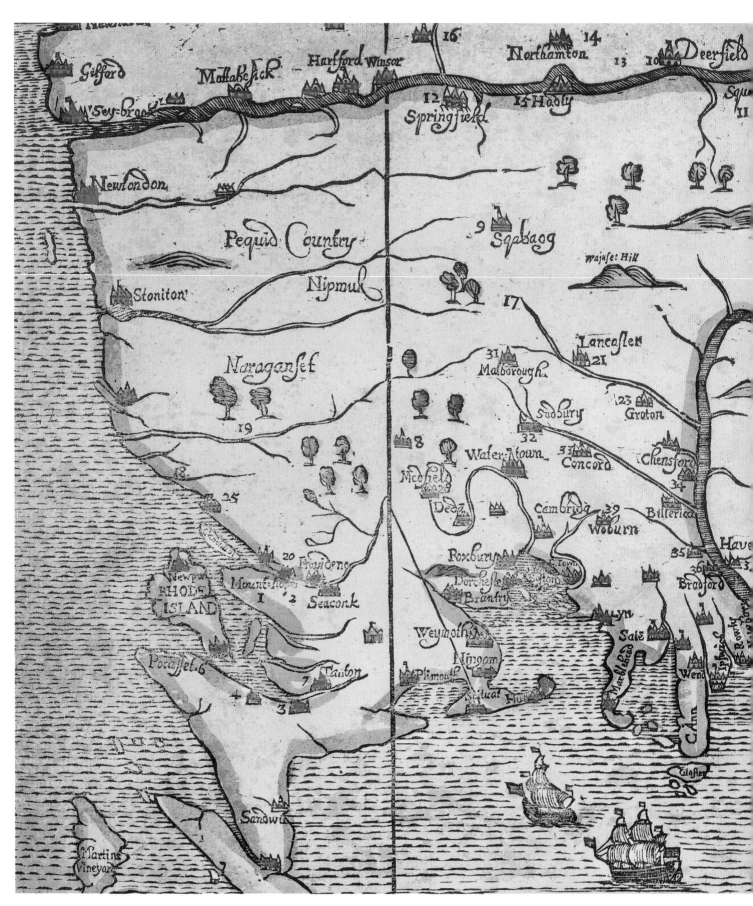

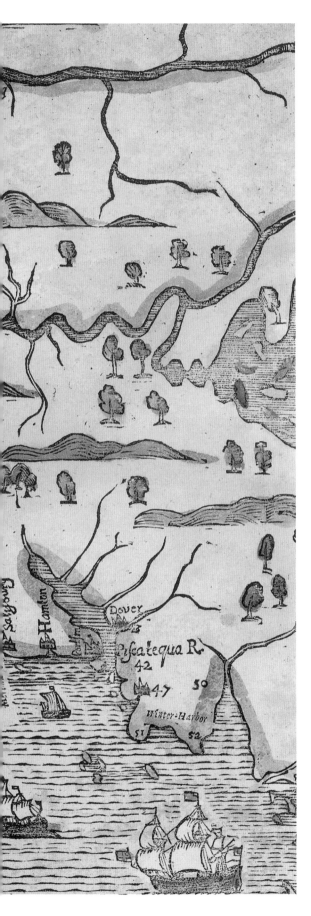

resources, for example, while other tribes continued to depend more on hunting game; some lived in what were virtually fortified villages, while others continued to move about with their more temporary wigwams; some were more aggressive than others. But the Indians of New England in the centuries before the coming of the Europeans had a culture that was well designed to respond to their environment. They had a whole toolbox of specialized stone tools for farming, preparing animals for food or skins, and for grinding nuts and vegetables. They used bark for baskets, canoes, and shelters. Shelters ranged from small conical birchbark wigwams to bark-covered longhouses up to 200 feet long. They used hemp, flax, and other plants for cords and nets. They fashioned baskets in several styles—woven, twined, and coiled. They made clay pots of all sizes and shapes. They were most famous for their versatile birchbark canoes, but they also made dugout canoes reported to be up to 50 feet long. Their weapons included war clubs, spears, knives, and bows and arrows.

New England peoples of this period used animal skins for everything from shelter coverings to clothing and moccasins. They used porcupine quills for colorful decorations. Beads made from the shells of shellfish were used as decoration and were known as "wampum," which also served as a form of money. They collected syrup from the maple trees. They smoked their fish and game to preserve it. To plant crops, they cleared an area of land, then made small oval mounds in which they sowed the corn seeds; small fish or ground horseshoe-crab shells were buried in the mounds to fertilize the soil; beans and squash were then planted among the corn hills.

Page 40: An early snowfall in the late autumn presages the coming of winter to a forest in Greensboro, Vermont, typical of the environment that New England Indians long experienced.

Page 41: Up to 300 feet high, the Otter Cliffs section of Acadia National Park along the coast of northern Maine is the highest headland on the Atlantic coast north of Rio de Janeiro, Brazil. Shell heaps and burial sites with red ocher attest to settlement in this area up to 5,000 years ago; the Abenaki lived here when Europeans first arrived.

Left: This map was originally published in 1677 with William Hubbard's Narrative of the Troubles with the Indians of New England. *North is to the right. As well as many towns still in existence, it recognizes Indian nations like the Narragansett and Pequid (Pequot).*

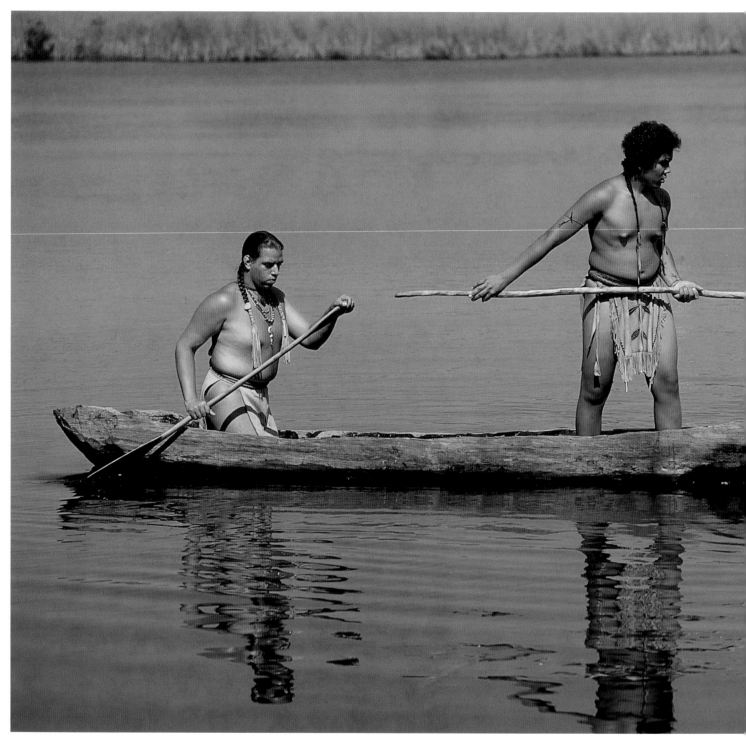

It is generally accepted that this New England culture evolved independently of any European influence until the first contacts in the early 1500s—or the late 1490s at the earliest. But there have long been theories to the contrary. Some believe that there was contact with non-Indians before even Columbus "discovered" the New World. Even if their claims are not accepted by most authorities, these "pre-Columbians," as we shall dub them, persist in promoting their sites to the extent that they continue to be part of the New England "scene."

It is widely accepted that the Norse maintained a settlement on the northern tip of Newfoundland for about ten to fifteen years starting about AD 1000. The debate arises over how far south these Norse reached in their journeys. The fact that the Norse records seem quite clear about their having found grapes—and thus naming this newly found territory, Vinland—does support the claim that they must have sailed at least down to northeastern New Brunswick, Canada, the northern limit for grapes to grow. Further supporting this claim is the fact that at the Norse site in Newfoundland, L'Anse aux Meadows, were once found remains of butternuts (*Juglans cinerea*), also found growing no farther north than the New Brunswick limit.

One possible indication of an early Norse presence in New England is a penny coin that was found at an Indian burial site in Maine. The site was dated to the twelfth century, and the coin dates from the reign of Norway's King Olaf Kyrre, 1065–80. But the coin was found along with objects attributed to the Dorset Eskimos of northern Labrador, and archaeologists are quite certain that it was originally obtained in trade between these Eskimos and the Norse of Greenland, and subsequently passed along southward to Maine.

But not content with this version of the Norse presence in North America, there have long been people—mostly, but not all, New Englanders—who have insisted that the Norse traveled down the coast as far as New England. (Others claim they even reached the Carolinas.) Their principal evidence for this is the Old Stone Tower in Newport, Rhode Island, but archaeologists have established that it was built in colonial times, probably in the late 1600s. In Massachusetts, there are two rocks with inscriptions—the Bourne Rock and the Dighton Rock—that some claim were made by Vikings, whether those from the Newfoundland site or earlier, or later. In Maine, rocky ledges at Grand

Left: At Plimouth Plantation, the replica of the original settlement at Plymouth, Massachusetts, these re-enactors demonstrate the way the Wampanoag fished from a dugout long before the coming of the Pilgrims.

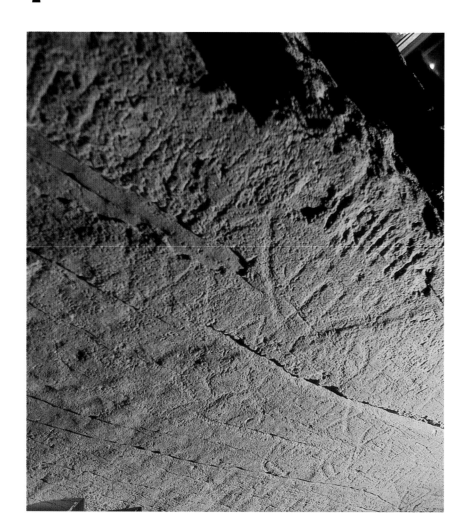

Above: Dighton Rock, now in a special museum near Fall River, Massachusetts, was found in the waters along the nearby Atlantic coast. It has long been controversial because of the inscription carved into it, which is of disputed origin.

Lake Stream and Manana Island have carvings that some claim to be the runic inscriptions left by the Vikings.

But the problem is then clouded by the fact that for everyone who insists that the inscriptions are old Norse runic signs, others see an ancient Phoenician language, an ancient Celtic language, an ancient Native American inscription, or, in the case of the Dighton Rock, a message left by early Portuguese sailors. Experts in these languages do not accept such claims. They point out, for instance, that it is hard to accept these as isolated instances of Native American inscriptions when no other examples of Indian script are known from this region.

In addition to the inscriptions claimed by the "pre-Columbians," there are also numerous lithic sites, or stone structures, found throughout New England that many people believe were erected if not by pre-Columbian visitors from the Old World, then by early Native Americans. In Vermont, there are several stone chambers at South Royalton, while South Woodstock claims the largest stone chamber in New England. In Maine there is the tunnel-like chamber at Grand Lake Stream. In Connecticut, there are dozens of conical stone piles in the Patachaug State Forest, while at Gungywamp there are concentric stone circles 11 feet in diameter, stone chambers, standing stone alignments, a stone-lined underground tunnel, and a very large stone cairn. Massachusetts has a large beehive chamber at Upton, an underground beehive chamber at Petersham, and a whole complex of stone-lined tunnels at Goshen.

Beyond claiming that these various structures were erected anywhere from 500 to 5,000 years ago, some pre-Columbians claim that they served a ritualistic or religious purpose. Others claim that some of these stones were aligned to provide astronomical sightlines. The entrance to the stone chamber at South Woodstock, Vermont, for instance, is said to be aligned to the winter solstice—that is, the rising sun at this time lights up the interior. But undoubtedly the most spectacular of these sites is the one known as Mystery Hill, at Salem in southern New Hampshire. Mystery Hill includes chambers, underground passageways, stones standing in astronomical alignments, and some inscriptions. There is even a so-called sacrificial stone, a large flat stone with a groove around its edge that comes to a run-off: pre-Columbians see this as allowing for sacrificial victims' blood.

Promoted as "America's Stonehenge"—it is now a major tourist attraction—the site is undeniably "mysterious," but professional archaeologists believe this is because so many people have deliberately manipulated these stones. For one, a William Goodwin purchased the site in the 1930s and quite overtly engaged in some reconstruction in order to "prove" that Irish monks had come there in the tenth century in flight from Viking raids.

There is no denying that these many sites are fascinating and they do continue to raise questions. But in general, archaeologists assign them to the colonial era even if they cannot be positive about the function of these stone structures. One of their arguments is that the Indians of New England do not appear to have had any tradition of building with stone or even bricks, comparable, for example, to the great mounds of the Mississippi Valley or the pueblos of the Southwest. In fact, except for the stone items—tools, bowls, pipes—and the pottery, the material culture of the pre-contact New England Indians was one of perishable materials, artifacts that could not stand up to the inevitable wear-and-tear of both nature and human presence across the centuries.

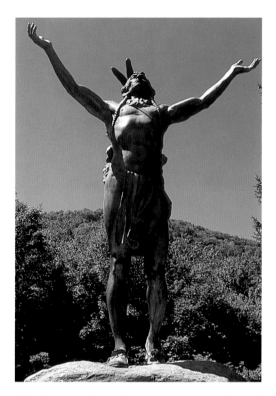

While arrowheads continue to be found throughout New England, wooden shelters and leather clothing disintegrated long ago. It is ironic that the preservation of most of the artifacts of the early New England Indians would depend on the very people who eventually destroyed their way of life—the Europeans who began to appear among them in the late 1490s. This explains why, to this day, some of the oldest Native American artifacts reside in European museums.

Left: This statue, called "Hail to the Sunrise," stands along the Mohawk Trail in Charlemont, Massachusetts. Dedicated in 1932, it is the work of Joseph Polia and honors the Five Indian Nations who once lived along the trail in the northwestern corner of the state.

Overleaf: The Tannery Falls are located in the Savoy Mountain State Forest in northwestern Massachusetts. Located atop the Hoosac Range, the forest is crossed by the original Mohawk Trail that was used as a trading route across the Berkshire region.

Left: These are reconstructions of the weapons used to hunt larger game animals that the early Indians encountered when they first moved into New England. The stone spear and tool heads are bound to the wood by sinews or rawhide, to which hide glue was sometimes applied.

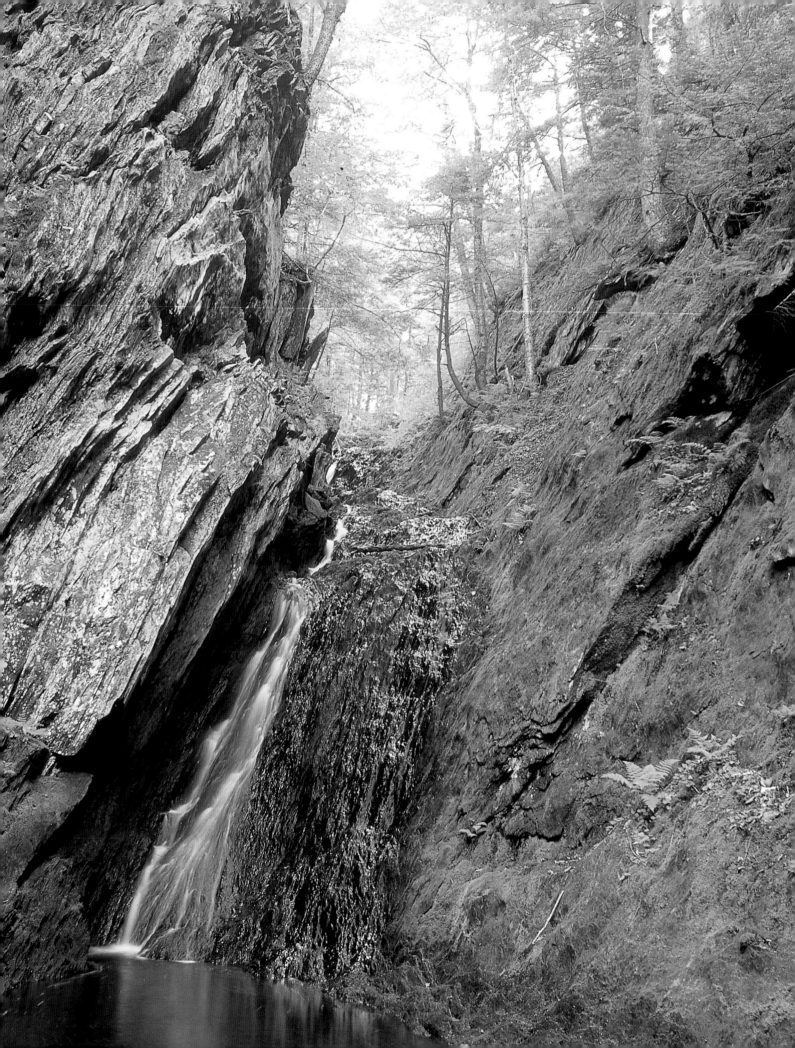

EXPLORERS
AND
EARLY COLONISTS

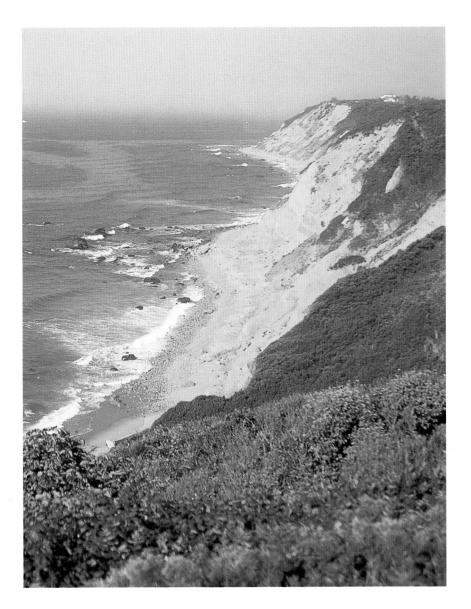

Previous page: Block Island, twelve miles off the coast of Rhode Island, was sighted by Verazzano around 1524 but was named after the Dutch explorer Adriaen Block, who visited it in 1614.

Below: The French explorer Samuel de Champlain mapped the coast of New England in 1604–6 but settled in Quebec, Canada, two years later. He became lieutenant-general of New France.

The answer to the question "Who first settled New England" is as difficult to pin down as "Who first settled America?" In one sense, the answer to both questions is simple: the Native Americans who moved into the region thousands of years ago. In general, though, the Pilgrims of 1620 are recognized as establishing the first lasting white settlement in New England.

Nonetheless, the historical record should not ignore the transient explorers who preceded them. Some French, English, and Spanish fishermen may have visited the region even before Columbus, and certainly did soon afterward. The Italian-born English sailor John Cabot (born Zoane Caboto) landed on the coast of Nova Scotia, called the spot Prima Tierra Vista (or "first land seen") and claimed it for King Henry VII on June 24, 1497. The claim that he got to Maine is not generally accepted, but in any case, this voyage established an English claim to North America.

Giovanni da Verazzano of Italy, commissioned by King Francis I of France, explored the East Coast from North Carolina to New York Harbor and Nova Scotia and might have been the first European to set foot in New England, in 1524. After returning to Europe with an Indian boy in tow, he wrote a fascinating report for the king that referred to a "new world" he believed was on the outskirts of Asia. Verazzano compared Block Island to the Mediterranean island of Rhodes, but the name Rhode Island could also have been derived from the Dutch name Roodt Eylandt (or "Red Island"), based on the Indian description of the red clay on its shore. This name was attributed to Holland's Adriaen Block, who visited Manhattan, braved its Hell's Gate passage (Hellegat in Dutch) and discovered the Housatonic River. He then sailed up the Connecticut River to Hartford in 1614—a Dutch fort was constructed there in 1633—and had Block Island named after him.

Long before Block, however, the Portuguese mariner Estevao Gomes, seeking a northwestern passage to Asia for the king of Spain, in 1525 sailed south along the coast from Cape Breton, discovered various features along the coast of Maine, sailed up the Penobscot River, then continued south to Cape Cod and probably ventured as far as Newport, Rhode Island. Gomes has never been widely recognized for his accomplishments, but Portuguese-Americans are well aware of them.

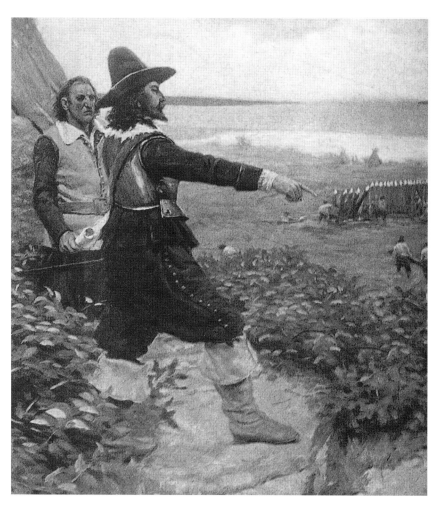

The British neglected the New World during the sixteenth century because they lacked the money to expand their empire and Spain had gobbled up so many southern possessions. England turned west again after having defeated the Spanish Armada in 1588. In 1602, England's Bartholomew Gosnold landed off Cape Cod on the islands of Martha's Vineyard, which he named after his daughter, and Cuttyhunk, which he named Elizabeth's Island, after the queen. On May 15, 1603, Gosnold and four others splashed ashore on Cape Cod—which he named after the schools of fish he found—to become the first Englishmen in New England. When he found the natives unfriendly and provisions scarce, he left the area and returned home with a cargo of sassafras, which was considered a cure for syphilis.

Rapid-fire exploration soon followed. England's Martin Pring (1603), in search of more sassafras, met Indians at Plymouth Bay or Martha's Vineyard and sent a trading ship ten or twelve miles up the Piscataqua River in Maine, where he admired the area's "goodly groves and woods." George Waymouth (1605) touched down in Maine and returned home with profitable furs and five kidnapped Indians who eventually adopted British ways and promoted colonization.

The well-traveled and astute Frenchman Samuel de Champlain (during 1604–6), who had once advocated a canal across Central America, mapped the New England shoreline, named Mount Desert Island off the Maine coast, landed on the New Hampshire coast and explored Vermont, but decided to settle in present-day Canada. Lake Champlain, between Vermont and New York, bears the name of the explorer who eventually claimed vast tracts for France. Fishermen established seasonal base camps on the Maine coast. One of them, the Protestant Captain Samuel Argell, expelled Jesuit missionaries who had created a French colony called Saint Sauveur in 1614. There was even a short-lived English colony established near the Kennebec River by George Popham and Raleigh Gilbert at Popham Plantation in 1607, the same year as the Jamestown, Virginia, landing. The leaders squabbled, Popham died in 1608, and the colony was abandoned, so Jamestown is considered America's first permanent English colony.

By all odds, the most interesting early explorer was Captain John Smith. Yes, the celebrated figure who was mythically saved from execution by the Indian maiden Pocahontas and who ran the Jamestown, Virginia (1607), settlement with the stern warning "He who does not work will not eat." Suffering from a gunpowder burn, Smith returned to England in 1609, but five years later he mapped the coastline from Maine to Cape Cod and coined the name "New England." (Thomas Hunt, who commanded the second ship on that expedition, kidnapped twenty-five Indians, including Squanto, who later helped the Pilgrims.) Alas, Smith suffered from woefully bad luck. Other names he gave places, including the Smith Islands (now called the Isles of Shoals), didn't stick. Nonetheless, his 1616 book, *A Description of New England,* made a strong case for settlement and inspired the Pilgrims to voyage west.

If the English had all but ignored the New World during the 1500s, they soon began to arrive in force. The words "Pilgrim" and "Puritan" are often used interchangeably, but they shouldn't be. "Pilgrim" was coined by their longtime

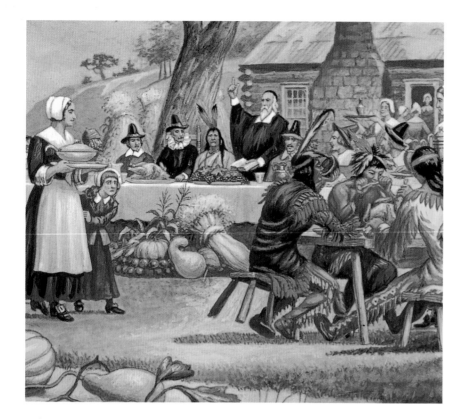

Above: Sometime between late September and late November in 1621, the Pilgrims of Plymouth, Massachusetts, held a "thanksgiving" feast to celebrate their survival and thank the local Indians for helping them. English-speaking natives Samoset and Squanto had taught the Pilgrims useful hunting, planting, and building techniques.

colonial leader, William Bradford, in reference to the Hebrews in the Epistle of Paul the Apostle. The Pilgrims who established New England's first permanent colony at Plymouth in 1620 headed west for religious reasons. Increasingly unpopular in England, whose society they considered decadent, they moved to Holland and then America in order to "separate" themselves from the Church of England. They arrived on board the Mayflower with people of different faiths.

The Puritans, who settled north of Plymouth ten years later in places like Boston, Dorchester, Charlestown, Watertown, and Roxbury, also had left England as religious refugees, but their beliefs and practices were far different from those of the Pilgrims. Rather than separating, they wanted to "purify" the Anglican Church, which they felt had been compromised by ritual tilting toward "popery." They saw themselves as a model for the world—"we shall be

as a Citty upon a Hill," in the words of their governor John Winthrop. (He had many local hills to choose from. The word Massachusetts is Algonquin for "the great mountain.")

Because they settled first and created the Thanksgiving feast tradition, the Pilgrims' story is the best known New England legend. Though their religious beliefs were respected in Holland, they struggled financially and worried that their children would lose Pilgrim values by assimilating. In 1619, they contracted with the London merchants who formed the Virginia Company, and on September 16, 1620, a group of 102 adventurous souls set sail from Plymouth, England, on the Mayflower.

During the nine-week voyage, intended to land in "northern Virginia," which actually meant New York, the Pilgrims and the 60 percent of passengers from other backgrounds feuded constantly. The ship landed on November 9 somewhere on Cape Cod. Because they were far from the Virginia Company's jurisdiction, some passengers declared themselves free of any government. On November 21, forty-one Pilgrims and other "strangers" signed the Mayflower Compact to become a "civil body politic" governed by laws "most meet and convenient for the general good." It was the first form of government in New England.

In December, the passengers disembarked at Plymouth harbor, where they settled on the site of an Indian village whose Patuxet inhabitants had been wiped out in an epidemic several years earlier. Owing to malnutrition and disease, half of the English died by spring, and the entire assemblage might have perished if not for the local Wampanoag and their chief Massasoit. Other Indian

men, including the surviving Patuxet Indians Squanto and Samoset, who had learned English from Maine seamen, taught the colonists the basic skills of farming and hunting. In November of 1621, certain the helpful natives were a sign from God, the settlers enjoyed a "thanksgiving" feast also attended by Massasoit and 90 other Indians. The Pilgrims and Wampanoag signed a peace treaty that lasted more than fifty years.

The colonists bought up the shares from their London backers and made a living from farming, furs, and fish. The Pilgrim government, which was not restricted to church members, reflected a tolerance of spirit. A General Court was formed by adult male property holders called "freemen." The governor and seven fellow "magistrates" held high positions, and "selectmen" oversaw town activities between town meetings.

There were others in northern New England before the Puritans arrived in Boston. In 1622 the Council for New England authorized Sir Fernando Gorges and John Mason to settle all land between the Merrimack and Kennebec rivers. When they divided the territory, Mason named his acreage New Hampshire. (The name Maine probably referred to "mainland," as opposed to islands.) On a 1623 grant that was approved by the Crown, David Thompson and Edward Hilton established a fishing colony on the Piscataqua River in New Hampshire. Subsequently Thompson took his followers to Odiorne's Landing (Rye), while Hilton took his to Dover.

In contrast to the modest Pilgrims in Plymouth, the Puritans who moved to the Boston area in 1630 seemed downright worldly. Many had been relatively

Below: A reconstruction of Plimouth (Plymouth) Plantation Village, the first permanent southern New England settlement constructed by Europeans. The "living museum" re-creates life in the first years of the settlement.

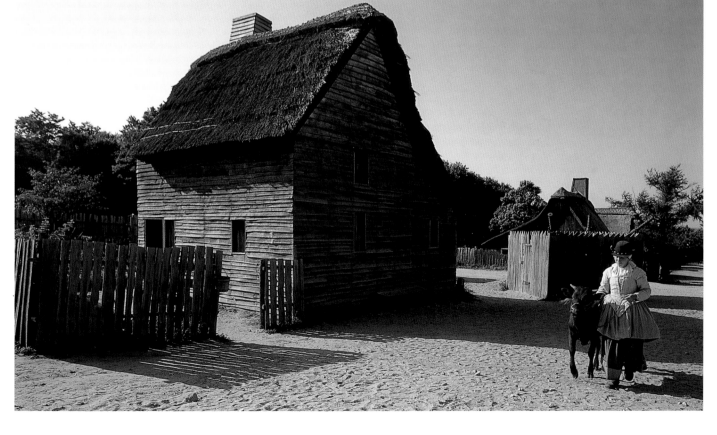

Above: Puritans on their way to worship. Their population in New England rose from 17,800 in 1640 to 106,000 in 1700, with nonbelievers expected to convert or leave.

prosperous businessmen and farmers in England. The Puritans reluctantly left when Charles I, amid depression and unemployment, disbanded Parliament and took dead aim at religious minorities. Therefore, the Puritan-led Massachusetts Bay Company sent eleven ships with some 700 passengers to the Boston region. During the Great Migration of the next seven years, another two hundred ships brought some twenty thousand settlers to the colony. But even though they had sought religious freedom, it was to be limited to themselves. Under Massachusetts Governor John Winthrop, only church members could vote, and only the most orthodox form of religion was encouraged. As Boston Globe columnist Ellen Goodman bluntly puts it, "The early Boston Puritans 'warned out' a Jewish merchant, passed an anti-Catholic law, hanged four Quakers and regarded Native Americans

as heathens." The pervasive attitude was "my way or the highway"—and the nonconformists who did not move away themselves were often exiled.

The most famous of them was the Reverend Roger Williams. A minister in Salem, he believed in religious freedom and the separation of church and state and—horrors!—disputed the white man's right to take Indian lands. As prophetic as any early American, Williams believed that "enforced uniformity, sooner or later, is the greatest occasion of civil war...and the destruction of millions of souls." Found guilty of heresy by the General Court, he was banished south, where he founded Providence Plantations in 1635.

Joining Williams in exile were Anne Hutchinson and her brother-in-law John Wheelwright, both expelled for their belief that individuals relate to God without the need for a church or moral laws.

In 1638, Wheelwright led his followers to New Hampshire, where they founded Exeter and signed the Exeter Compact, modeled on the Mayflower example. Traveling with them were Old World immigrants prohibited from settling in Massachusetts without the sponsorship of two magistrates—the first immigration law in America. Two years later, poor Wheelwright moved to Maine—itself doomed to be swallowed up by Massachusetts—after Exeter and three other New Hampshire towns were annexed by Massachusetts.

Things were not that much smoother in Rhode Island. For her part, Hutchinson was excommunicated in 1638 and settled in Portsmouth, Rhode Island, two years later. There were soon four disputatious communities: Portsmouth, Warwick, Newport, and Providence. Williams united them by acquiring a parliamentary charter in 1643 to protect them from land claims and establish the most democratic government in the British colonies.

The word Connecticut derives from the Native American term "Quinatucquet," meaning "beside the long tidal river." Connecticut claimed independence from Massachusetts in 1636, when the Reverend Thomas Hooker led his followers to the 360-mile-long Connecticut River and founded Hartford, which he named after the English birthplace of his assistant, Samuel Stone. In "The Fundamental Orders of 1639," America's first written constitution—hence, the Constitution State—Hooker made a case for direct elections among the ordinary citizens. Though religious in orientation, the orders provided proportional representation, with each town sending elected members to Hartford. Significantly, if the governor acted against established law,

the freemen could "meet together and choose to themselves a moderator," after which they "may proceed to do any act of power which any other general court may do." This was government for the people and by the people. True, elected representatives had to be law-abiding property owners and believers in the Trinity. True, they could not be Quakers, Jews, or Atheists. But in reducing the power of self-perpetuating clergy and the magistrates, the document seemed downright radical.

After New Hampshire was annexed by Massachusetts in 1643, local governors scandalized Boston by allowing all freemen to vote. If some white residents struggled for freedom, Indians had it much worse. There were an estimated 100,000 Native Americans within New England before European contact. By 1675 their numbers were reduced to some

Overleaf: John Seller's 1675 map of New England. Note how Rhode Island was pictured exclusively as an island.

Below: The Reverend John Eliot (1604–90), "Apostle to the Indians." He organized fourteen villages of converts in Massachusetts before King Philip's War reduced the number to four, which also soon vanished. His more permanent legacy was an Indian-language Bible, the first in any language printed in North America.

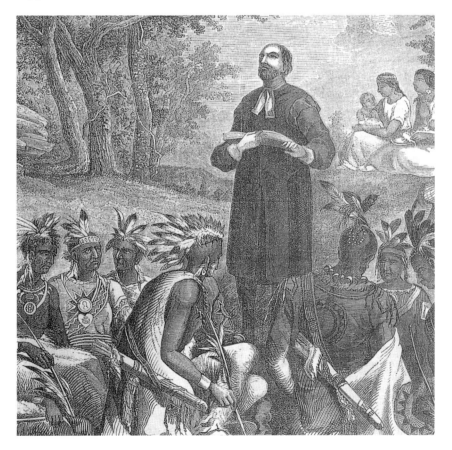

The manner of the Indian Fortifications
Towns Houses and Dwelling
places

A Mapp
of
New ENGLAND
by
John Seller Hydrographer
To the King
And are to bee Sold at his
Shop at the Hermitage in Wapping
And by John Hills
In Exchange Alley in Cornhill
London

Ornat.mo Prudent.moqr Domino
ROBERTO THOMSON
Armigero
Hanc Novæ Angliæ Tabulam
D.D.D. Johannes Seller.

5 10 15 20 25

N E

Poanntack

W

C O N E C T I C O

Connecticut River

the B

Hope Isle

Hadley

Whales Isle
New Albanie
Fishers point
Kates hill
Isle Beares

East reach

Bakers reach

North Hampton

Cheespie River

Dearfield
Springfield

C U T N

Moricans or
Pistol Point
The Straights

G

Winser
Hartford

C E N

Raulph Johnstons hill
Witts Isle
Magdalens Isle
Slipstons
Great Espouse
little Espouse

Tames kanter
Seppings hill
Keyes Isle

Narashoo

Fishers reach

hoole

high reach
Coples reach

C O L O N Y

Wethersfield
Midletown

The Coneticuts
Country

P

Ninicrofts

L

The Waoranacks Country

The Mouhegans Country

L A N

Norwich
Country the Pe

New London River Thames alias Pakwett River

Cutherton
Naragansek
Saybrook

Seabrook
Hartford
Millford
New haven
Branford
Stratford
Fairefield
Shatfurd
Norwalke
Stamford
Greenwich
Crechts

Fishers Isle

HUDSONS RIVER

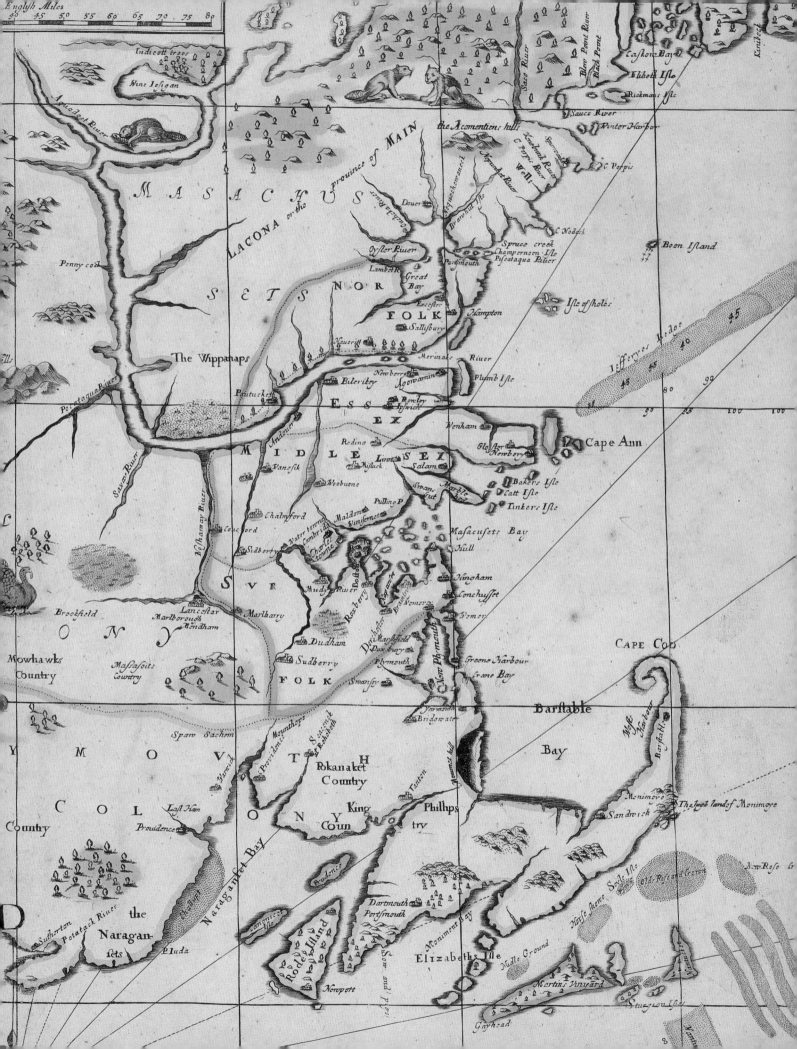

twelve thousand. Whole tribes were decimated by white man's diseases, and somewhat fewer numbers by the white man's musket. In 1637, reacting to what *The American Heritage History of The Thirteen Colonies* called "a series of murders and punitive measures by the whites," Pequot warriors killed some traders in Connecticut. After rumors surfaced that local tribes intended to kill all whites, a force of ninety men led by Captain John Mason set fire to a fort on the Mystic River and killed some 400 elders, women, and children, then cornered several hundred men in a swamp. Many survivors were sold into West Indian slavery, indentured, or traded for black slaves.

Their religious intolerance notwithstanding, the Puritans had much to commend them. They were hard-working, diligent, thrifty, and all the other qualities Benjamin Franklin later waxed enthusiastic over. They were thinkers, they were educators and they were achievers. They established the first public secondary school, Boston Latin, in 1635. The first college, Harvard, was founded in 1636 and supported by local farming towns. Puritans turned adversity into advantage. When immigration and commerce slowed shortly after their arrival, the colonists became merchants, seamen, fishermen, and shipbuilders. The Saugus (Massachusetts) Iron Works, which operated from 1643 to 1675, signaled the beginning of industrialization in America. This first major ironworks in North America had seven water wheels powering a blast furnace, a forge, and a fire mill to transform bog iron ore from the Saugus River swamps into pig and wrought iron. In the forests close to the mill, Scottish laborers, who had been taken prisoner by English ruler Oliver Cromwell and indentured to

Right: An Indian guide for a military expedition led by Captain Miles Standish. Although probably not a Pilgrim himself, Standish (c.1584–1656) was the acknowledged military leader of the Plymouth colony.

the iron master, each cut a cord or so per day. The wood was "cooked" into charcoal and provided the highest paying job at the Iron Works.

The colonies kept expanding. In 1665, Massachusetts resolved endless land disputes by annexing every Maine outpost, many of which couldn't afford ministers. The Bay Colony bought the deed to Maine in 1677, and William and Mary incorporated it and the Plymouth Colony into the newly formed Province of the Massachusetts Bay in 1691. Maine's "Downeasters" would not become self-governing until 1820.

In the northwest regions of New England, Vermont had begun as a French colony after Champlain claimed it for France. In 1666 the French built a fort on Lake Champlain's Isle La Motte. The French called the region Les Verts Monts ("the green mountains"), which

morphed into Verts Mont, and then Vermont. The current state capital, Montpelier, means "naked mountain." In 1690, British forces under Jacobus De Warm arrived in Middlebury, but France didn't relinquish control over the colony until the French and Indian War three-quarters of a century later.

Holland was another country with a claim on New England. The Dutch sailor Adriaen Block had sailed up the Connecticut River in 1614. Firmly established to the southwest, where they created New Amsterdam (New York) in 1624 and bought Manhattan from the Indians in 1626, the Dutch settled on the Delaware River in 1631 and in Connecticut two years later. But after England captured New Amsterdam and renamed it New York in 1664, Holland's days on the continent were numbered. When an English-Dutch war spread into the Nutmeg State, the Dutch were thrown out of Connecticut in 1674.

The final consolidation of the early New England colonies involved a very ugly episode. It was called the King Philip's War of 1675-8. The Wampanoag and Pilgrims had coexisted harmoniously for half a century before Pilgrim leader William Bradford and Indian sachem Massasoit died in 1657 and 1660, respectively. Massasoit's son and successor, whose Wampanoag name was Metacom (or Metacomet or Ponetacom) and who was known as King Philip by the colonists, suspected that the English had murdered his brother Alexander (Wamsutta). Tensions increased when the whites forced many land sales on the Indians, who needed English goods in return, and made them turn in legally acquired guns. In 1671, the Pilgrims fined Philip and forced the Wampanoag to

Overleaf: *The Deerfield River in western Massachusetts. Short, swiftly running rivers, common in New England, provided power for mills and other water-related industries.*

Right: Forces led by Metacomet—called King Philip by the colonists—face English soldiers in King Philip's War (1675–6). The bloody conflict ended half a century of peace made possible in part by Metacomet's father, Massasoit.

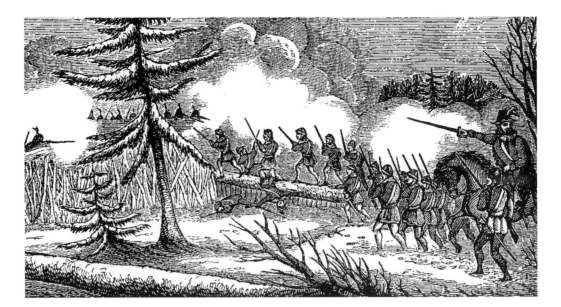

surrender their arms. In the final provocation, three Wampanoag were executed in response to the killing of a reputed Indian informer to the colonists.

In June 1675 Indians raided white communities, and within a year killed hundreds of settlers and one-sixteenth of the men able to bear arms. The whites retaliated in kind, and soon all the New England colonies were at war with the Wampanoag, Nipmuck, and Narragansett nations, as well as Christian Indians who had been friendly to the settlers. Narragansett chief Canonchet burned Providence, and his allies destroyed the Durham, New Hampshire, settlement. But the underequipped Indians had to return home to fish, hunt, and plant.

Double-teamed by the English and the Mohawk—their traditional rivals—the warring tribes eventually were routed. In the pivotal Great Swamp Fight, the Narragansett and Wampanoag were overcome in southwestern Rhode Island. Philip was murdered in August 1676 when an Indian servant disclosed his Mount Hope (Bristol, Rhode Island) hiding place. His body was drawn and quartered and his head displayed on a pole in Plymouth—grisly notice that Indian influence had been virtually exterminated and European settlement could proceed in southern New England. But the cost was heavy all around: some five hundred colonists and countless Indians killed, sixteen communities destroyed, surviving Indians sold as slaves and banished to the West Indies in violation of a Rhode Island law. In Maine Indians fared better during a 1676–8 war that ended in a truce.

Colonists as independent-minded as the New Englanders were bound to come in conflict with the Mother Country. Trouble began long before the American Revolution. Connecticut had received a royal charter in 1662 that gave citizens the right "to have and to hold...for ever" this place "in Newe England in America." Twenty-five years later King James II wanted it back so much that he sent Sir Edmund Andros, who had been appointed governor of the Dominion of New England (which included New York and New Jersey) in 1686, and an armed expedition to wrest it from Hartford. There follows a story quite familiar to Connecticut schoolchildren.

After lengthy debate between Andros and the colonial leaders, with the charter sitting on a table between them, all the candles in the room flickered out. When light was restored, the charter was gone. Taken by Joseph Wadsworth, a colonial leader, it was secured in a large oak tree on the Wyllys estate. The king never got the charter back, and the charter oak became the state tree.

In 1684, King Charles II cancelled the Massachusetts charter. But when King James II abdicated his throne to William and Mary in the "Glorious Revolution" of 1688–9, the colonists jettisoned—in fact, jailed—Governor Andros on April 18, 1689. King William gave them a new charter and installed Sir William Phips of Maine as their new governor. Except for the 1686–9 period, New England was essentially self-governed.

But religiosity rather than self-rule was the hallmark of the early colonial period. Just as it had started with stiff-neck absolutists in leadership, so it would end—only bloodier. A surge in witch-hunting in the New England colonies—with 200 accused in 1689–92—culminated in the disastrous events of 1692. The year began with some girls in Danvers, Massachusetts (then called Salem Village), exhibiting weird behavior, including crying "Whish, whish," trying to fly, and interrupting a sermon with the words "Enough of that!" Pressured to identify the source of their affliction, the girls named three women. Two maintained their innocence, but the third, a West Indian slave named Tituba, said she'd met the devil, who approached her "sometimes like a hog and sometimes like a great dog." She insisted there were nine witches in New England.

Hysteria soon mounted. Townspeople accused the poor, the nonconforming, even "good citizens" of witchcraft. We can still read the record of the trial of the "witches," such as Sara Good's:

> *What evil spirit have you familiarity with?*
> None.
> *Have you made no contract with the devil?*
> No.
> *Why do you hurt these children?*
> I do not hurt them. I scorn it.
> *Who do you imploy then to do it?*
> I imploy no body.
> *What creature do you imploy then?*
> No creature. I am falsely accused.

Within a year, twenty men and women had been executed before authorities came to their senses. In a time of noble impulses and beastly behavior, years of peace and bloody war, yearning for religious freedom and condemning those who strayed, the examination of Sara Good survives as a haunting epitaph.

Overleaf: A reconstruction of Salem Village, which was located in today's Danvers, Massachusetts. Originally settled on stormy Cape Ann, the present Salem was relocated in 1627 to a sheltered site at the mouth of the Naumkeag River.

Below: A woman being arrested during the Salem witch trials of 1692. Fourteen of the twenty executed for witchcraft were women. Ironically, Salem was named for Shalom, *the Hebrew word for "peace."*

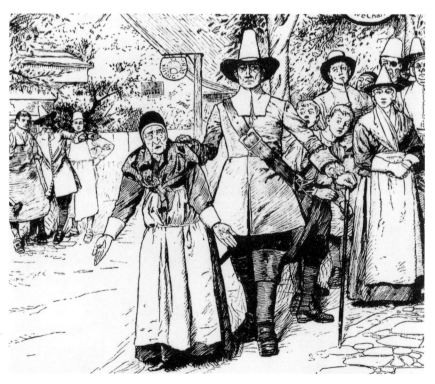

Forging
Their
Destinies

By the late 1600s, New England had become a contested region—not only between Indians and colonists, but between the colonial powers Great Britain and France. The four French and Indian wars of 1689–1763 would win the region for England exclusively. They also laid the groundwork for the American Revolution.

In the strictest sense, the French and Indian War refers to the events of 1754–63. Actually, they were preceded by three significant conflicts. Overseas, the British and French fought almost non-stop between 1689 and 1763, causing inevitable repercussions in North America. When King William III of England attacked France, the ensuing 1689–97 war became known in North America as King William's War. Allied with the French were the Algonquins, while the Iroquois, dependent on everything from English blankets to English rum, favored the New Englanders.

The result appeared all but preordained—at least in North America: England had 200,000 colonists, the French only 13,000 *habitants*. However, the French used professional soldiers, the English poorly trained militia hampered by feuding colonies. Moreover, the French were more skilled than the English at infiltrating Indian culture. Reacting to the French capture of Indians and British traders in the Midwest, Iroquois warriors on August 4, 1689, captured or slaughtered 200 settlers at the La Chine settlement near Montreal. The French, under Comte de Frontenac, retaliated by destroying Schenectady, New York, in February, and in March capturing fifty-four settlers and butchering about thirty at Salmon Falls on the Maine-New Hampshire border. Two

months later the French took Falmouth (Portland), Maine, and turned its settlers over to the Indians for more carnage.

Sir William Phips, the first royal governor of Massachusetts, took fourteen ships to Nova Scotia's Port Royal and on May 11 forced the French commander to surrender. The rascally Phips, who had grown rich on sunken Spanish treasure, illegally plundered a chapel and pillaged the shops before returning home in triumph. But results weren't universally favorable for the English colonists. Casco, Maine, was ransacked by the French and Indians. In October Phips led an expedition of thirty-four ships and 2,000 men to Quebec. Replying to Phip's demand for surrender, Frontenac wrote, "Tell your general that I have no answer to give other than through the barrels of my muskets and the mouths of my cannons." Phips staggered home, having lost 500 men and £50,000. Fortunately for him, the Puritans blamed God rather than him for his failure.

The war continued another seven years, with settlements in western Massachusetts, Maine, and New Hampshire never safe from guerilla raids. In the war's most storied and perhaps exaggerated episode, a group of Abenaki traveled from Maine to attack Haverhill, Massachusetts, and returned with Hannah Dustin, her baby, nurse Mary Neff and a fifteen-year-old English boy, Samuel Lennardson. Angered by the baby's crying, the Indians killed the child. But as the group camped near Concord, New Hampshire, Dustin and company plotted an escape. In the dead of night they slaughtered their sleeping captors with hatchets; Dustin then scalped each one. The ten scalps earned her and her friends a £50 bounty back home.

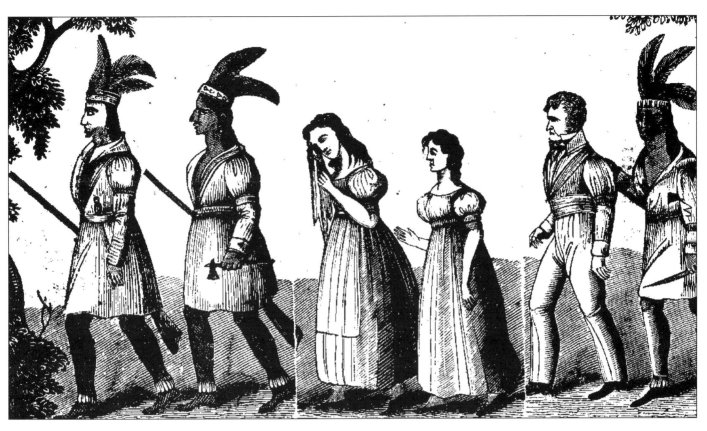

The European war ended with the Treaty of Ryswick in 1697 that negated all gains by either side. In America, hostilities lingered, the Iroquois turned neutral, and the British subjects, who got no support from overseas, worried about their vulnerability. In 1702–13 war broke out again—the War of the Spanish Succession in Europe, Queen Anne's War in the colonies. With battles stretching from the Caribbean in the south to Canada in the north, New England was again the scene of bloody conflict. The French encouraged the Abenaki to ravage settlements in Maine and often succeeded because Boston, true to form, did little to support outlying regions. On February 29, 1704, an Indian party under Hertel de Rouville fell upon some 300 sleeping residents of Deerfield, Massachusetts. The result was the well-chronicled "Deerfield Massacre," although 111 residents were marched to Canada. Some of the captives actually fared well there, but returning home in 1707, the Reverend John Williams took a different position in *The Redeemed Captive Returning Home to Zion*. He compared the existential death from the forced conversion to Catholicism some of the captives endured to physical death in combat.

Benjamin Church, a New Englander who had taken the lead in King Philip's War, raided five French settlements in Maine and Nova Scotia and won fishing rights to Nova Scotia. In 1708, French and Indians killed forty-eight residents of Haverhill in another night raid. Boston supplied off-again, on-again aid, some felt, because wealthy merchants wanted to trade with the French. Not until Peter Schuyler arrived in London with four exotically dressed Mohawks did the Mother Country deliver 500 marines and vessels. On October 2, 1710, the British captured Port Royal, Nova

Above: A period engraving of captives. During the French and Indian wars, many New England villages were attacked by Indians; they killed numerous residents but led away others into captivity.

Above: Old Deerfield Village, Massachusetts. The living museum re-creates life from the 300-year-old community, and an event commemorating the famous 1704 raid includes conversations with authentically dressed French, Indian, and English re-enactors.

Scotia. Sir Hovenden Walker's expedition from Boston Harbor to Quebec, however, floundered when ships ran aground and nearly 800 troops and sailors drowned. The Peace of Utrecht (1713) gave Nova Scotia and the Hudson Bay country to England, but the French still controlled the St. Lawrence Valley.

During some thirty years of peace in New England, both sides kept building forts. In King George's War (1744–8)—called the War of Austrian Succession in Europe—the American and English forces again failed to take Quebec, but they captured Louisbourg on Cape Breton Island. Later the French and Indians captured the English Fort Massachusetts in East Hoosack (Adams), leaving colonists all over the region fearful of further raids.

In the Treaty of Aix-la-Chapelle that ended the war, the English returned

Louisbourg to the French in exchange for European possessions. The Mother Country's betrayal and the anger it caused may have been the first step toward dissolution of British North America. At the war's end, however, the presence of about 1,250,000 English colonists next to a mere 6,000 French assured British colonization inland, though the French dominated the interior from Louisiana to the Midwest.

The French and Indian War of 1754–63—the Seven Years' War in Europe because it began two years later—ended the French threat east of the Mississippi. The basic facts about the war are well known: the defeat of a twenty-two-year-old colonel named George Washington at Great Meadows; the disastrous loss of General Edward Braddock to guerrilla-fighting opponents near Fort Duquesne

(both locales in Pennsylvania); the resurgence of the English when Prime Minister William Pitt fought a two-continent war against France; the British victory of General James Wolfe's troops on the Plains of Abraham outside Quebec; the final French surrender at Montreal to General Jeffrey Amherst. The contributions of New Englanders are less appreciated. Two thousand New England and English troops captured Fort Beauséjour in Nova Scotia, finishing off all French resistance in that region. Massachusetts native Robert Rogers organized "Rogers' Rangers," fought several important battles against the French and Indians in the Fort Ticonderoga region and got the French to surrender at Detroit. One of his underlings, John Stark, along with Ethan Allen of Vermont, fought well in the war and later became heroes of the American Revolution.

It would be easy to assume that constant warfare forestalled peacetime activities in the New England of 1689–1763. That was not the case. Early in the eighteenth century, Connecticut created the colonies' first manufacturing industry. Rhode Island prospered with southern-style plantations (using slave labor). Massachusetts became a maritime colony par excellence, and Boston, with 16,282 souls in 1743, was the largest city in North America.

But more than anything, the wars laid the groundwork for the American Revolution. Afterward, the mother country sent ten thousand soldiers to North America and the West Indies to prevent further incursions from its rivals. In order to support them and reduce England's £167-million debt, the imperious George III began imposing taxes that infuriated the colonists.

Below: The Mission House in Stockbridge, Massachusetts. In its varied history of an old frontier community, Stockbridge featured everything from "praying Indians" to an engagement during Shays' Rebellion.

When we think of Revolutionary War-era heroes, certain names spring readily to mind: George Washington, Samuel and John Adams, Paul Revere. In fact, the first American patriot was James Otis.

Born in West Barnstable, Massachusetts, in 1725, and trained in the law, he resigned as the king's admiralty in vice-admiralty court to fight the writs of assistance, which were search warrants that didn't name a place to be searched. The English wanted to use them to search for contraband in colonial homes; the colonials objected to them as contrary to parliamentary law. Otis lost this seminal battle over privacy in court—the state attorney general vindicated his position five years later—but continued fighting on other fronts. In a famous four-hour 1761 oration, Otis decried "taxation without representation."

John Adams' comment about that address was almost as famous: "Otis was a flame of fire!…he hurried away everything before him. American independence was then and there born; the seeds of patriots and heroes were then and there sown."

Until a 1769 attack by British authorities left him with a head wound that cost him his sanity, Otis spoke for colonists on issue after issue. And what issues they were! At the behest of King George III, Parliament passed the Sugar Act, or Revenue Act, of 1764, which increased taxes on wine, sugar, and other goods while adding new taxes. The Stamp Act (March 22, 1765) required colonists to use special stamped paper for newspapers and emboss a stamp on documents like ships' papers. Samuel Adams organized the Boston Sons of Liberty to protest the

Right: *The Boston Massacre (1770). It supposedly began when a young apprentice insulted a British officer, got belted, called for help, and drew an unruly crowd. Historians will forever debate whether the British fired legitimately in self-defense.*

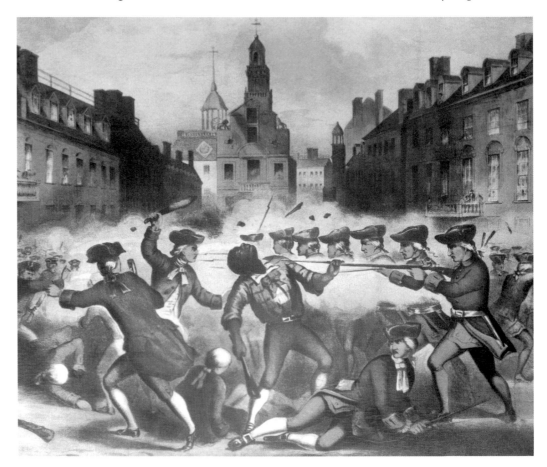

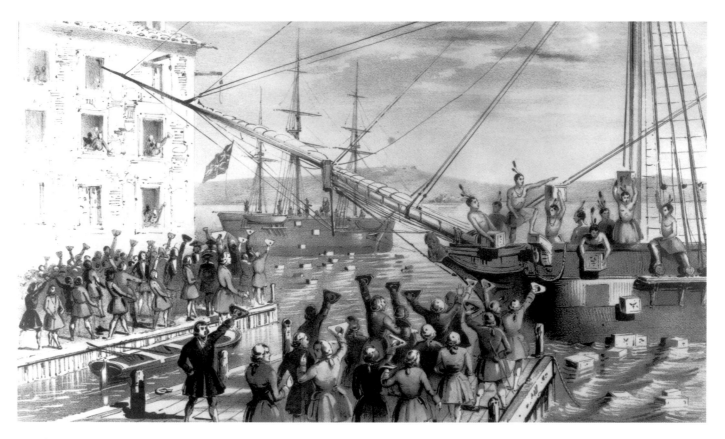

tax that summer, and his minions sometimes assaulted British officials and burned their homes. The Stamp Act Congress (October 5–25, 1765) objected to taxation without representation and called for a boycott of British goods. Parliament's reaction—repealing the Stamp Act while passing the Declaratory Act giving it the right to pass laws and tax colonists "in all cases whatsoever"—merely fanned the flames. When England levied new taxes in 1767, the cry of "no taxation without representation" was heard throughout the colonies.

Hated British soldiers, known as "lobsterbacks" and "redcoats" because of their uniforms, were billeted in Boston in October 1768. On March 5, 1770, British soldiers were pelted with snowballs and iceballs while standing guard at Boston's Custom House. They responded by firing into the taunting crowd, killing five, including Crispus Attucks, the first black

American to die in what would become a revolution. In the trial that followed, John Adams and Josiah Quincy defended the soldiers. "Facts are stubborn things," said Adams, arguing that the soldiers had fired in their own self-defense. Two soldiers were found guilty, but had only their thumbs branded as punishment. Nonetheless, the incident was called the "Boston Massacre" and given credibility by a Paul Revere engraving showing disciplined soldiers firing into a helpless mob.

After two years of relative peace, warlike portents began swirling around New England like the dust preceding a storm. On June 9, 1772, a British ship pursuing an American smuggler ran aground off Rhode Island. Colonists removed British sailors, then burned the ship. No American testified, enraging the British. Later that year, Bostonians organized the Committees of Correspondence to send the anti-British message through the

Above: The Boston Tea Party (1773). While dumping British tea into Boston Harbor rather than paying taxes on it, colonists dressed as Indians set an example emulated by other seaports. The British government responded with the Coercive (Intolerable) Acts that inflamed Americans even more.

colonies. The celebrated Boston Tea Party (December 16, 1773) saw angry Bostonians dressed as Mohawks dump 167 chests containing 90,000 pounds of imported British tea into Boston Harbor rather than pay the tax.

Parliament responded with more coercive acts in 1774: the Quartering Act, requiring colonists to board and feed British soldiers; the Massachusetts Government Act, putting the colony under military government; the Boston Port Act, closing the harbor to commercial ships. Colonists organized militias throughout eastern Massachusetts. In December, insurgents under John Sullivan seized supplies at a British arsenal in Portsmouth, New Hampshire: although not widely known, it was technically the first act of war.

Right: A replica of one of the three ships raided during the Boston Tea Party. A year after organizing the event, Samuel Adams began to advocate independence from Great Britain.

Left: *The Paul Revere House in Boston. Best known for his midnight ride to Lexington, the colonial silversmith also carried crucial documents and messages to places as distant from Boston as Philadelphia and Portsmouth, New Hampshire. A notable peacetime inventor, he helped Robert Fulton develop copper boilers for steamboats.*

Historians generally consider the battles of Lexington and Concord the first shots of the American Revolution on April 19, 1775. British troops ferried across the Charles River from Boston, sought military supplies in Concord, and hoped to capture Samuel Adams and John Hancock, perhaps the prime colonial organizers. Alerted by Paul Revere's and other couriers' "alarm" rides the night before, scattered colonists mustered on Lexington's green. The British killed eight militiamen while suffering no casualties in Lexington and destroyed much ordnance in Concord. Returning to Boston, however, they were routed by guerrilla fighters hiding behind rocks, trees, and walls; for the day they suffered 273 casualties to 95 for the Americans. Similarly,

the British "won" the June 17 Battle of Bunker Hill (actually fought on Breed's Hill), but lost the casualty count, 1,054 to about 400. On July 3, George Washington took command of the Continental army on Cambridge Common.

The fighting spread across New England. In the war's first naval battle, men from Machias, Maine, captured the British ship Margaretta, and Vermonter Ethan Allen with his Green Mountain Boys took Fort Ticonderoga in New York, then won the Battle of Bennington back home. Asked by the British on whose authority he was attacking the fort, Allen replied, "In the name of the great Jehovah, and the Continental Congress!" Rhode Island led all colonies in establishing the continental navy and

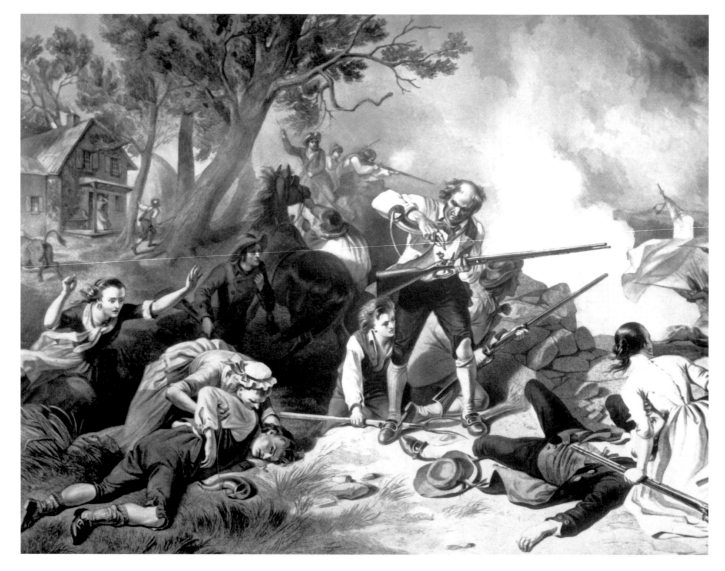

Above: *The Battle of Lexington. Although the British won the skirmish on Lexington Green, they were whipped on their retreat to Boston. Of equal importance, the events of April 19, 1775, mobilized colonists everywhere to organize and Bay Staters to run the British out of Massachusetts.*

was the first to declare its independence from England, in May 1776. An infamous Connecticut resident, the future traitor Benedict Arnold, launched an inconclusive attack on Canada but delayed British forces from moving south of the border. Connecticut also contributed patriots like Jonathan Turnbull and Nathan Hale. The latter supposedly delivered these immortal words before being hanged as a spy by the British: "I regret that I have but one life to give for my country." If so, he may have been borrowing from British author Joseph Addison, who wrote "What pity it is / That we can die but once to serve our country."

Thirteen days after Washington placed cannon on Dorchester Heights above Boston, on March 4, 1776, British troops evacuated Boston Harbor and the war shifted south. New Englanders kept contributing, and not just troops. Could there have been a greater gift than John Adams's inspired oratory, convincing colonists to sign the Declaration of Independence on July 4, 1776? Or a more dramatic symbol of defiance that John Hancock's bold signature on the document? "There, I guess King George will be able to read that," he said.

The rebels' motives were loftier than merely refusing to pay taxes. Sixty-seven

years after Lexington and Concord, old Captain Levi Preston was asked if he fought because of stamp or tea taxes. "Young man," he replied, "what we meant in going for those red-coats was this: we had always governed ourselves, and we always meant to."

The fact that the colonies declared their independence didn't mean they were truly self-governing. That didn't happen until the British yielded at Yorktown in 1783. And just because they were self-governing didn't mean they were effectively governed. That didn't happen until the Constitutional Convention, which took place in 1787.

Americans were first ruled by the Articles of Confederation, proposed in 1777 and not ratified for five years, with no executive branch and a Congress that couldn't tax. No wonder the rather disunited states struggled to become a new nation, amid starts and stops, curious offshoots, and even rebellion.

There was, for openers, the strange case of Vermont. Discovered and colonized by the French, Vermont had no English residents until Fort Drummer (Brattleboro) was built in 1724. The French abandoned the colony after the French and Indian War ended in 1763, but who exactly governed it?

Claimed by New Hampshire and New York, Vermonters rejected both. In 1770, Ethan Allen and his brother Ira formed the Green Mountain Boys as vigilantes to oust settlers from New York. Four years later, the colony became America's

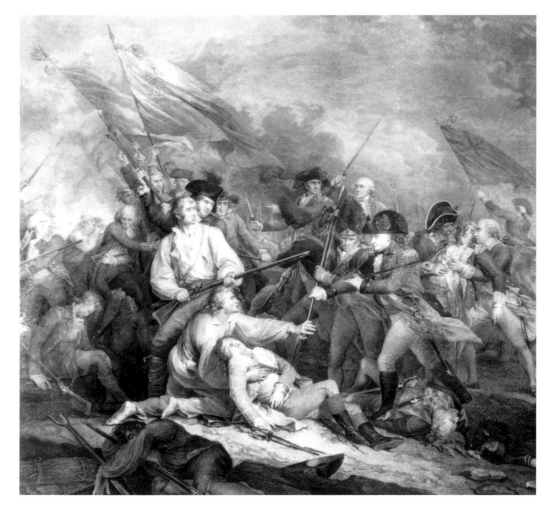

Left: *The Battle of Bunker Hill. The British again won the land war and lost the body count, suffering casualties to 40 percent of their troops. The June 16, 1775, event, which convinced colonists that their oppressors weren't invincible, was commemorated by the building of a monument in 1842.*

Right: *Concord Bridge, Concord, Massachusetts. On this site on April 19, 1775, colonists pouring in—"They seemed to drop from the sky," said a British officer—found their enemies in disarray and throttled them.*

Below: *The John Adams residence at Adams National Historical Park in Quincy, Massachusetts. The second president (1797-1801) edited the Declaration of Independence and led the fight to ratify it.*

first to grant universal male suffrage, and in 1777 a Windsor convention proclaimed Vermont an independent country called New Connecticut in honor of many settlers from there. During the American Revolution, Vermont fought for the colonies while holding secret talks with England, then relented and became the fourteenth state in 1791.

In 1785, Maine residents founded the state's first newspaper, the Falmouth Gazette, to advocate separating itself from its Massachusetts rulers. The next year western Massachusetts farmers, hard-pressed to pay taxes, staged an open rebellion under Daniel Shays. His forces threatened tax collectors and assaulted the Springfield arsenal. State militiamen and volunteers beat them back, killing four men, and scattered the rebels again in Petersham, New Hampshire. Shays

fled meekly to Vermont. Nonetheless, the Massachusetts legislature decided not to impose a direct tax, lowered court fees, and exempted many products from debt collection. To others, the Shays' Rebellion signaled the need for a stronger central government.

Despite all the upheaval, there was plenty of achievement in postwar New England. Rhode Islanders unveiled the first cotton-spinning jenny in 1787, and Samuel Slater introduced power spinning there in 1790. And New Englanders were movers and shakers on the national stage. Bay Stater John Adams served as the second president of the United States in 1797–1801 and avoided war even as American ships were being attacked by the French. Unfortunately, he went too far to ensure domestic peace. The Alien Act (June 25, 1798) gave the president

Above: The Ethan Allen homestead in Burlington, Vermont. Allen and his Green Mountain Boys helped Benedict Arnold capture Fort Ticonderoga (1775). Allen governed the Free and Independent Republic of Vermont, which didn't join the Union until 1791.

Right: Samuel Adams (near right) and his cousin John Adams. The former, a failure in business, helped organize the American Revolution and governed Massachusetts in 1794–7. The latter, an influential scholar, activist, theorist, and ambassador, ruled ineffectually during his lone term as president.

the right to banish all foreign-born residents suspected of treason or secret associations. And the Sedition Act (July 14, 1798) imprisoned anyone who published "false, scandalous and malicious writings" against the government. These outrageous extensions of executive power lapsed a few years later.

Adams was defeated in his bid for re-election by Thomas Jefferson of Virginia, and New Englanders grew disenchanted with the national government. When British ships "impressed," or kidnapped, American sailors, Congress passed the Embargo Acts (1807–8) banning virtually all trade with foreign countries. New England merchants howled and began smuggling goods to Canada. Even as America reeled toward another war with Great Britain, divisions in the country raised the question of who would support it.

During the years 1800–12, some 2,500 Americans were taken off their ships and forced to join the British navy. Under attack at sea from the east, Americans

were also threatened on land to the west, where British forts were supplying Indian tribes hostile to the U.S. Still, New Englanders rued the ban on foreign trade. Wrote a New Hampshire poet: "Our ships all in motion/ Once whiten'd the ocean/ They sailed and return'd with a cargo; / Now doomed to decay/ They are fallen a prey, / To Jefferson, worms and embargo."

When the Twelfth Congress convened on November 4, 1811, "War Hawks" from the South pushed for a conflict that Federalists from New England dreaded. The Hawks were determined to push the British out of the lands to the west, and their position carried in June of 1812. Even as Parliament was reassessing its maritime policy, America declared war.

New Englanders didn't completely boycott the war. On June 1, 1813, the USS *Chesapeake* was beaten by the HMS *Shannon* off the coast of Massachusetts. American captain James Lawrence at least supplied ringing oratory with his dying words, "Don't give up the ship." The same day, American captain Stephen

Decatur took two ships out of New London, Connecticut, only to reverse course off Long Island and return to port. No wonder the day is known as "the infamous first of June."

New Englanders also fought in the stirring victories at the Battles of Plattsburgh and Lake Champlain of September 11, 1814, in which American captain Thomas Macdonough captured all the British warships and sent enemy troops scurrying back to Canada. His actions prevented the British from heading down the Hudson to New York City and splicing off New England from the nation.

Nonetheless, most New Englanders were reluctant participants. Some merchants traded illicitly with foreign countries, including England, and smuggled goods to and from Canada—hence, Smuggler's Notch, Vermont. Governor Caleb Strong of Massachusetts ordered a

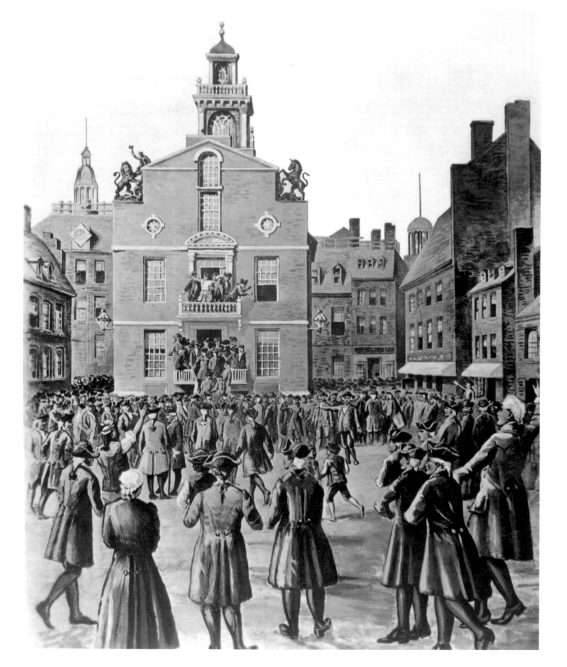

Left: Reading the Declaration of Independence outside the Old State House in Boston. True to his nature—idealistic, ostentatious, arrogant, annoying—John Hancock had the largest signature.

public fast of protest, and Governor John Cotton of Connecticut kept his militiamen from joining the U.S. army. A Federalist congressman from New Hampshire named Daniel Webster lambasted the Madison administration for waging war. With merchants and tradesmen losing money to the British blockade and with England occupying 100 miles of the Maine coast and part of Massachusetts, New England delegates to the secret 1814–5 Hartford Convention voted to defederalize the armed forces, limit embargoes to two months and limit the president to one term. They spoke openly of secession. But when their delegates reached Washington in January 1815, they were overwhelmed with news of the victorious battle of New Orleans. In any case, the Treaty of Ghent had ended the War of 1812 weeks earlier.

Though the Treaty of Ghent resolved no specific issues, the war's end had a profound effect on New England. Andrew Jackson's victory in New Orleans sparked a surge of national pride that even infiltrated the flinty Northeast. With the need for a full-time military never more apparent, a munitions industry sprang up. Even more important, the United States and Great Britain quickly settled their differences. Manufacturing, trade, and shipping were freed to flourish. Suddenly, it was boom time in New England.

Below: *Mystic (Connecticut) Seaport. The whaling and maritime-heritage museum celebrates a history of wooden shipbuilding in the nineteenth century.*

THE FLOWERING
OF
NEW ENGLAND

Previous page: Fence detail from a property in Old Bennington, Vermont. The nineteenth-century blooming of culture was reflected in everything from literature to architecture.

Below: The Massachusetts State House, the oldest building on Boston's Beacon Hill, with its striking gilded dome.

After the War of 1812, New England prospered. The architecture was only the most visible proof. Public buildings could have been set down in ancient Rome, while the elite lived in beautiful homes filled with fine furniture and sophisticated artworks. In many other areas, the cultural life of New England also flourished.

Public buildings reflected the Federal or Adam style, which is also known as Classical Revival. After returning from the continent in 1787, Charles Bulfinch (1763–1844), influenced by Scottish architect Robert Adams, designed light, airy buildings with large windows, glass-framed entrance doors, oval rooms, and curved stairways. "They stood out in somber old Boston like deer in a cow pasture," according to Edwin Tunis in *The Young United States: 1783 to 1830.*

Bulfinch designed the Massachusetts State House (1795–8), whose crowning dome inspired state capitols elsewhere; the Massachusetts General Hospital (1818–23); and India Wharf (1803–7), all in Boston. Attracted to Bulfinch's style, Samuel McIntire (1757–1811) built mansions in Salem like the Gardner-Pingree House (1804–5, now the Essex Institute) and the South Congregational Church (1805). Asher Benjamin's book *The Country Builder's Assistant* popularized the Federal style across the nation.

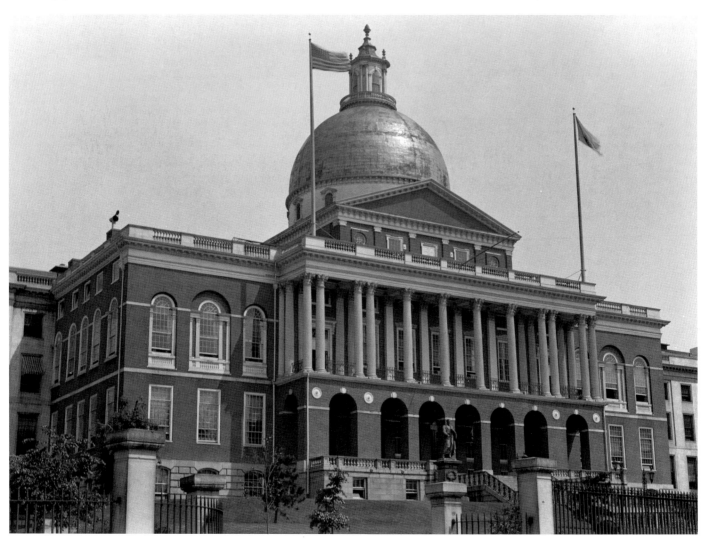

Furniture made by McIntire, Thomas Seymour, Stephen Badlam, John Dunlap, and John Doggett, among others, further reflected the Federal style, with fine mirrors, painted clocks, and chairs and tables using slim legs and delicate inlays. Around 1810 the Federal style was supplanted by Napoleonesque Empire furniture, employing themes from Greek vases. If there was one feature that followed furniture from period to period, it was the bald eagle gracing everything from doorways to bars of soap—witness to its status as America's "national bird." The word "bald," incidentally, refers not to the lack of hair but the piebald black and white patterns.

What fine home could lack a family portrait by the likes of Washington Allston or John Singleton Copley? Like so much else in vogue, these paintings used fanciful European themes. Other portraitists traversed the New England countryside, painting ordinary people as they actually looked. Silhouettes became another popular art form.

Beginning with Boston Latin (1635), the country's first public school, and Harvard (1636), its first college, New England had led the country in education. Many other outstanding colleges, including Yale (1701), Brown (1774), Williams (1793), Bowdoin (1799), and Dartmouth (1769)—founded "for the education of Youth of the Indian Tribes" and "English Youth and Others"—followed in the eighteenth century. Between 1800 and 1860, New England filled up with more colleges, among them Amherst (1821) and Wesleyan (1831). Mount Holyoke began as a women's seminary in South Hadley, Massachusetts, in 1837, but the first bona fide women's college was nearby Smith, in

1875. Concord, Vermont, established the first school for teachers in 1823. Not to be overlooked, many of the country's top private "preparatory" schools were built by 1860, especially in Massachusetts. In 1778, troubled by "a growing neglect of youth in our time," Samuel and John

Above: An Adam-style doorway in Newport, Rhode Island. Also known as American Federal, the style included wings and fancy oval rooms.

Phillips had founded Phillips Academy in Andover, Massachusetts. Everyone has probably heard of Andover's several New England successors, such as Phillips Exeter, Milton, St. Paul's, and Groton. Few are aware that it was another New England private school, the Round Hill School (1823–32), in Northampton, Massachusetts, which was responsible for introducing European teaching methods to the curriculum.

With its notable emphasis on private education, Massachusetts never built a state university on the order of California or Michigan or Wisconsin. Nonetheless, public higher education was not neglected. Horace Mann, a Massachusetts native, took the lead in promoting universal nonsectarian public schools. After a state board of education was created in 1837, schools to train teachers sprang up in Westfield (1839), Framingham (1839), Bridgewater (1840), Boston (1852), and Salem (1854). They and others founded after them

comprised the state college system, and an agricultural college at Amherst (1865) would eventually develop to become the University of Massachusetts.

Hard upon the growth of schools came intellectual, philosophical, and spiritual movements. William Ellery Channing (1780–1842) popularized the liberal religion Unitarianism, an offshoot of Congregationalism that he called "a rational and amiable system." The influence of Unitarianism should not be underestimated. When the Reverend Henry Ware was appointed Hollis Professor of Divinity at Harvard in 1805, Unitarianism had equal standing with orthodox Calvinism as practiced by the Puritans. The Andover Theological Seminary was founded in opposition to the Unitarians, and an 1809 Calvinist church on Boston's Park Street was built where preachers could lambaste the insurgents. With many New England towns split between the two faiths, some orthodox grew more

Opposite: The Harvard Boat House on the Charles River. Beginning with rowing, sports boomed in New England colleges during the nineteenth century and then spread to colleges throughout North America.

Left: Detailed carving in Harvard Yard, which still retains many eighteenth-century structures. Elsewhere in the 22-acre area, the Bradstreet Gate (1997) carries a plaque with this quote from seventeenth-century poet Anne Dudley Bradstreet: "I came into this Country where I found a new World and new manners at which my heart rose."

Right: Ralph Waldo Emerson, promoter of Transcendentalism. His philosophy has been characterized as "a compound of German idealism, Neo-Platonism, Asian mysticism, and Swedenborgianism."

and more bigoted—an activity that would soon enough take its toll on non-Protestants and non-Christians.

The essayist, poet, and lecturer Ralph Waldo Emerson (1803–82), an early adherent of Channing's, developed the philosophy of transcendentalism. Drawing from theology and economic and social reform movements, advocating both pacifism and abolitionism, transcendentalism is best known for advocating the connection of man and nature. Another leading transcendentalist, Henry David Thoreau (1817–62) wrote *Walden, or Life in the Woods* (1854) based on his time at Walden Pond outside Boston. Thoreau was jailed for refusing to pay taxes during the unpopular Mexican War; his philosophy of civil disobedience was later advocated by Gandhi and Martin Luther King, Jr. In general, according to one description, "the transcendental was whatever lay beyond the stock notions and tradi-

tional beliefs to which adherence was expected because they were generally accepted by sensible persons."

Transcendentalists often put their ideas into practical life. Brook Farm (1841–7), in West Roxbury, Massachusetts, was the brainchild of Unitarian minister George Ripley (1802–80). Like other utopian communities, it attempted to create an ideal society. Financially, it was a failure, owing to sandy soil unsuitable for farming and the burning of the central building in 1846. Brook Farm's intellectual life, however, was stimulating. A variety of New Englanders like Nathaniel Hawthorne, John S. Dwight, Charles A. Dana, and Isaac Hecker were members at least briefly, while Emerson, W.E. Channing, Margaret Fuller, Horace Greeley, and Orestes Brownson were visitors. The community's school used the progressive ideal of learning from experience that John Dewey later popularized.

Believing that Brook Farm wasn't pure enough, Amos Bronson Alcott (1799–1888) founded Fruitlands (from June 1843 to January 1844) in Harvard, Massachusetts. Using animals neither for food nor labor—one woman was expelled for eating a single bite of fish—Fruitlands existed mainly to satisfy the spiritual needs of its few members. One man practiced nudism, another wore a beard at a time when facial hair was virtually illegal. When participants tried to farm using only spades and hands, the community's days were numbered. "They look well in July," Emerson wrote after a visit. "We shall see them in December." By January they had dispersed, although Alcott's daughter, the author Louisa May Alcott (1833–88), kept the memory of Brook Farm alive by writing *Transcendental Wild Oats.*

Florence, in western Massachusetts, was known for the Northampton Association of Education and Industry (1841–6), a utopian community supporting "abolitionism, pacifism, equality and the betterment of human life." Although noted progressives and abolitionists like William Lloyd Garrison (1805–79) and Frederick Douglass (1817–95) were supporters—the abolition movement was stronger in New England than in any other region of the country—the association is best remembered for providing a haven for Sojourner Truth (?1797–1883). A former slave who became a mesmerizing preacher, singer, lecturer, abolitionist, and feminist, she was immortalized by her "Ain't I a Woman? " speech at the 1851 woman's rights convention held in Akron, Ohio. A statue is finally being erected in her honor in Florence.

The orderly and productive Shakers (once known as the Shaking Quakers because they danced during religious ceremonies) ranged through Massachusetts from the late 1700s to 1918 and have survived in Maine and New Hamsphire to the present time. Alas, they doomed themselves to virtual extinction by advocating celibacy, but they left behind crafts and furniture in the simple but functional New England style. Admirers have preserved their stone barn at Hancock, Massachusetts, whose round shape enabled a farmhand to feed an entire herd.

The flowering of thought so prevalent in New England did not produce an instant literature. Emerson complained in the 1830s that there was "not a book, a speech or a thought" in Massachusetts. Soon enough, he produced them himself, along with Nathaniel Hawthorne

(1804–64), John Greenleaf Whittier (1807–92), William Cullen Bryant (1794–1878), and others. And surely Herman Melville's (1819–91) trips from New York to Berkshire County in western Massachusetts to converse with Hawthorne in 1850–2 greatly influenced his writing. As one authority on the life and works of Melville has put it, "Hawthorne's influence, in fact, is credited as the prime catalyst behind Melville's decision to transform what originally seems to have been a light-hearted whaling adventure into the dramatic masterpiece that is arguably the greatest American novel of all time." The reference, of course, is to *Moby-Dick*.

Although national leadership had generally shifted south, New Englanders continued contributing to national affairs. As president from 1825 to 1829, John Adams' son John Quincy Adams (1767–1848) oversaw the building of the

Overleaf: *Hancock Shaker Village. A historic site in western Massachusetts, it re-creates the habitat and activities of the Shakers who resided there from 1783 into the early 1800s.*

Left: *Sojourner Truth. She grew up a slave on a Dutch New York estate and became a social reformer who was eventually received at the Lincoln White House.*

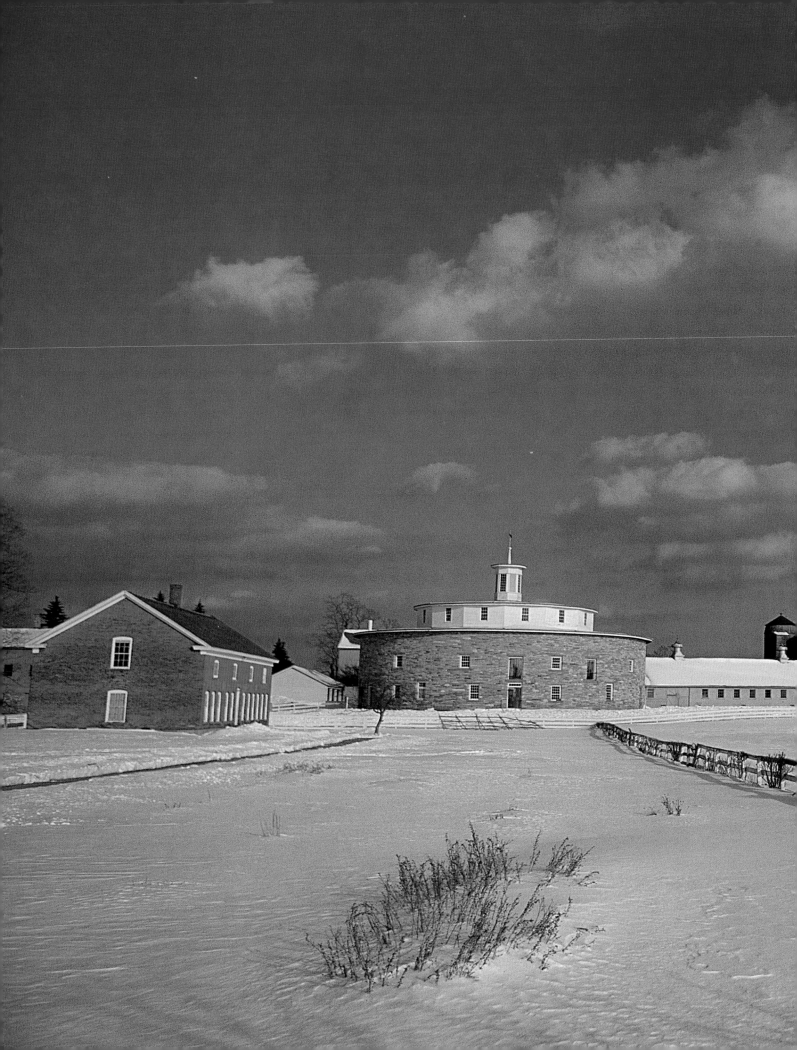

Below: A Currier & Ives print of a Union soldier leaving for war. The firm was started by Boston-born and -trained Nathaniel Currier (1813–88), who then hired James Merritt Ives (1824–95). It produced more than one million hand-colored prints, posters, and handbills of some 7,500 subjects ranging from disaster to humor.

country's first canals and highways but his work before and after that period may have been more telling. Serving as secretary of state under President James Monroe, he helped to formulate the Monroe Doctrine, share the Oregon territory with England, and force Spain to yield Florida. After losing his bid for re-election in 1828, he returned to Congress. His successful defense of the slaves who took over the ship Amistad has been captured in a popular movie of that name.

Hillsboro, New Hampshire, native Franklin Pierce (1804–69), president in 1853–7, hoped to preserve the union, but the Kansas-Nebraska Act that superseded

the Missouri Compromise fomented trouble by allowing new territories to decide the question of slavery. As a result, southerners and northerners rushed into Kansas and, predictably, clashed. "Bleeding Kansas" started America down the road to the greater conflict of 1861–5, and Pierce was not renominated. Far more celebrated, Daniel Webster (1782–1852) of Salisbury, New Hampshire, was a lawyer, congressman, senator, and secretary of state who passionately argued the case for preserving the Union.

The New England population had always been dominated by Yankees of English extraction, but this began to change as great numbers of Scottish, Irish, Germans, and French Canadians arrived. Yet the attitudes of many New England leaders remained ossified.

When old John Adams, with Jewish friends and associates in mind, tried to get the Massachusetts legislature to adopt a freedom-of-religion amendment, he was rudely rebuffed. And on April 18, 1842, Thomas W. Dorr led a rebellion after Rhode Island refused to extend voting rights, authorize a bill of rights, or pass reapportionment to suit new arrivals. After failing to occupy a

state armory and becoming governor in an extralegal election, Dorr was arrested and sentenced to life in prison. In a year, however, he was pardoned, and the reforms passed. Anti-Catholicism was especially pronounced. In 1860 Lynn, Massachusetts, residents brandished "No Foreign Police" placards to protest Irish immigrants serving as cops.

New Englanders had generally looked askance at the Mexican War (1846–8), which they viewed as an expansionist scheme by President James Polk. True to their abolitionist history, however, they were actively involved in the Civil War—"the great and necessary struggle," as described by Massachusetts Governor John A. Andrews. A mob tarred and feathered a Haverhill newspaper editor sympathetic to the South. Many storied regiments headed into battle, including the black one immortalized by the movie Glory. On the other hand, some Yankee elite hired unwilling but impoverished Irish immigrants to fight in their place—an act that produced lasting resentment.

Several famous New England generals helped the North prevail. Among them were Joshua Lawrence Chamberlain of Brewer, Maine (1828–1914), who went on to become governor of his state; Joseph ("Fighting Joe") Hooker (1814–79) of Hadley, Massachusetts, whose name has been falsely claimed to have been given to the prostitutes who followed the soldiers—"hookers"; and Benjamin Franklin Butler (1818–93) of Deerfield, New Hampshire, who occupied New Orleans and later governed Massachusetts. Oxford, Massachusetts's Clara Barton (1821–1912), who would found the American Red Cross, nursed soldiers and helped search for missing ones. Despite

New England's historical pacifism, the Naval War College was established in Newport, Rhode Island, in 1884.

New England's industries flourished during the Civil War, because the region was relatively little affected except for its departing soldiers and equipment. There was one exception: in 1864 Confederate soldiers raided Vermont from Canada, prompting raids on Canada by Irish-American Vermonters. It would soon become apparent that the rebirth of New England after the War of 1812 was nothing compared to what followed the Civil War. In came a "gilded age" of great fortunes and accomplishments.

Opposite: Boston's Shaw Memorial, erected in 1865, commemorates the soldiers of the first African American regiment to be recruited in the Northeast for the Union Army.

Below: Clara Barton. At seventy-nine the hardy American Red Cross founder spent six weeks helping homeless and ill flood victims in Galveston, Texas.

Right and opposite:
The Breakers,
Commodore Cornelius
Vanderbilt's summer
home in Newport,
Rhode Island.

Below: Trinity Church
in Boston. While
rebuilding the fire-
destroyed structure
in 1873–7, Henry
Hobson Richardson
trained another
famous architect,
Stanford White.

Visible proof of the new wealth existed over most of New England: in a fabulous span of homes along the oceanfront in Newport, Rhode Island; the mansions on Boston's Beacon Hill; the Mark Twain House, now a museum, where the great author resided in Hartford, Connecticut; and the huge hotels accommodating vacationing "swells" in New Hampshire and Maine.

Publishing and literature flourished. Although a native of Ohio, William Dean Howells (1837–1920) settled in Cambridge, Massachusetts, where a plaque now marks his house. He edited *The Atlantic Monthly* in 1871–81, wrote for *Harper's Monthly,* and published novels, plays, and travel books. His prime fictional works—*The Rise of Silas Lapham* (1885) and *A Hazard of New Fortunes* (1890)—dealt with what *The Cambridge Dictionary of American Biography* calls "the need for realism, morality and edification."

Howells was perhaps the most versatile but by no means the only literary star of the era. He had stiff competition from Oliver Wendell Holmes (1809–94). The inventor of an early stethoscope and father of a Supreme Court justice, he also published influential poetry and essays. His 1830 poem "Old Ironsides" led to the preservation of the USS *Constitution*, a classic ship from the War of 1812, and his biography of Ralph Waldo Emerson (1885) was considered authoritative.

Other well known New England authors included James Russell Lowell (1819–91), *The Atlantic Monthly's* first editor and author of the poems "The Bigelow Papers" (1848; second series 1867) and "A Fable for Critics" (1848); Sara Orne Jewett (1849–1909) of South

Right: *Nathaniel Hawthorne. This Puritan-haunted author began his career with twelve years of study and writing, having little human contact except during summer vacations. Many of his writings have New England settings, and his birthplace home in Salem, Massachusetts, may still be visited.*

Berwick, Maine, whose knowledge of provincial life in South Berwick, Maine, distinguished her novel *The Country of the Pointed Firs* (1896); and Henry Wadsworth Longfellow (1807–82), the best known American poet of the century, whose *Tales of a Wayside Inn* (1863) opens with the schoolchild classic "Paul Revere's Ride." And, although unknown to her contemporaries, Emily Dickinson (1830–86) composed deeply personal poems that would influence the form in the next century.

Perhaps the apotheosis of "gilded age" writing was Henry James (1843–1916), who dropped out of Harvard Law School in 1863 to become one of the world's greatest writers. His complex sentence structure and nuanced psychological themes would influence a respected school of modern literature.

In other areas, Massachusetts native Susan B. Anthony spearheaded the women's rights movement, while the quintessential New Englander Mary Baker Eddy (1821–1910), who lived in New Hampshire, Maine, and Massachusetts, created the Church of Christ, Scientist and founded the *Christian Science Monitor.*

New Englanders took the principle of "healthy mind, healthy body" seriously. The following examples only begin to suggest the frantic pace of activity. In 1852, the Yale and Harvard crews staged the first intercollegiate athletic event in the U.S. on New Hampshire's Lake Winnipesaukee. Amherst and Williams played the first intercollegiate baseball game on July 1, 1859. In 1891, Canadian James Naismith invented basketball at the Springfield, Massachusetts, Young Men's Christian Association (YMCA), and only a year later women's basketball began at Smith College in nearby Northampton. At another western Massachusetts YMCA, in Holyoke, William G. Morgan introduced volleyball in 1895. Actually, he called the blend of baseball, basketball, tennis, and handball "mintonette" until someone suggested that players were "volleying" the ball back and forth. The first game was played at Springfield College on July 7, 1896.

America's first YMCA opened in Boston on December 29, 1851. Expanding quickly, Y's eventually offered swimming, weightlifting, libraries, auditoriums, living facilities, summer camps, and courses in everything from literacy to lower-back relief. The YMCA helped establish the American branches of the Red Cross, the Boy Scouts, the Camp Fire organization, the Student Christian Movement, the World Council of Churches, and the World University Service. No wonder Bostonians refer to their city as the "hub of the universe"!

Cultural institutions flourished all over New England. There were museums, libraries, opera companies, and symphony orchestras. Boston's New England Conservatory of Music (1867), the country's oldest independent music school, put the lie to one critic's claim that "It would be no more possible to establish a conservatory in this country, than to make a whistle out of a pig's ear."

After building New York's Central Park, Frederick Law Olmsted (1822–1903) designed the entire Boston park system and moved his landscape architecture offices to nearby Brookline. The Romanesque-influenced architecture of Henry Hobson Richardson (1838–86), who was known for massive stone buildings with powerful towers, left its mark on Boston's Trinity Church (1873–7), as well as on libraries, railroad buildings, and other New England structures.

New England sprang to the fore in medical facilities, a field in which it still may lead the nation in excellence. Henry James' brother William (1842–1910) created America's first psychological laboratory at Harvard and wrote *Principles of Psychology* (1890). Charles William Eliot (1834–1926), Harvard president in 1869–1909, introduced seminal reforms like electives and a liberalized curriculum. He published his progressive ideas in *The New Education* (1869). His 1892 report on secondary school education, moreover, led to standardized public school curricula and the Board of College Entrance Examinations.

None of which is to suggest that conflict was absent from the New England of 1865–1900. Life on the farm was giving way to life in the city as many exurbanites and French Canadian immigrants sought work in grim, often unsafe small-town mills and urban factories. Unions grew up to support them, and friction between labor and management produced strikes. Starting about 1880, the "new immigration" saw countless Italians and Eastern Europeans, including Jews, arriving from overseas. Lines were drawn. The Republican Party was founded in 1854 to oppose the extension of slavery into the territories but also became stridently anti-immigrant. In practice, that often meant anti-Catholic and anti-Semitic. Class resentments surfaced. People of Yankee stock, especially the more prosperous, tended to be Republican. So did African Americans, who remembered the abolitionist party of Lincoln. By contrast, other minorities and working-class immigrants were loyal Democrats who gained jobs, patronage, and housing from effective but occasionally corrupt big-city machines. Indeed, political and religious loyalties within these communities often supplanted loyalty to state and country.

The "flowering of New England," then, was firmly embedded in the social and economic realities of the century. But they are the subject of another chapter.

Overleaf: Walden Pond in Concord, Massachusetts, where Henry David Thoreau did some of his best thinking. It led to his famous Walden, or Life in the Woods, *which advised readers to understand their own nature as well as nature itself.*

Left: Susan B. Anthony, born in Adams, Massachusetts. As a suffragette, she fought through ridicule to respect, and won her first victory with New York's Married Women's Property Act in 1860.

A Region
at Work

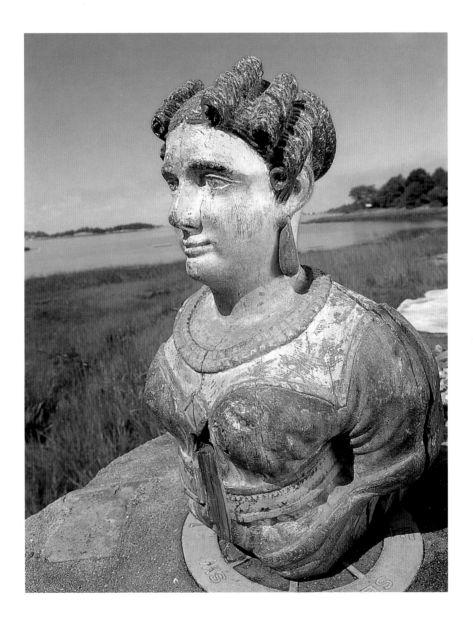

Previous page: A ship's figurehead in Hingham, Massachusetts, once known as Bare Cove, and long one of New England's leading shipbuilding and fishing towns.

Below: A Singer sewing machine early in the twentieth century. In 1850, Isaac M. Singer was working in a machine shop in Boston when he was asked to repair an early type of sewing machine. He quickly improved on it and soon was making and marketing the world's most famous sewing machines.

For the United States in general, and New England in particular, the nineteenth century was an era of vast and varied enterprise. Its residents worked hard at every possible occupation, from such age-old tasks as farming and fishing to the occupations based on the newest technologies.

The term "Yankee ingenuity" could only have been coined to describe New Englanders. Although they had shown signs of this tendency almost from their first years in the New World, New Englanders gave full expression to creative impulses in the nineteenth century. It was no coincidence that Missouri-bred, Western-matured Mark Twain called one of his most popular books *A Connecticut Yankee in King Arthur's Court*. A single product could make a state or community famous. Witness Vermont's "sweet water" (maple syrup) and "Whip City"—Westfield, Massachusetts.

Barred from importing British fabrics by the Embargo Act of 1807, New Englanders became inventive. Francis Cabot Lowell, backed by Boston's richest Brahmin families, built the country's first textile mill in Waltham, Massachusetts (1814), and communities like Lowell, Massachusetts, and Lewiston, Maine, built up both textile and shoe industries. Perhaps the most ingenious Yankees were from Connecticut. Edward Howard popularized wrist watches, Edward and William Pattison sent their minted coins to South America, and Frederick Tudor shipped ice to India! Fellow Nutmegger Samuel Colt invented the six-shooter pistol in 1835. Rhode Island's Dodge brothers used metal plating to establish the country's first jewelry industry. The first stagecoach was produced in 1826 by Concord, New Hampshire, entrepreneurs Lewis Downing and J. Stephen Abbot. Eli Whitney of Westboro, Massachusetts, best known for his 1793 invention of the cotton gin, actually made his fortune by initiating mass production of interchangeable gun parts. The sewing machine, mass-produced to perfection by Isaac M. Singer, got its start in New England. Perhaps even more significant was Charles Goodyear, of New Haven, Connecticut, who invented vulcanized rubber following an accident when he dropped a mixture of rubber and sulfur onto a stove and was amazed when it didn't melt.

Of course as the nineteenth century began, New England's basic economy and way of life centered on farming. The 1790 census disclosed that three of every four Americans lived on a farm. Things didn't change much here during the early years of the nineteenth century. Generally favoring mixed crops for their own subsistence as well as sale, New

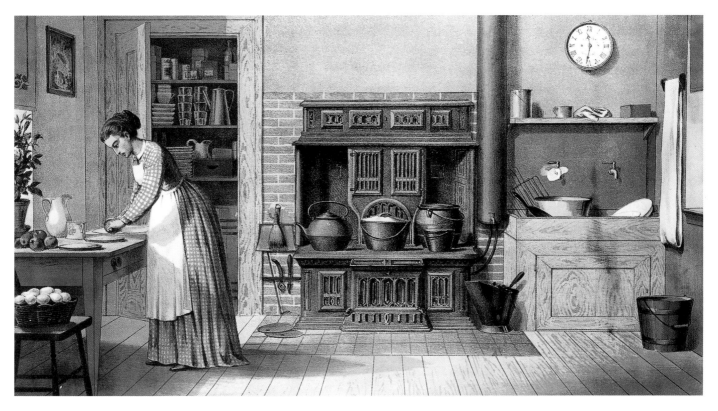

England farmers grew large fields of wheat and hay. Vermont became the dairy capital of the Northeast (by no coincidence, Ben & Jerry's ice cream is a Vermont institution). Maine potatoes—"buhdadoes" to Downeasters—became a huge cash crop.

The farmer's barn, constructed of heavy timber and planks, was built on level ground, with doors front and back to accommodate wagons loading hay and straw. Livestock were corralled with wooden fences, but more often with dry walls made of stones. New England's farmers used the rocks they dug up to create the stone walls that remain a signature of the region.

A typical farmer's house, as plain in appearance as its inhabitants, was a two-story building constructed of stone, brick, or clapboard, with a pitched roof to the first-floor ceiling. Its floor plan—three downstairs rooms and two upstairs—included a large first-floor space serving as kitchen, dining room, and living room. The stove and a centrally located fieldstone chimney heated the farmhouse. Although cookstoves appeared in 1815, most cooking was done over an open fire. And what bounty sat on the kitchen table! In addition to wheat, corn, pork, and cattle, the absence of hunting regulations allowed for consumption of deer, pigeon, and anything else that ambled or flew by.

At first, farms stood near navigable rivers or in fertile valleys protected by nearby hills. On rivers like the Charles, the Connecticut, or the Merrimac, farmers loaded cargo on rafts, headed downriver and sold both produce and craft to tidewater towns. Some of the profits were used to purchase necessities like salt, powder, coffee, and tea that traveled upstream on long boats called gundalows. An engaging figure in early farming days, the ubiquitous Yankee peddler traveled overland from farm to farm selling everything from pewter to shoes to candles.

Above: A New England kitchen from Prang's Aids for Objective Teaching *(1874). Louis Prang (1824–1909), the Polish-born lithographer who after moving to Boston introduced art education and the four-color printing process, is best known as "Father of the Christmas Card."*

Later in the nineteenth century, the invention of the gasoline-powered tractor made farming more than a subsistence industry. The 1869 Golden Spike, meanwhile, had created a national railroad system that made the entire country accessible. For better or worse, this favored the large farms in the flat lands of the West, and New England, which began the century as a farming region, ended it as an industrial center, with abandoned farmhouses littering the landscape. Some farmers deserted their lands for factory jobs in the cities, while others moved west to the siren song of richer soil and California gold.

Orchards—fruit trees of many kinds—were another of New England's strong points, especially apple orchards. Indeed, Johnny Appleseed (1774–1847) was from Leominster, Massachusetts. This was a real man, not a figure of fantasy. Born John Chapman, Appleseed spent almost half a century roaming through 100,000 square miles to plant apple trees in Pennsylvania, Ohio, Kentucky, Illinois, and Indiana. Walking unarmed and barefoot, eating berries and sleeping outdoors, he pursued a dream that no one should die of starvation. If we are to believe the legend, he wore clothes made of sacks, used a tin pot for a hat and cooking, and made water by melting snow with his feet. Even today he inspires his own web page, which argues quite convincingly: "The longevity of trees

Opposite: A red barn in Brownsville, Vermont. Even as agriculture declined in nineteenth-century New England, the Green Mountain State maintained its dairy industry and rustic environment.

Below: Cows on a Vermont farm. Black-and-white Holsteins, weighing some 1,500 pounds and producing 6.4 gallons of milk a day, are Vermont's most numerous breed of cows.

and their ability to spread makes John Chapman's contribution perhaps the most lasting in American history. Laws, wars and political parties have come and gone; lawyers, soldiers and statesmen have grown powerful, only to see their life's work eventually undone. But John's apple trees have endured and multiplied, changing the face and food of a continent. All from a gentle man, possessed by a strange and wonderful dream."

Another age-old occupation that New Englanders took up was animal husbandry. In an era before automobiles, humans could not live without animals. They were useful for transportation (read: horses) and labor (read: horses and oxen). Everything—from winter sleighs to plows to people—was hauled by horse or oxen. And horses created a critical industry for blacksmiths, who not only shod them but produced many necessary items from iron. Cows, pigs, and sheep proliferated all over New England. Milking, long a labor-intensive practice, became streamlined by the inventions of the vacuum-type milking machine (1865) and a machine using hand and foot pedals (1890s).

To provide wool for textile mills, Vermont farmers imported sheep from Merino, Spain, in mid-century and sent the product south by wagon and railway. When western farms produced more wool at cheaper prices in the 1870s, Vermonters turned to an expanding butter industry. Two providential events helped them considerably. In St. Albans, the Franklin County Creamery constructed a centralized butter factory in 1880, and the following year the Maine Central started refrigerated service.

The Ocean State became famous for its Rhode Island Red hens, the state bird. First developed in Rhode Island and Massachusetts in the 1880s and 1890s, Reds—which actually range from red to chocolate in color—can lay 200–300 eggs a year and begin laying as early as six months of age.

Lumbering was yet another of the basic occupations of New Englanders. The vast forests of New Hampshire and Maine provided lumber to build ships, carriages, and furniture. Maine, newly independent from Massachusetts in 1820, nearly as large as the rest of New England and bursting with pride, held

Right: Cutting lumber to build a house in Bradford, Vermont. The idiosyncratic town, settled without grant, charter, or patent, was eventually named after colonial Governor William Bradford of Massachusetts Bay. Its primary claim to fame: the first practical world globes were invented here by James Wilson.

its own with much larger timber states. According to *Life in America,* "To the major ports where the finest and biggest packets and clippers were built, came an endless parade of ships carrying live oak from Georgia and Florida swamps, red cedar and locust wood from Chesapeake Bay, light pitch pine from the Carolinas and Georgia, and white pine spars from Maine—the best woods that could be procured for their various purposes in building the world's stoutest and most perfect sailing vessels."

For such achievement came a heavy human cost. Life in the Maine lumber camps was about as rugged as anything you could find in nineteenth-century New England. As an old lumberman recounted in an exhibit at the Maine Folklife Center, "You sleep two in a bed…and…they didn't take good care of their blankets…those heavy blankets…in the fall of the year lots of times they wouldn't bother to laundry them…Next spring you'd have to crawl into them dirty old blankets."

If anything came to personify nineteenth-century New England it was river-based business. Sawmills, grain-grinding mills, dams—all flew up on the region's endless waterways. Francis Cabot Lowell's Merrimack Manufacturing Company, built on the banks of a Massachusetts river, the Merrimack, set the standard. Sales increased from $3,000 in 1815 to an unheard-of $345,000 seven years later, while 100,000 spindles wove more than thirty miles of cloth daily. Moreover, the company treated its workers well, at least by contemporary standards. With clean dormitories and ample cultural opportunities, Merrimack, in the words of British novelist Anthony Trollope, was "the realization of commercial utopia."

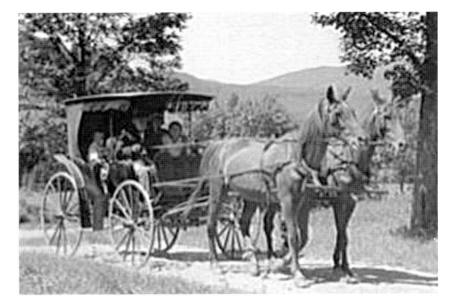

In many small towns, life centered on mills. Close by a stream dammed well enough to produce power to turn a waterwheel, the gristmill generally used a single pair of grinding stones to process grain. According to *The Young United States,* the gristmill was a social center for the farmers lined up there. Another sociable fellow, the blacksmith, set up his forge nearby. Elsewhere on the stream was a sawmill, and a tanner washed his hides in another stream location.

Above: A horse-drawn carriage. The noble beast was used for transportation, labor, and recreation.

Below: A gristmill in South Sudbury, Massachusetts, which used huge stones turned by waterpower to grind corn into meal.

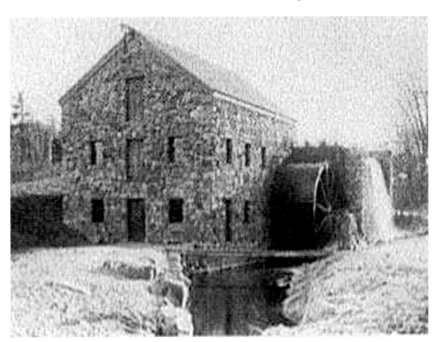

Above: *A sheep farm in Warren, Vermont, with the Green Mountains forming a backdrop. To produce wool for mills, state farmers imported sheep from as far away as Merino, Spain.*

Not all mills were so ideal, nor should they be overly idealized. Samuel Slater and Moses Brown had built the first successful American cotton-textile mill at Pawtucket, Rhode Island, in 1789; as early as 1800 its underpaid workers, laboring for seventy hours a week, staged the country's first strike. In towns like Lowell and Lawrence, Massachusetts, mills were grimy places, with substandard wages and often dangerous working conditions. Yet these mills provided much-sought-after jobs. Manchester, New Hampshire, still notable for its red-brick mill architecture, attracted New England's first major influx of French-speaking Canadians.

With so much local water, mills and manufacture flourished. Mill owners like Nelson W. Aldrich, a force in national life as well, dominated the local economy. As Rhode Island became more urbanized, generations of foreign-born workers went to work for him and other magnates. English, Irish, and Scottish immigrants arrived in the first half of the century, to be followed by French-Canadians, and after 1880 Poles, Italians, and Portuguese. The role of immigrants cannot be overstated. French-Canadians also contributed heavily to the bakery, carpentry, and contracting industries. In Holyoke, Massachusetts, the Germania Mills were

named after immigrants who brought from the old country their expertise in hand weaving and woolens.

Mills were particularly prevalent in Massachusetts. In his *Massachusetts: A Pictorial History,* Norman Kotker states unequivocally, "there were hundreds of mills making everything from anchors to zinc." Connecticut built the country's first silk mill in 1810. By the century's end, New England had two-thirds of the country's cotton mills, mostly in Massachusetts, and Rhode Island processed some 20 percent of America's wool.

And it was not just textile mills that New England supported. Factories of all kinds grew up. There were Connecticut's Eli Terry's clocks and Yale Locks and Pratt & Whitney manufacturers, whose catalogue ran hundreds of pages. Boasting of Pratt & Whitney, an 1899 book called *Hartford in History* brayed, "Here the resources of science, art and skill have been devoted to their task of embodying the ideal in the real. Its imprint to the informed mind signifies simplicity, strength, precision, elegance, durability and complete adaptation of means to

Below: Historic farm implements in a barn at Old Sturbridge Village, Massachusetts. New England's largest outdoor history museum re-creates a water-powered mill, a working farm, and other facets of life in a nineteenth-century Shaker community.

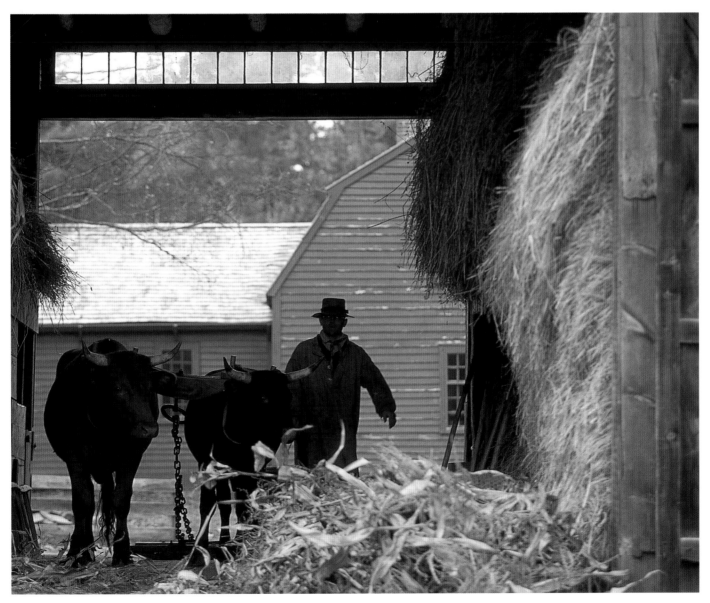

Page 108: Castle Hill Light in Newport, Rhode Island. Before opening in 1890, its construction was delayed for years by naturalist Alexander Agassiz, who objected to the encroachment on his property. To protect their boats at night during this period, steamboat companies painted the nearby cliffs white.

ends." The Vermont towns of Springfield and Windsor produced machine tools that helped the North win the Civil War.

The first of several industries oriented to salt water, fishing boomed in the nineteenth century. Traveling all the way to the Grand Banks off Labrador in search of cod, mackerel, pollack, and other species, fishermen took several trips a year and used individual handlines. Shares from the catch, in descending order, went to the boat owner, the captain, the fishermen, apprentices who salted fish for storage, and the hapless cook. When 60-foot boats were built, fishing towns sprouted in numerous locations, including many Maine villages, the Cape Cod islands of Martha's Vineyard and Nantucket, New Bedford, Massachusetts, and the Boston neighbor of Marblehead, where the catch was exported to Europe and the Caribbean. Boston, Salem, and Nantucket—the small island that had ninety fishing vessels in 1842—became New England's major maritime ports. Inevitably, related industries sprang up. In Provincetown on Cape Cod, the beach was lined with windmills that evaporated seawater, reducing it to salt for curing fish. Mashpee Indians made artificial pearls from the scales of alewives caught in Cape Cod brooks.

Easily the most storied of fishing industries—Herman Melville's novel *Moby-Dick* is an American classic—whaling thrived until kerosene supplanted whale oil in the 1870s. Used in lamps, the oil also lubricated machinery and leather. Spermaceti from the oil made candles burn without smoking or dripping. Legends aside, the reality of whaling was a combination of cruelty and danger. Strapping a whale to the side of the ship, cutting it up, and boiling down the blub-

ber for oil was stinking work. Crew members, viciously exploited, often finished voyages owing money rather than collecting it, while the task of hunting the monster mammals from small whaleboats with a weapon as primitive as a harpoon carried the risk of death every time. A thrashing whale could swamp the boat or crush boat and passengers in its jaw. In places like Nantucket, Martha's Vineyard, and the leading whaling port, New Bedford, Massachusetts, nervous women prowled "widow's walks" atop their houses watching and waiting for their loved ones to return home.

As the fishing industry grew, so did New England's ports. By the early 1800s they became centers of international commerce. In addition to employing sailors, ports gave a living to chandlers, clerks, port authorities, customs inspectors, stevedores, and many others. And then there was the business of guiding ships around shoals and reefs to get them to port. In contrast to whaling, operating a lighthouse was a genuinely romantic, if lonely and hazardous, occupation. The night guiders who kept beacons going saved the lives of countless crews. In 1800 there was an average of one shipwreck a day. The use of glass and reflectors forever changed a business that started as bonfires on the beach. Before satellite technology and automatic beacons replaced humans, there were ninety-eight staffed lighthouses in southern New England, from Newburyport, Massachusetts, to Greenwich, Connecticut, which were celebrated in art and literature. Thomas Doughty painted a famous mural of the lighthouse on Nantasket Beach near Boston.

To supply the many vessels required for all these tasks, boat yards operated profitably from Maine to Connecticut.

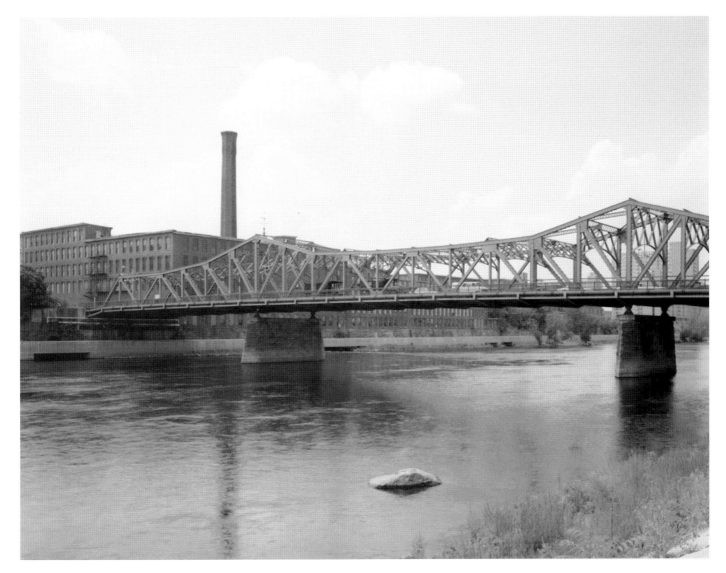

Boston's Charlestown Navy Yard, home to the famous U.S.S. *Constitution* ("Old Ironsides"), which won all forty-two of its engagements during the War of 1812, is only the best-known yard today. Nonetheless, little-known shipyards in places like the North River's Hanover and Pembroke did as much to make Massachusetts famous.

In the late 1700s, there had been triangular trade among Europe, New England, and the West Indies. Improvements in shipbuilding enabled New England merchants to make their fortunes trading with partners as distant as China. The United States' tea trade with China, built up to one million pounds a year by 1787, gave rise to the need for bigger, faster ships in the nineteenth century. The Yankee clipper, high-masted with billowing sails, enjoyed a brief and celebrated career before it was put out of business by steam-engined ships late in the century. Perhaps the most famous clipper was the Flying Cloud, a 208-foot craft with a knifelike bow that could sluice through heavy seas at twenty knots. Launched from Boston Harbor in 1851, it reached San Francisco in an astonishing eighty-nine days. The Yankee Clipper survives in brand names ranging from shavers to furniture, and more

Above: Boott Mill and Ouellette Bridge spanning the Merrimack River in Lowell, Massachusetts. Active in 1821–36, Boott had eighty-eight power looms and a "mill girl" boardinghouse for its workers.

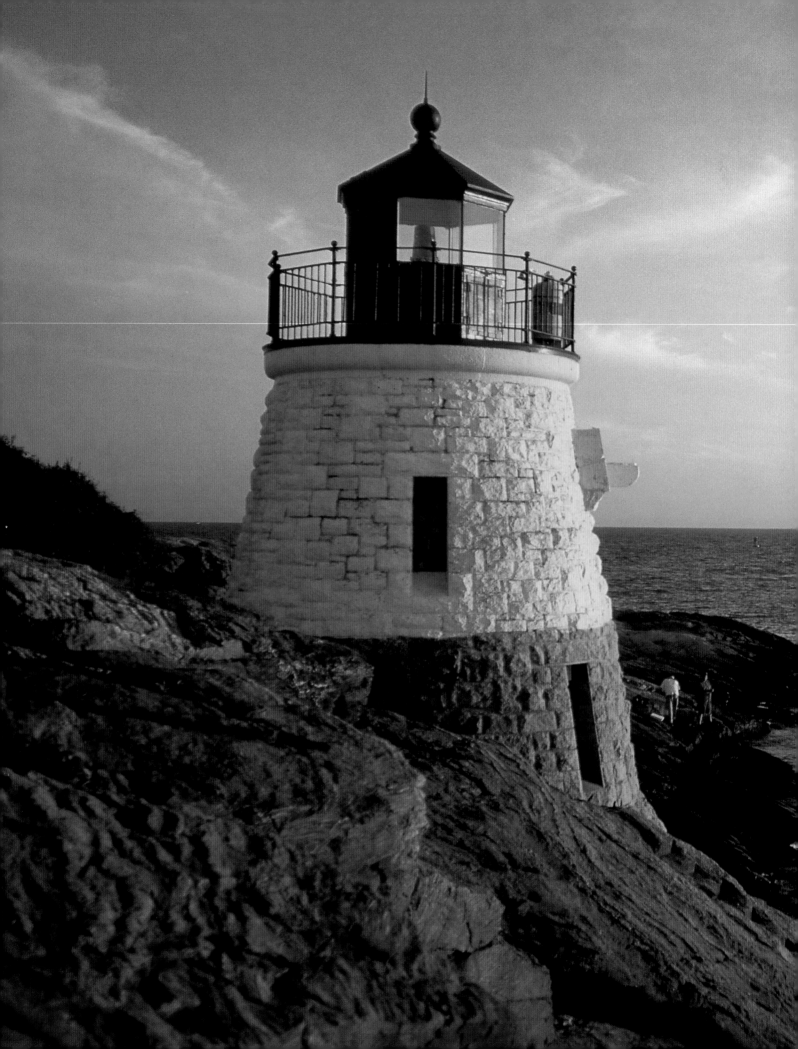

elegantly in the nickname given the late, great Yankee slugger Joe DiMaggio.

As bigger and better ships probed the seas, scientists studied it. The National Marine Fisheries Service (1871) and the Marine Biological Laboratory (1888) were established in Woods Hole, Massachusetts. And there were other benefits to taming the seas. Reliable steamship service opened up places like Martha's Vineyard and Nantucket as Bay State resorts, and enabled people to reach craggy harbors in places like Newport, Rhode Island, and Bar Harbor, Maine. Other benefits of the friendlier sea included fishing and the enjoyment of yachting for recreation.

As people found more time for travel and recreation, New England became a magnet for other activities. Tennis at Boston's Longwood Cricket Club and golf at nearby Brookline's The Country Club laid the groundwork for two other hobbies that would go nationwide and appeal to people of all backgrounds. New Hampshire, the birthplace of American skiing, became a tourist mecca. Among its many attractions were the 183-mile coastline of Lake Winnipesaukee, with its 274 islands, and the 360-degree view from

Mount Monadnock, the second most-climbed peak in the world after Mount Fuji. Vermont's tourist industry got boosts from unexpected sources—Mary Todd Lincoln, who spent the summer of 1863 in Manchester, and British historian Lord Bryce, who called the Green Mountain State "the Switzerland of America." Lake Champlain, "Vermont's Cape Cod," attracted summer residents galore, and the discovery of a pure-springs water cure in Brattleboro had more practical visitors pouring into town from 1846 to 1871.

Despite New England's reputation for horse-drawn carts, railroads as much as anything else opened up the region. America's first railway, using horse-drawn cars with wooden wheels, carried granite from a Quincy quarry four miles to Charlestown for use in construction of the Bunker Hill Monument (1842). By the century's end, there were two terminals, North Station and South Station, in Boston alone. Trains crisscrossed New England and connected the region to the West on the Boston and Albany route. The 1869 Cog Railway dragged tourists 3½ miles up New Hampshire's Mount Washington. Of course, trains were not just used for passenger traffic. They allowed marble and granite to be shipped from places like Graniteville's Rock of Ages Quarry, Vermont, to the greater world—an important contribution when most houses were built of stone. In the same tradition as New England rivers, railroads even created towns built alongside them, like Vermont's White River Junction.

People no longer commuted solely to the mill or factory or wharf. White-collar office jobs were a reality by 1900. To take just one example, the New York fire of 1835 highlighted the need to create financial

Below: The Wilson Point ferry terminal in Norwalk, Connecticut. It connected New England trains to the Long Island Railroad, which then made for a faster entry into Manhattan Island.

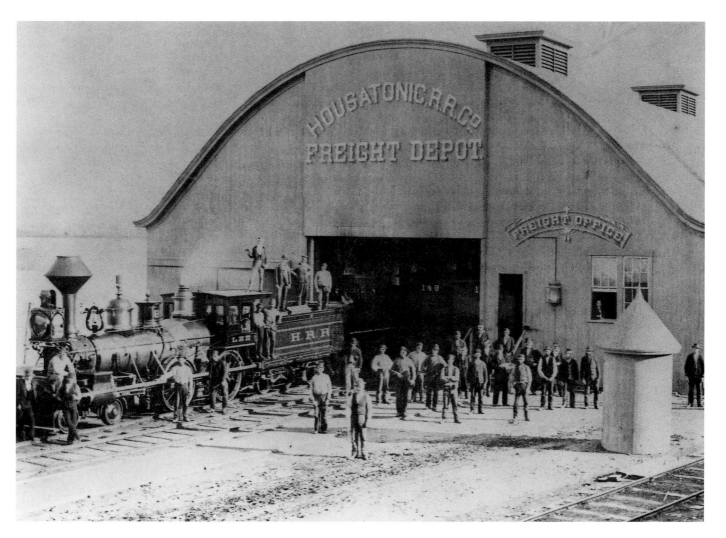

reserves for losses, and two years later Massachusetts led the nation in requiring companies to provide them. Hartford, Connecticut, became the self-anointed insurance capital of America. It didn't hurt that the local Plimpton Manufacturing Company was producing three million envelopes per day! Businesses required large office staffs of clerks and secretaries. The growth of office work opened new opportunities for women, who quickly mastered that incredibly modern invention, the typewriter. Because offices were built in ever-growing urban areas, they created jobs for workers in related fields, including sanitation, police, firefighting, public transportation, hospitals, and department stores.

One might best cap off this story of a century of New England's industry with a tribute to Alexander Graham Bell (1847–1922). Born in Scotland, he emigrated to Canada and then Boston. There, on March 10, 1876, he sent the first telephone message to his assistant, Thomas A. Watson: "Mr. Watson, come here; I want you." In short order, he established the Bell Telephone Company, researched ways to teach the deaf to speak, improved Edison's phonograph, founded the journal Science, and ran the National Geographic Society. In his person and work, Bell personified both nineteenth century New England's old-time Yankee ingenuity and its openness to new immigrants and enterprise.

Above: *An 1850 photo of a freight depot in Bridgeport, Connecticut.*

Overleaf: *New England's maritime heritage, which began booming when ports became international centers of commerce in the early 1800s, was celebrated by Boston's Tall Ships Regatta in 2000. Among the tallest, proudest—and short-lived—vessels were the famous Yankee Clippers.*

SHAPING
THE
MODERN WORLD

Lobstering in South Freeport, Maine. Harvesters routinely rise between 3:30 and 4:30 a.m. before sea breezes kick up, ride out to color-coded buoys, and haul hundreds of traps until dusk. Maine lobstering took off as a successful business during the first half of the twentieth century.

New England entered the twentieth century removed from many of the nation's struggles: battles between labor and management in big industries, trust busting, conservationists vs. Western interests, land disputes with Mexico. As a result, a certain smugness accompanied the region's confidence and prosperity. Before the century had reached midpoint, however, this smugness would be sorely tested and New England would emerge as quite a different region.

Visible proof was apparent in the arts in the early 1900s. In fairness, wealthy families like the Peabodys, Eliots, and Forbeses invested parts of their fortunes on bettering local culture. They just weren't very innovative. Architectural styles did not change. The work of Daniel Chester French epitomized the cultural establishment. Born in Exeter, New Hampshire, and brought up in Cambridge and Concord, Massachusetts, he was known for lofty historical works like the statue of "The Seated Lincoln" at Washington's Lincoln Memorial and the "Minute Man," a tribute to the Battle of Concord. It was agreeable work—"good sculpture which the people could love," wrote fellow sculptor Lorado Taft—with its back to the future.

But French might as well have been on the cutting edge. For the most part, the Boston art scene relied on its reputation and viewed innovation with suspicion. A notable exception was Isabella Stewart Gardner, who founded her own museum in Boston, a neo-Venetian palazzo that she opened in 1903. "Mrs. Jack"—so named for her marriage to John Lowell Gardner—was a grand dame known to horrify Brahmin Boston by parading two lions down Beacon Street. In addition to assembling an eclectic collection in the four-story, glass-roofed courtyard that became her museum, she was the major American sponsor of painter John Singer Sargent.

Meanwhile, there were acute strains between the old Yankees and the new immigrants who worked for them. By 1907, about 70 percent of Massachusetts citizens were from foreign countries. They refused to accept the treatment they'd been getting from the native-born, especially during the 1850s, when the racist Know-Nothing Party owned the governorships of Massachusetts, Rhode Island, New Hampshire, and Connecticut. Immigrant-bashing Republican boss Charles Brayton ran Rhode Island so cunningly that journalist Lincoln Steffens commented that the state was "for sale and cheap."

Immigrants fought back at the ballot box and on the picket line. The first non-English immigrants to arrive in great numbers, the Irish led the pack. Refugees from the potato famine, they first traded Old World misery for backbreaking construction work and life as domestics. Municipal service, with its entry into politics, drove them upward. Unfortunately, when they assumed power, they could be as guilty of corruption and cronyism as their tormenters. James Michael Curley, five-time mayor of Boston and one-term governor of Massachusetts, provided jobs for Irish immigrants, but in return for kickbacks and votes. The battle lines, to be sure, were sharply drawn. Newspaper employment sections commonly carried the acronym N.I.N.A. It stood for "No Irish Need Apply." Curley acidly described his Yankee opponents as people who "got rich selling opium to the Chinese, rum to the Indians, or trading in slaves."

After a 12.5 percent wage cut, the overwhelmingly Portuguese textile workers in Fall River, Massachusetts, went on strike in July 1904. Every mill closed, and twenty-three thousand workers languished without pay until returning to work the following January—minus 12.5 percent of their future wages. The 1912 "Bread and Roses" strike at the American Woolen Company based in Lawrence, Massachusetts, showcased the emerging importance of women in the labor force. On January 12, after the company used a state law reducing working hours as an excuse for a pay cut, Polish women led some ten thousand workers of forty different nationalities to the picket lines.

Unskilled workers in a company town where women and children under eighteen comprised most of the work force, ignored by the male-dominated American Federation of Labor and its affiliates, the strikers had the odds stacked against them. Nonetheless, they shut down virtually all production in Lawrence and won their four major demands by March 1912. The strike was notable for its gains in dignity as well as wages and benefits. That so many immigrants from so many cultures, led by women, could unite so successfully, was stirring indeed. The strike's catchy title didn't hurt. In the words of a national union organizer, Rose Schneiderman, "Women need bread, but

Above: The Industrial Workers of the World's (IWW) "Big Bill" Haywood (tall man in suit looking to his right) led a 1912 strike in Lowell, Massachusetts. Trained as a miner, Haywood was accused of murdering the antilabor former governor of Idaho and successfully defended by Clarence Darrow.

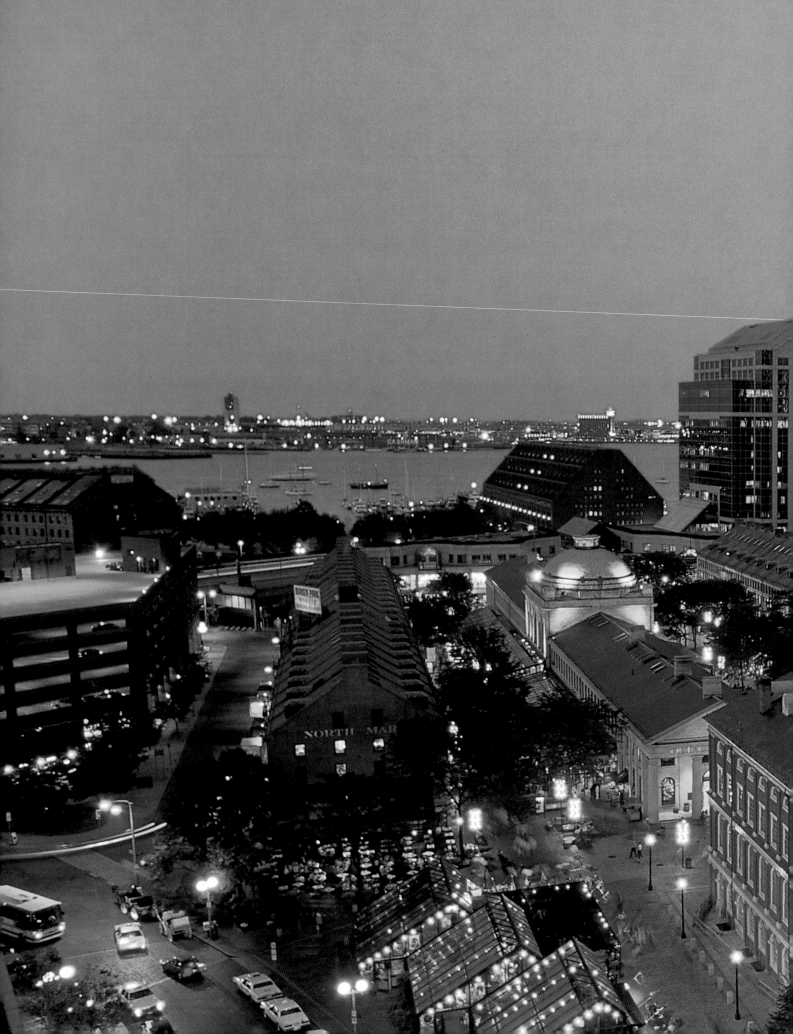

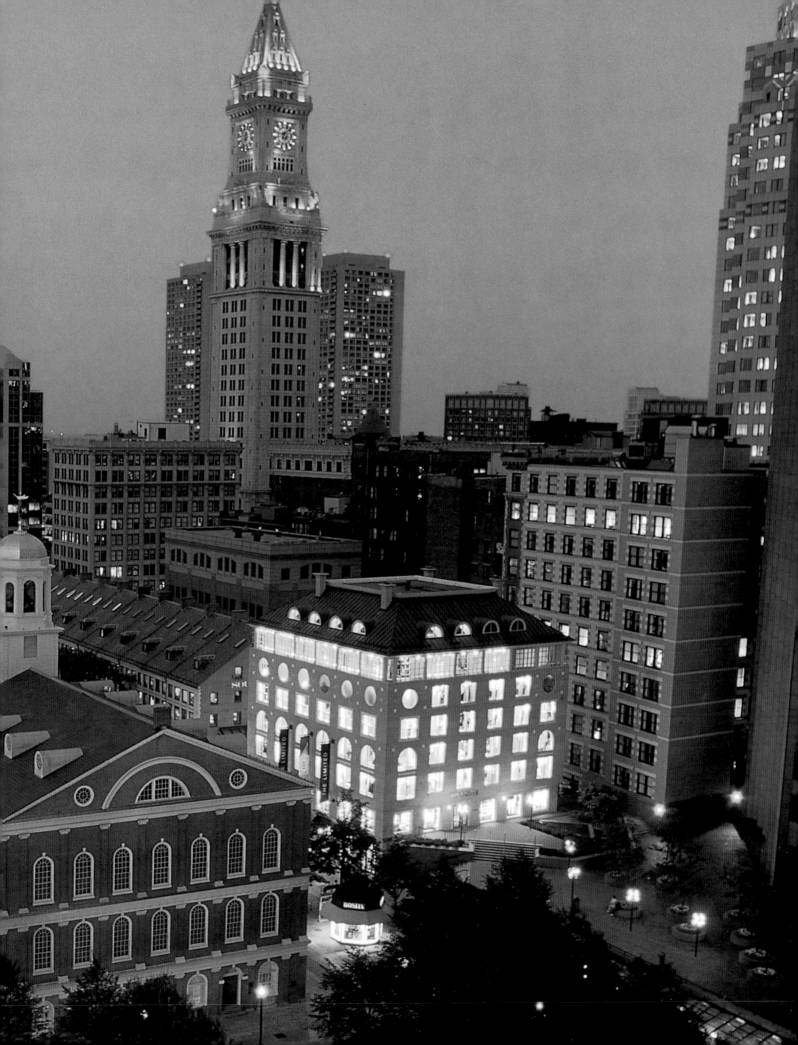

some time. The United States Coast Guard Academy opened in New London, Connecticut, in 1910; a submarine base opened at nearby Groton in 1917; the Portsmouth, New Hampshire, Navy Yard supplied ships throughout the conflict. The first National Guard unit sent to France was from Massachusetts. Just as quickly as New England could be on-again, it was off-again. Massachusetts Senator Henry Cabot Lodge, an eminent political science professor, champion of civil service reform and the Panama Canal, is now usually remembered for his opposition to the peace treaty ending the war and its linkage to the United States entering the League of Nations. As a result, New England, the most international of American regions, figured prominently in the isolationism that laid the groundwork for World War II.

As New England turned inward, it also revealed an unfavorable side. The old conflicts between native-born and immigrant resurfaced with the Sacco and Vanzetti case of 1920–7. On April 15, 1920, two men were gunned down while transporting a $16,000 payroll from the office of the Slater and Morrill shoe company in South Braintree, Massachusetts. Authorities quickly arrested Italian immigrant anarchists Nicola Sacco, a shoe-factory worker, and Bartolomeo Vanzetti, a fish peddler. They were convicted in 1921, and the six-year appeal process before their 1927 executions included a worldwide protest by liberals and radicals who contended that the defendants were punished not for being criminals but immigrants, anarchists, and draft dodgers. Countless articles, books, plays, songs, poems, and novels have been written about the episode. Although there probably can never be

Above: *A booth at the 1917 Connecticut State Fair in Hartford. The state's "Housewives' Army" and many other volunteer organizations sustained U.S. troops during World War I.*

Previous Pages: *The Boston skyline, with Faneuil Hall in the foreground. Today a tourist mecca and a symbol of Boston's rebirth, it was erected in 1742 by wealthy merchant Peter Faneuil.*

they also need roses." As if on cue, poet James Oppenheim wrote the poem "Bread and Roses" that became a rallying cry for unionists everywhere. As the first stanza put it:

As we come marching, marching in the beauty of the day,
A million darkened kitchens, a thousand mill lofts gray,
Are touched with all the radiance that a sudden sun discloses,
For the people hear us singing: "Bread and roses! Bread and roses!"

Off-again, on-again in their support of foreign wars, New Englanders backed World War I wholeheartedly. Indeed, it was as if they'd been planning war for

absolute proof, some authorities on the case believe that though Vanzetti was innocent, Sacco may have been guilty.

The Sacco and Vanzetti case coincided with a "Red scare" sweeping across the country. The Palmer raids of 1919–21—named after U.S. Attorney General A. Mitchell Palmer—targeted aliens and radicals. It was not long before New England was caught up in the scare. In January 1920, a salesman named Joseph Yenowsky was arrested for allegedly saying of Lenin, "He is the most brainy man on earth" in an argument with one Herbert Warner at a clothing store in Waterbury, Connecticut. Though eyewitnesses disputed the words and a corroborating witness could not be found for Warner, Yenowsky was sentenced to six months under the Connecticut Sedition Act. The act in its entirety reads: "No person shall in public, or before any assemblage of ten or more persons, advocate in any language any measure, doctrine, proposal, or propaganda intended to injuriously affect the Government of the United States or the State of Connecticut." Who is to say what is "injurious"? The authorities had broad rein.

When Brahmins and Irish Catholics worked harmoniously, the results could be disastrous. Led by Cardinal William Cardinal O'Connell, bluenoses and blue stockings alike banned books like *An American Tragedy* (1925) by Theodore Dreiser and *The Sun Also Rises* (1926) by Ernest Hemingway. The phrase "Banned in Boston" was a mark of pride to these moralists, who were active on other fronts as well. As late as 1959, a Massachusetts obscenity law was changed from a misdemeanor to a felony, allowing police to seek out and prosecute "pornographers."

Like the rest of the country, New England superficially went along with Prohibition (1919–33), the unfortunate social experiment that attempted to ban alcohol. Other places found ways around it—including bathtub gin and "speakeasies" in New York City and moonshine whisky in Appalachia. New England had its leaky border with Canada. Highgate, in northwest Vermont, had long been a haven for smugglers. During Prohibition, it accommodated bootleggers who drove whole motorcades into town. Maine's bars and restaurants benefited from the "Bangor Plan," which enabled bar managers to pay a fine twice a year and go ignored by authorities the rest of the time. Carry Nation, the famous ax-wielding teetotaler, considered Captain Horace Crockett Chapman, manager of the Bangor House, the leading rum-runner in the United States.

Below: Boston women collecting peach pits during World War I. Two hundred pounds of pits were needed to produce the activated charcoal used as filters in these early gas masks.

Above and opposite:
The crate of apples above and the garden and former home of Celia Thaxter on Appledore Island, New Hampshire (opposite), represent the two aspects of New Englanders' appreciation of the land—the practical and the aesthetic.

The era was not without accomplishment. In 1926, Robert Goddard launched the first liquid-fuel rocket in Worcester, Massachusetts. And New England got its first president since John Quincy Adams in Calvin Coolidge, who was born in Vermont, became governor of Massachusetts, and served as president in 1923–9. Gaining national prominence as governor when he used the militia to crush a Boston police strike, Coolidge was a taciturn, hands-off president whose most famous comment was: "The business of America is business."

After the stock market crashed in 1929, New England was swept into the Great Depression with the rest of the country. The six states didn't suffer from the most extreme side-effects like the Oklahoma dustbowl, but they were depressing places. Mills, shipyards, and factories closed down, while food lines and

parades of unemployed men wound around blocks. Even the well-heeled were affected. According to a magazine article, Boston's old guard dined "annually upon champagne and terrapin in the memory of a crushed world."

With the 1935 closing of Amoskeag Mills, New Hampshire hit rock bottom. Fortunately, that wasn't as low as other states went, because the Granite State was governed by John Gilbert Winant. Under his stewardship, New Hampshire passed laws to protect dependent women and children, spare municipalities from bankruptcy, reorganize the banking commission, and upgrade accounting practices at state agencies. Working closely with Democratic President Franklin Delano Roosevelt, the Republican Winant was the first governor to fill the enrollment quota for the Civilian Conservation Corps (CCC). This remarkable man later served

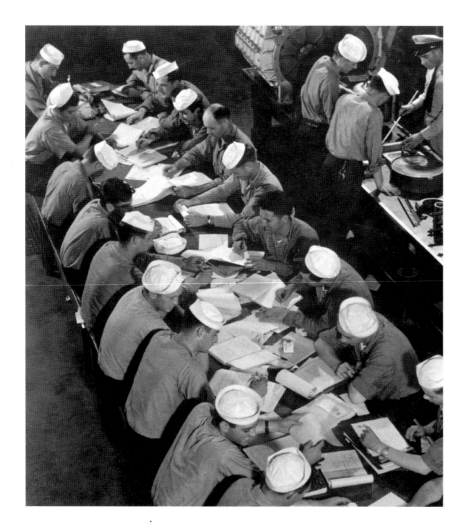

Above: *Students in a diesel lab at the submarine training school in New London, Connecticut, in August 1943. Despite their historical ambivalence about war, New Englanders mobilized immediately after Pearl Harbor.*

Roosevelt in a variety of posts, including director of the social security administration and ambassador to Great Britain.

New Hampshire was not the only New England state to benefit from Roosevelt's New Deal. Among the 250,000 unemployed men given work in CCC forest camps by July 1, 1933, some 8,000 war veterans from eight eastern states converged on Vermont for flood-control labor. (Vermont had experienced a devastating storm flood November 2–4, 1927, which claimed fifty-five lives.) The Works Progress Administration (WPA) was even more visible, with bridges, highways, schools, and post offices to its credit. Roosevelt evidently believed in roses as well as bread: the WPA paid artists to paint

murals in new government buildings all over New England. One such, the Norwalk, Connecticut, collection of murals and panels, comprised one of the largest Depression-era arts projects in America; covering birds, mammals, and other local scenes, the display still resides at Norwalk High School.

While Roosevelt was providing jobs, his labor secretary, Boston's Frances Perkins, promoted economic security. The first woman appointed to a cabinet, she wrote minimum wage legislation and chaired the President's Committee on Economic Security that pioneered the Social Security Act of 1935. Historian Arthur Schlesinger, Jr., described Perkins: "Brisk and articulate, with vivid dark eyes, a broad forehead and a pointed chin, usually wearing a felt tricorn hat, she remained a Brahmin reformer, proud of her New England background…and intent on beating sense into the heads of those foolish people who resisted progress. She had pungency of character, a dry wit, an inner gaiety, an instinct for practicality, a profound vein of religious feeling, and a compulsion to instruct."

In fall 1938, the Great New England Hurricane devastated southern New England, killing 564 people and destroying 8,900 homes and 2,605 vessels. The Blue Hill Laboratory outside Boston reported sustained winds of 121 miles per hour, with a peak gust of 186 mph. Hardest pounded was Rhode Island's Narragansett Bay, where 15-foot tidal surges wrecked virtually every house, marina, and yacht club.

A different storm was building up in Europe. When World War II hit, New Englanders, among the closest Americans to the overseas conflict,

reacted quickly. They volunteered to watch night skies for German planes, conducted air-raid drills in schools, endured blackouts at night, collected scrap metal, and grew Victory Gardens. Gardens provided the most palpable way ordinary citizens could contribute to the war effort. Nearly 20 million Americans planted their own vegetables to ensure enough food for themselves and troops. It was a pick-up-the-babies-and-grab-the-old-ladies operation, with everyone from oldsters to kids, and every organization from government agencies to seed companies pitching in. Growing produce in window boxes, private plots, and community gardens, citizens accumulated what they needed and canned the rest for winter. Money-saving gardens freed the government to feed military personnel overseas.

Maine factories produced shoes and uniforms for troops. Connecticut turned out submarines, airplane engines, shell cases, and other vital ordnance. Shipyards in Bath, Maine (the nation's fifth largest seaport), Portland, Maine, Quincy, Massachusetts, and Portsmouth, New

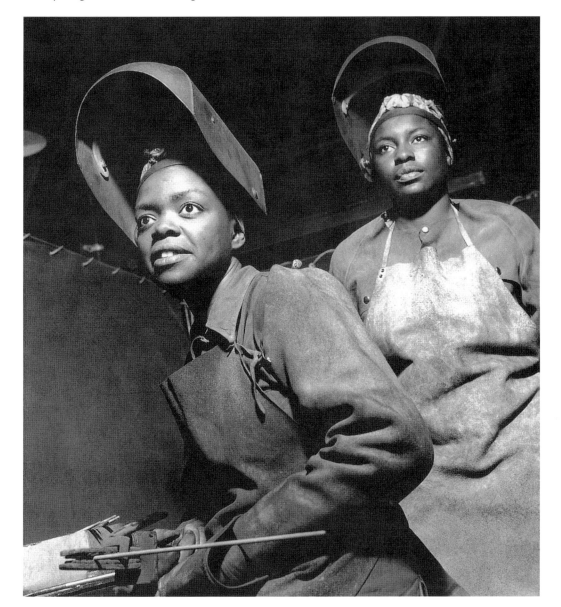

Left: A famous Gordon Parks photograph of women welders in New Britain, Connecticut, in June 1943. Collectively known as "Rosie the Riveter," women ably filled in for men during the war, only to be told they were best suited for homemaking in its aftermath.

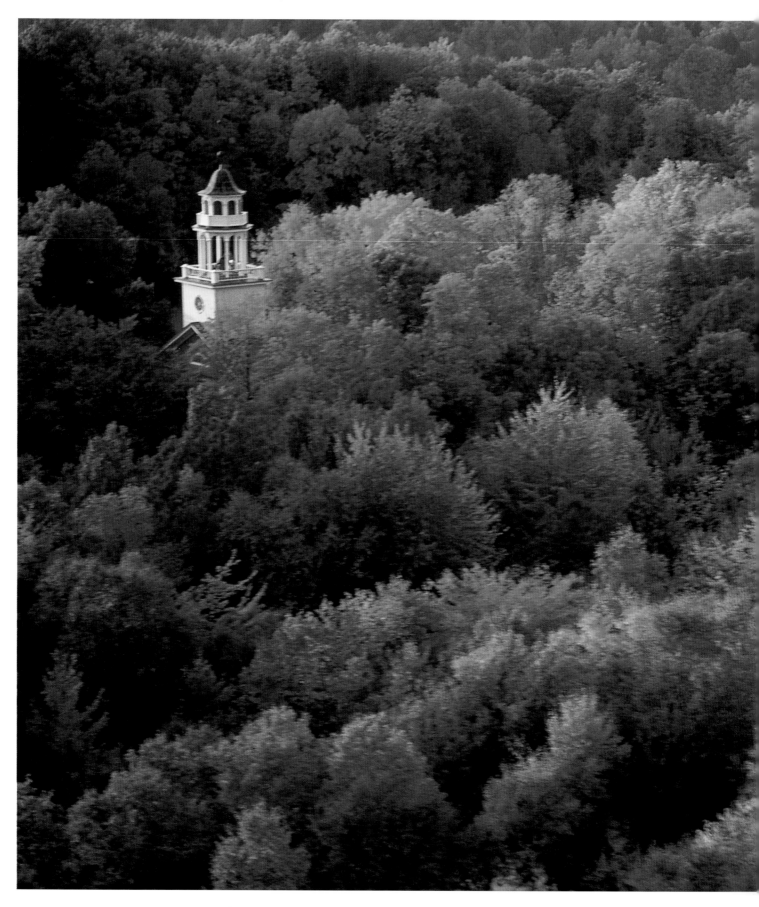

Left: *Fall colors surrounding a white church in Wethersfield, Vermont. Humorously called "leaf-peepers," people from all over the United States— indeed, the world— flock to New England to enjoy this annual autumn spectacle.*

built and used from North Africa to the Aleutian Islands. In a final New England contribution to the war effort, the United Nations Monetary and Financial Conference (July 1–22, 1944) was held in Bretton Woods, New Hampshire. The Bretton Woods Conference, as it is more commonly called, led to creation of the International Monetary Fund and the International Bank for Reconstruction and Development.

After the war, New England boomed. Returning veterans educated under the G.I. Bill Of Rights swamped the college system. Many of them were determined to leave their old homes in cramped urban neighborhoods, and a tremendous building boom in the suburbs serviced them. With suburban homes came highways, most notably Route 128 ringing Boston and the Massachusetts Turnpike that opened in 1957. If veterans didn't already have families, they wished to start them promptly. The result: the "baby boom" that began to reach middle age in the 1990s.

Many suburban homes were prefabricated and undistinguished. The new architectural style for people who could afford it was the so-called International Style—glass-and-steel or plain cement. Most famous of the new buildings was Philip Johnson's Glass House (1949) in New Canaan, Connecticut. Considered one of the most beautiful and least functional homes in America, the Glass House was a symmetrical, one-floor statement with brick floors and walnut cabinet room dividers. You didn't have to live in it to admire it. In fact, said many, you wouldn't want to live in it.

The general prosperity was not shared by all. Rhode Island remained in a depression until the 1950s. With hourly

Above: *Italian-Americans celebrating Japan's surrender on August 14, 1945. Italians immigrated to New England in large numbers starting at the end of the 1800s and proved to be proud, hardworking members of the New England community.*

Hampshire, worked overtime to manufacture warships and merchant ships. Troops were trained in college ROTC classes—Smith College in Northampton, Massachusetts, became a WAVES headquarters—and were stationed at Massachusetts' Fort Edwards, Camp Devers, and other locations throughout New England. The U.S. Naval Station in Quonset Point, Rhode Island, produced wartime housing called "Quonset Huts." Resembling Iroquois council lodges, some 170,000 of these cheap, portable, steel-and-sheet-metal structures were

wages ranging from 16 to 60 percent higher than in the South, mill owners and manufacturers began moving their remaining operations below the Mason-Dixon Line and eventually overseas. The sight of abandoned factories and mills now rivaled the unforgettable tableau of the abandoned farm late in the nineteenth century.

Ever resourceful, New Englanders turned to other occupations. Happily, the expanding defense industries provided new jobs. The first nuclear-power submarine was launched at Groton, Connecticut, in 1954, and five years later the first nuclear-power submarine slid out of the chute in the Boston suburb of Quincy. Maine's Bath Iron Works continued generating Navy ships. The Raytheon Company in Cambridge, Massachusetts, produced microwave ovens and guided missiles. If textiles, shoes, and furniture no longer bolstered the economy, burgeoning universities (not to mention secular and religious colleges, junior colleges, professional and vocational schools), high-tech and electronic industries and world-class hospitals would fill the gap. Boston became one of the country's major investment centers.

Among the industries that took off was tourism. Many of the sites—Old Sturbridge Village, Sherburne Museum, Plimouth Plantation (which re-created the conditions of the earliest settlers), and the Freedom Trail, all in Massachusetts—are well known. Less appreciated were treasures like the Wedding Cake House in Kennebunk, Maine. Supposedly built by a sea captain who had to ship out shortly after his wedding and failed to give his bride a cake, the 1826 house and its carved wooden scrollwork are still on display.

Down the coast, Portland became a cultural center after repealing a Puritan statute stating that plays "have a pernicious influence on the minds of young people and greatly endanger their morals by giving them a taste for intrigue, amusement and pleasure." Skiing, which had started in New Hampshire during the previous century, boomed all over northern New England. In the autumn, "leaf-peepers" descended on New England to view the vivid foliage. And cultural festivals, such as the Boston Symphony Orchestra's summer concerts at Tanglewood in the Berkshires, began to become a major summer attraction.

In the end, New Englanders were again working together. There were successive Italian-American governors—the Democrat Foster Furcolo succeeded by the Republican John Volpe. The new partnership between white-collar Irish and the establishment produced the "Green Brahmins"—or Irish aristocracy. New England entered its modern progressive age when Massachusetts Senator John Fitzgerald Kennedy was elected president in 1960. The great-grandson of immigrants who fled the Irish potato famine of the 1840s, the youthful, popular politician represented in the national imagination the culmination of the Irish-American dream—and as such, of the American Dream.

"The evolutionary process by which John F. Kennedy arrived in the White House was the same as that by which older settlers of English origin, like the Adamses, Cabots, Lodges and Saltonstalls, had reached their place in American life," wrote the historian Walter Muir Whitehill. Was this not the ultimate tribute to New England?

Overleaf: *Block Island, just off the coast of Rhode Island. Like many New England locales, it boomed as a tourist spot after World War II. The island's bluffs, beaches, ponds, and hills attract visitors from all over the world.*

MAINE

THE NORTH

Saint John Valley

Territory settled by the French during the 1600s and Acadians in the 1780s, where a mixture of Old French, Quebecois, and English is spoken; Maine Acadian culture is kept alive here through historical societies, clubs, and museums; activities include boating, dogmushing, fishing, and snowmobiling

Allagash Wilderness Waterway

A 92-mile-long protected stretch of lake, shore, and river corridor, through conifer forests and ridges of northern hardwoods; offers a range of boating activities

Aroostook State Park

Gives access to the North Maine Woods, the Allagash Wilderness Waterway, and New Brunswick and Quebec; encompasses Quaggy Jo Mountain and Echo Lake; offers camping, cross-country skiing, and snowmobile trails

Baxter State Park

Wilderness area of 202,064 acres that includes Maine's highest point, the 5,268-foot Mount Katahdin; starting point for the 2,000-mile *Appalachian National Scenic Trail,* which traverses 13 states to Springer Mountain, Georgia

Silver Lake

Katahdin Iron Works: built in 1843, once a thriving industrial community; remains include a brick oven and the blast furnace tower

Greenville

Moosehead Lake: offers tours on *Katahdin,* a restored 1914 steamboat and marine museum

THE SOUTH

Kingfield

Stanley Museum: housed in the 1903 Georgian-style Stanley School, birthplace of Francis and Freelan Stanley; displays their inventions of the steam-powered car and the dry plate photographic process, and period photographs

Sugarloaf

Primarily a ski resort; other activities include guided mountain bike tours and moose-watching

Orono

Hudson Museum: contains over 8,000 archaeological artifacts from a wide range of Native American cultures

Bangor

Main Street: famous 31-foot-tall statue of Paul Bunyan, given to the city on its 125th anniversary in 1959

Augusta

Maine State Museum: features artifacts and displays of the state's landscape and industrial past

THE COAST

Passamaquoddy Bay

Saint Croix Island International Historic Site: one of the earliest European settlements on the North Atlantic coast (est. 1604) and the first attempt by the French at year-round colonization in Acadia; interpretive center and estuary with birdwatching and boating

Lubec

The Roosevelt Campobello International Park: 2,800-acre park established in 1964 as a memorial to the relationship between the United States and Canada; offers extensive gardens, ocean views, scenic drives, hiking trails, and camping; includes President Franklin D. Roosevelt's vacation cottage with period rooms, personal artifacts, and guided tours

West Quoddy Head

The easternmost point of the U.S., with a bridge to Campobello Island in Canada; attractions include an 1808 striped lighthouse with visitor center and the 1830 settlement of Bailey's Mistake, named for a sea captain who beached his lumber vessel here, and settled with his crew, building homes from the ship's cargo

Machias

Burnham Tavern: where the first naval attack of the Revolutionary War was planned in 1775; the oldest standing building in eastern Maine (built in 1770)

Mount Desert Island

Acadia National Park: encompasses 47,633 acres of diverse habitats with spectacular views; offers walking, hiking, biking, and other seasonal outdoor activities; ranger-led programs include bird and nature walks, boat cruises, slide programs, mountain hikes, and stargazing; several visitor centers

Isleford Historical Museum: tells the story of the Cranberry Isles and their people

Mount Cadillac: the highest point along the North Atlantic seaboard

Bar Harbor: one-time resort and summer home to the Vanderbilts and Astors; now offers sea trips, cruises, and whale-watching expeditions; includes the **Robert Abbe Museum**, with its vast collection of Native American artifacts

Belfast

Waterfront historic district: contains the old-fashioned Greyhound and Western Union office and a number of whitewashed Greek-Revival houses

Old railroad station: of the Belfast and Moosehead Lake Railroad; offers excursions in reconditioned Pullman cars along an 1870 track by the Passagassawakeag River

Camden

Camden Hills State Park: contains a tower that gives one of the best views of the Maine coastline; offers coastal camping and sailing expeditions

Thomaston

Thomaston Historical Society and Museum: exhibits on the Revolutionary War, local shipbuilding, and local history

St. George Peninsula

Port Clyde: offers boat trips to the tiny **Monhegan Island**, where stunning cliffs and isolated coves have attracted artists such as Edward Hopper for years; wilderness hiking trails lead past a beautiful 1824 lighthouse

Boothbay Harbor

Boothbay Railway Village: operates a narrow-gauge coal fired steam train in a re-created historic town

Wiscasset

Castle Tucker Museum: Federal-style mansion built in 1807 on a hill overlooking the Sheepscot River; preserved much as it was in the late nineteenth century

Bath

Maine Maritime Museum: offers tours around a shipyard where wooden schooners are built by traditional techniques, narrated excursions along the harbor, and exhibits of maritime artifacts

Brunswick

Peary-Macmillan Arctic Museum: expedition equipment and notebooks of Admiral Robert Peary, who is considered to be the first man to have reached the North Pole, in 1909

Harriet Beecher Stowe House: now an inn, once home to the author of *Uncle Tom's Cabin*

Joshua L. Chamberlain Museum: former house of the Civil War hero, Maine governor, and president of Bowdoin College

Skolfield-Whittier House: 17-roomed home, built 1925; preserved with original features

Pejepscot Museum: archive with over 15,000 local photographs

Bailey Island

Lobster Village: pretty, historic community that has made a living farming lobster for over 200 years

Portland

Wadsworth-Longfellow House: first brick house in Portland, built by Henry Longfellow's grandfather in 1785–6, and subsequently the poet's childhood home; memorabilia of Maine history

Portland Museum of Art: housed in an innovative structure, designed by I.M. Pei & Partners in 1983; highlights include Winslow Homer engravings and Andrew Wyeth paintings

Victoria Mansion/Morse-Libby House: built 1858–60, claimed to be the finest surviving Italian villa–style house in America

Maine Narrow Gauge Railroad & Museum: displays old railroad equipment and offers rides on an original Maine narrow-gauge train along Casco Bay

Portland Harbor Museum: offers maritime artifact exhibits, tours of a nineteenth century fort, and great views of Casco Bay; also includes the **Spring Point Ledge Lighthouse**

Portland Observatory: 86-foot-high signal tower constructed in 1807 to tell local businessmen when their ships were coming in; the last remaining in the United States

Kennebunkport

The Seashore Trolley Museum: the world's oldest and largest electric railway museum; over 250 trolleys and transit cars

Ogunquit

Small village offering views of beautiful white beaches and rocky coastline; three-mile beach, considered to be the state's finest

York

Old Gaol: served as such in the seventeenth century, now a museum of its history and of local Native Americans

MASSACHUSETTS, CONNECTICUT, AND RHODE ISLAND

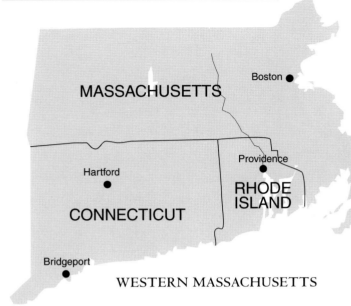

WESTERN MASSACHUSETTS

The Berkshire Hills

Mohawk Trail: passes through North Adams and Williamston, following the scenic route traveled by Native Americans between the Connecticut and Hudson River valleys

Appalachian National Scenic Trail

see Baxter State Park, Maine

Hancock Shaker Village

An outdoor history museum concerning the life of the Shaker community that lived here from 1783 to 1960; contains buildings, a working farm, and gardens that interpret Shaker life

Stockbridge

Norman Rockwell Museum: collection of Norman Rockwell's *Saturday Evening Post* covers

Mission House: built by the Reverend John Sergeant in 1739; period furnishings and a colonial garden

Chesterwood: luxurious 1920s summer home and studio of Daniel Chester French, sculptor of the Lincoln Memorial

Naumkeag: 26-room mansion, designed by Stanford White in 1885; summer home of Joseph Choate, U.S. ambassador to Queen Victoria; displays porcelain, furniture, rugs, and tapestries; set in elegant gardens designed by Fletcher Steele

Springfield

Springfield Armory National Historic Site: preserves the history of the first National Armory, 1794–1968, and encompasses several buildings of the original armory complex; includes the Arsenal Building, constructed in the 1840s, now a museum with an extensive and unique firearms collections

CENTRAL MASSACHUSETTS

Old Sturbridge Village

Outdoor history museum, made up of more than 40 restored and reconstructed buildings brought from all over the region; re-creates a rural New England town of the 1830s with costumed interpreters demonstrating period craft and industry

Blackstone River Valley National Heritage Corridor

Nearly 400,000 acres of landscape significant during the Industrial Revolution, where American craftsmen built the first machines that successfully used waterpower to spin cotton (1790); stretches from Worcester, Massachusetts to Providence, Rhode Island

Worcester

Higgins Armory Museum: housed in a striking steel and glass Art Deco structure with a vaulted Medieval Great Hall; an eclectic collection of weapons and armor representing a range of historical, cultural and technological periods all over the world

BOSTON AND EASTERN MASSACHUSETTS

Lowell

Lowell National Historical Park: contains the **Boott Cotton Mills Museum**, with its operational 1920s weave room of 88 power looms, **"mill girl" boardinghouses**, the **Suffolk Mill Turbine Exhibit**; and interactive workshops and guided tours

Cambridge

Cambridge Common: first used as a cow pasture by Cambridge's earliest settlers; contains Watertown Path, the Redcoats' retreat route during the Revolutionary War; a monument to Lincoln and Civil War dead; the Washington Elm, under which it's alleged, George Washington took command of the Continental Army

Dawes Park: named for patriot William Dawes, who rode to alert residents that the British were marching on Lexington and Concord on April 19, 1775

Harvard Houses: historic upperclassmen's residences; include tunnels decorated with the graffiti of past residents in **St. Adams House**; the blue-topped bell tower of **Lowell House**, with one of Harvard's most beautiful courtyards; the purple spire of **Eliot House**; and **Dunster House**, with its red Georgian tower top

Arthur M. Sackler Museum: features excellent collections of ancient Asian art and classical work such as the coins of Alexander the Great and seals from ancient Babylonia

Botanical Museum: flower models constructed of glass

Busch-Reisinger Museum: concentrates exclusively on the German Expressionists and the work of the Bauhaus

Harvard Semitic Museum: displays of artifacts chronicling Harvard's century-old excavations in the Near East

Peabody Museum of Archeology and Ethnology: displays on the history, art, traditions, and lifestyles of native peoples from around the world; materials from Harvard's anthropological and archeological expeditions, including Mesoamerica

William Hayes Fogg Art Museum: exhibits works from renowned artists around the world, from Medieval times

Harvard Yard: created in 1636 as a grazing field for university livestock; includes the John Harvard statue; Hollis Hall (1762); Matthews Hall (c.1862); Memorial Church; Harvard's Science Center; Harvard Law School; Memorial Hall, commemorating Harvard students who died in the Civil War; Carpenter Center, the only building in America designed by Le Corbusier; and the Widener Library, the largest private library collection in the U.S., including a first folio of Shakespeare and a Gutenberg Bible

Massachusetts Institute of Technology: one of the world's premier science and research institutions; features some interesting architecture, including Eero Saarinen and I. M. Pei; and an excellent museum

Old Burying-Ground: one of Cambridge's first cemeteries; occupants include several of Harvard's first presidents as well as two black veterans of the Revolutionary War, Cato Stedman and Neptune Frost

Brattle Street: contains mansions once used as the quarters of the Continental Army

Farwell Street: has several modest Federal-style houses dating to the early nineteenth century

Dexter Pratt House: home of the village blacksmith celebrated by Longfellow in a popular poem

Hooper-Lee-Nichols House: one of the oldest residences in Cambridge, a 1685 farmhouse, remodeled in 1742

Longfellow National Historic Site: erected in 1759, home of Henry Wadsworth Longfellow from 1837–82, with original furnishings from this time; also where General George Washington headquartered and planned the Siege of Boston from 1775–6; exhibits include American and European decorative and fine arts; Longfellow's personal library; and approximately 700,000 archived items, including many letters

Gloucester

Founded in 1623, the oldest fishing and trading port in Massachusetts; has the *Hammond Castle Museum*, which holds a collection of medieval European relics, including the partially crushed skull of one of Columbus's shipmates

Minute Man National Historical Park

Preserves and protects historic structures, properties and landscapes in Concord, Lincoln, and Lexington associated with the opening battles of the American Revolution on April 19, 1775; visitor center offers an acclaimed short film on the events

of that day; park consists of more than 900 acres of land which sit alongside original segments of the Battle Road; also preserves *The Wayside Home of Authors*, a more than 300-year-old yellow wooden house and home of Nathaniel Hawthorne, Louisa May Alcott, and Margaret Sidney; the *Hartwell Tavern*, with costumed guides; musket firing demonstrations

Concord

Colonial Inn: an old hostelry with traditional dining room and tavern that served as a wartime Revolutionary hospital

Old Manse: built for the Reverend William Emerson, in 1770; occasional home of Ralph Waldo Emerson where, in 1834, he penned the transcendentalist book *Nature*; contains period furnishings and a small study where Nathaniel Hawthorne, an 1840s resident, wrote *Mosses from an Old Manse*

The Wayside: see Minute Man National Historical Park, *above*

Concord Museum: founded 1886; contains numerous examples of seventeenth- to nineteenth-century decorative arts, all originally owned in Concord; features the lantern hung in the Old North Church steeple on the night of Paul Revere's ride, American Revolution artifacts, collection of Thoreau possessions, and the contents of Ralph Waldo Emerson's study

Sleepy Hollow Cemetery: holds the graves of Concord literati Emerson, Hawthorne, Thoreau, and Louisa May Alcott

North Bridge: site of the first effective armed resistance to the British; a 1954 replica of another replica of the original structure

Lexington

Battle Green: the town common featuring Henry Kitson's famous statue of *The Minute Man*, the musket-bearing figure of Captain John Parker standing on boulders taken out of the walls from where the colonial militia fired at the British on April 19, 1775

Buckman Tavern: preserves a British bullet hole from the battle in an inner door

Hancock-Clarke House: where Samuel Adams and John Hancock were sleeping when woken by Paul Revere; displays the drum on which William Diamond beat the signal for the Minute Men to converge, and the pistols that British Major John Pitcairn lost on his retreat

Rockport

Bearskin Neck: main street, lined with old saltbox fishermen's cottages; picturesque views

Paper House: eccentric project, begun in 1922; the entire contents are made of paper, including all furniture, even a piano

Salem

Salem Maritime National Historic Site: consists of twelve historic structures along the waterfront; shows the development of colonial-era trade; the role of privateering during the Revolutionary War, and the international maritime trade

New England Pirate Museum: re-created dockside village, pirate ship, and bat cave, displaying pirate history

House of the Seven Gables: inspiration for Nathaniel Hawthorne's famed novel; a 1688, three-story mansion by the sea with lovely gardens and a wishing well; grounds feature a complex of early houses including the author's birthplace

Peabody Essex Museum: the oldest continuously operating museum in the U.S., founded by ship captains in 1799 to exhibit their exotic items obtained while overseas; galleries display a major international collection of art and artifacts and the biggest collection of nautical paintings in the world; court documents from the Salem Witch Trials

Derby House: Georgian Colonial house built c.1762 for Elias Hasket Derby, America's first millionaire; oldest brick house in Salem

Salem Witch Museum: sound-and-light depictions of the events of 1692, housed in a one-time Romanesque church

Witch Dungeon Museum: site of imprisonment of the accused witches; re-created dungeon features reenactments including the trial of Sarah Good, based on transcripts

Witch Memorial: a series of stone blocks etched with the names of the hanged, set in *Old Burying Point Cemetery*

Walden Pond

Preserved site where Henry David Thoreau lived and worked in 1845–7, keeping a journal of his thoughts and encounters with nature and society, subsequently published in *Walden*; features his reconstructed log cabin

Marblehead

Settled in 1629, one of the most scenic ports in New England; contains remnants of the British *Fort Sewall* (1644); *Old Burial Hill*, with the graves of more than 600 Revolutionary War soldiers; and *Abbot Hall*, the 1876 town hall that houses Archibald Willard's famous painting *The Spirit of '76*

Saugus

Saugus Iron Works National Historic Site: site of the first integrated ironworks in North America, 1646-68; includes the reconstructed blast furnace, forge, rolling mill, a seventeenth-century house, and working waterwheels

Boston: Back Bay

Gibson House Museum: constructed 1860 for Catherine Hammond Gibson; preserves a horde of Victoriana

Christian Science buildings: world headquarters of the First Church of Christ, Scientist; a 224-foot Renaissance Revival basilica, a large pipe organ, and a Mapparium—a stained-glass globe, constructed in the 1930s of over 600 panels, the 30-foot diameter of which you can cross on a glass bridge

Commonwealth Avenue: 220-foot-wide, tree-lined street, modeled after the boulevards of Paris; contains the 1904 *Baylies Mansion*, with its opulent ballroom; the 1872 *Ames-Webster Mansion*; the 1899 *Burrage House*, a Vanderbilt-style urban palace; and the 1872 *First Baptist Church of Boston*, designed by architect H.H. Richardson

Boston Public Library: built in Italian Renaissance Revival style in 1852; features a marble grand staircase, decorated ceilings, and an open-air central courtyard

John Hancock Tower and Observatory: 62 stories high, designed by I. M. Pei and built in 1976, with an observatory on the 60th floor, giving views as far as New Hampshire

New Old South Church: Italian Gothic structure (1875) with a 220-foot bell tower and copper-roof lantern; interior features fifteenth-century English-style stained-glass windows

Trinity Church: designed by H.H. Richardson in 1877 and deemed a masterpiece of Romanesque Revivalism; has a lovely hidden garden

Arlington Street Church: the first building in the district (1861); Italianesque, with Tiffany stained-glass windows

Church of the Covenant: Gothic Revival structure with a soaring steeple; 30-foot-high Tiffany stained-glass windows

Prudential Tower: has a Skywalk on the 50th floor, offering the only 360-degree aerial view of Boston and beyond to Cape Cod

Public Garden: a 24-acre park, in public use since 1859; has a man-made lagoon with nineteenth-century pedal-powered Swan Boats for hire

Bay Village: one of the oldest sections of Boston, with gaslights and tiny brick houses, many with historic sunken gardens; encompasses a nineteenth-century fortress complete with drawbridge and fake moat, built as a private armory

Beacon Hill: once home to numerous historical and literary figures, including members of the Vanderbilt family, John Hancock, John Quincy Adams, Louisa May Alcott, and Oliver Wendell Holmes; has narrow gaslit streets

Boston African American National Historic Site: contains 15 pre-Civil War structures relating to the history of Boston's nineteenth-century African-American community; includes the *African Meeting House*, the oldest standing African-American church in the United States, restored with a museum; *Underground Railroad exhibits*; and the *Abiel Smith School*, 1834, the first public school for black children in Boston; linked by the 1.6 mile *Black Heritage Trail*

Massachusetts State House: originally designed in 1795 by Charles Bulfinch and built on land donated by John Hancock, its cornerstone was laid by Samuel Adams and the copper of its dome was rolled in Paul Revere's foundry in 1802 (covered with gold leaf in the 1870s); guided tours through halls of statues and murals; features the Hall of Flags, hung with original flags carried by Massachusetts soldiers into battle

Nichols House: another Bulfinch design, 1804, most recently the home of landscape gardener Rose Standish Nichols; antique furnishings, decorations, and fine art

Boston: Charlestown

Bunker Hill Monument: an obelisk with 294 steps winding up the 221-foot granite shaft to the top gives sweeping views of Boston; commemorates the 1775 Battle of Bunker Hill

Deacon John Larkin's House: 1795 wooden house of the man who lent Paul Revere his horse for the ride to Lexington

Warren Tavern: three-story wooden structure built soon after the Battle of Bunker Hill; named for Dr Joseph Warren, personal physician to the Adams (presidential) family

Phipps Street Burying Ground: dates from 1630; holds graves of many Revolutionary soldiers

USS Constitution *("Old Ironsides"):* the oldest commissioned warship afloat in the world; built 1794—7, 300 feet long, and about 90 percent reconstructed; launched two centuries ago and active during the War of 1812; victor in more than 40 battles; U.S. Navy guides show the elaborate rigging, sails, and cannons

Boston: Downtown

Blackstone Block: preserved since the 1650s, a fragment of Boston's original settlement, its street pattern still intact

Boston Athenæum: established 1807, moved here in 1849; designed by Edward Clarke Cabota as a replica of the Palazzo da Porta Festa in Vicenza, Italy; includes books from the private library of George Washington and an array of paintings

Boston Common: established 1634; has contained the **Central Burying Ground** since 1756, which holds the tombs of artist Gilbert Stuart, whose portrait of George Washington appears on the dollar bill; members of the largest family to take part in the Boston Tea Party; soldiers of the Revolutionary Army; and Redcoats killed in the Battle of Bunker Hill

Custom House District: contains such landmarks as the **Custom House Tower**, built in 1847 and surrounded by 32 huge Doric columns, with a 30-story Greek Revival tower added in 1915; Coolidge's 1893 **Grain and Flour Exchange Building**, with a turreted conical roof, encircled by a series of pointed dormers; and several Bulfinch Federal-style mercantile buildings

Faneuil Hall: four-story brick building with Georgian spire; marketplace and meeting hall since 1742; where Samuel Adams and James Otis gained support for independence

Old Granary Burying Ground: the resting place of Benjamin Franklin's parents, and the tombs of James Otis, Samuel Adams, the Boston Massacre victims of 1770, Peter Faneuil, Paul Revere, Judge Samuel Sewall (the only Salem Witch Trial magistrate to admit later that he was wrong), and signatories of the Declaration of Independence John Hancock and Robert Treat Paine

Bell Atlantic Office: a 1947 Art-Deco design, which houses a replica of the Boston attic room where Alexander Graham Bell first transmitted speech sounds over a wire in 1875

King's Chapel Burying Ground: the city's oldest cemetery; holds the graves of prominent Bostonians John Winthrop, the first governor of Massachusetts; Mary Chilton, the first Pilgrim to set foot on Plymouth Rock; and William Dawes, who accompanied Paul Revere to Lexington; the chapel's 1749 belfry boasts the biggest bell ever cast by Paul Revere

Park Street Church: built 1809, with an ornate 217-foot white steeple; started the first Sunday school in the country in 1818; where William Lloyd Garrison delivered his first public address calling for the nationwide abolition of slavery

Omni Parker House: legendary hotel that has hosted world luminaries since 1856; Ho Chi Minh and Malcolm X each used to wait tables in the restaurant

Boston Old City Hall: a grand French Second Empire building built 1865; served as Boston's City Hall until 1969

Boston Latin School: America's first public school, (1635); students included Benjamin Franklin and John Hancock

Boston Massacre site: a cobblestone circle marks the site of the riot between Bostonians and British Redcoats on March 5, 1770

Old Corner Bookstore: built in 1712, and one of Boston's oldest structures; housed the most famous publishing house of the nineteenth century, Ticknor & Fields, which handled the likes of Emerson, Longfellow, Hawthorne, Dickens, and Thackeray

Old South Meeting House: largest building in colonial Boston (1729); site where nearly 7,000 locals gathered on December 16, 1773, to hear that the Crown would impose duty on tea aboard ships in Boston Harbor, triggering the Boston Tea Party; museum with an audio tour reenactment of a Puritan service and the Boston Tea Party debates

Old State House: oldest surviving public building in Boston, built 1713 as government offices of the Massachusetts Bay Colony; now houses the Boston History Museum which contains Revolutionary War artifacts; the building's balcony was where on July 18, 1776, the Declaration of Independence was first read publicly in Boston

Boston Tea Party Ship and Museum: displays range from Colonial history to shipbuilding, the English culture of tea, and knot-tying; tours on a replica of the notorious ship and occasional re-creations of the Tea Party are held

Boston University: includes **Myles Standish Hall**, a small version of the Flatiron Building; **Shelton Hall,** which housed playwright Eugene O'Neill; a High Georgian Revival mansion; **The Castle**, an ivy-covered Tudor mansion; and **Marsh Plaza**, with Gothic Revival chapel and memorial to Martin Luther King Jr.

Boston: Brookline

John F. Kennedy National Historic Site: preserves the 1917 birthplace and boyhood home of John F. Kennedy; also the first home shared by the his father and mother, Joseph P. and Rose Kennedy, who repurchased the birthplace and restored it as a memorial shortly after his assassination in 1963; ranger-led tours of the house and nearby neighborhood including homes, schools, and a church associated with the Kennedy family; displays information on the president's life and family

Frederick Law Olmsted National Historic Site: commemorates the founder of American landscape architecture and the nation's foremost park maker; incorporates the restored "Fairsted," built 1889–1925 as his home and the world's first professional office for the practice of landscape design; contains nearly 1,000,000 original design records detailing work on treasured landscapes including the U.S. Capitol and White House grounds, Great Smoky Mountains and Acadia National Parks, Yosemite Valley, and New York's Central Park

Isabella Stewart Gardner Museum: opened to the public in 1903 by the Boston socialite, who collected and arranged more than 2,500 objects from around the globe in this four-story building she designed herself; spectacular central courtyard styled after a fifteenth-century Venetian palace

Museum of Fine Arts: renowned collection of art works; includes a fine collection of ancient art and Asian galleries

Symphony Hall: opened in 1900 as the first concert hall designed with acoustical principles in mind and regarded as one of the finest halls in the world

Boston: North End

Copp's Hill Burying Ground: burial site since 1659; has tilting slate tombstones and stunning harbor views; gravesite of Increase Mather and his son Cotton, a Salem Witch Trial judge

North Square: one of the most historic parts of Boston, includes the **Paul Revere House**, the oldest residential address in the city, dating from c. 1680, now restored; the oldest sign in Boston, 1694; the oldest brick house in Boston, 1710; and the 1723 **Old North Church**, the oldest church in Boston, with a 191-foot steeple, original weather vane, the first bells cast for the British Empire in North America, and a clock made in 1726—the oldest still functioning in an American public building

Paul Revere Mall: contains the famous bronze statue of Paul Revere on his borrowed horse

Boston: Southern districts

Dorchester Heights Monument: commissioned in 1898, the white marble Georgian revival tower commemorates George Washington's purge of the British from Boston on March 4, 1776; gives panoramas of Boston and southern communities

John F. Kennedy Museum and Library: housed in an I.M. Pei-designed building; holds the president's papers from his term in office; a short film and displays cover his presidential campaign and highlights of his administration

Arnold Arboretum: 265 acres with a collection of over 14,000 trees, vines, shrubs, and flowers

Fort Independence: oldest continuously fortified site in British North America, originally established in 1634; later included a pentagonal fortification with 22 cannons but rebuilt several times; traces of the original earthworks still remain

Boston: West End

Harrison Gray Otis House: originally built in 1796; has served as a Turkish bath, medicine shop, and boarding house

Boston Harbor Islands National Park

Encompasses 30 islands situated within the Greater Boston shoreline; ranger-led tours on the history and nature of several of the islands, and a discovery center with a unique virtual and birds-eye tours of Boston Light and all the islands in the Park

Newton

The Jackson Homestead: museum in an 1809 Federal-style farmhouse, once a site on the Underground Railroad

Quincy

Adams National Historical Park: comprises 11 historic structures and a landscape of almost 14 acres; interprets five generations of the Adams family from 1720 to 1927

Plymouth

Greek temple: Classical-style structure that encloses Plymouth Rock, where the 102 Pilgrims landed in December 1620

Mayflower II: Replica of the original, built in Britain by English craftsmen following the detailed and historically accurate plans of an American naval architect at MIT

Plymouth National Wax Museum: sound-and-light tableaux of the early days of settlement

Pilgrim Hall Museum: full of furniture that allegedly came over on the *Mayflower*

Plimoth Plantation: includes a re-created Pilgrim village of 1627 and a Wampanoag settlement

New Bedford

New Bedford Whaling National Historical Park: heritage of the greatest whaling port of the nineteenth century; encompasses 34 acres of cultural landscapes, historic buildings, museum collections, and archives that preserve the history of the era; includes a visitor center; the **New Bedford Whaling Museum**; the **Seamen's Bethel**, built 1831–2; the schooner **Ernestina**; and the **Rotch-Jones-Duff House and Garden Museum**

CAPE COD AND THE ISLANDS

Provincetown: has the 1764 **Seth Nickerson House**, the oldest of the town's clapboard houses; and a **Heritage Museum**, displaying town lore and local memorabilia

Cape Cod National Seashore: 43,604 acres of shoreline encompassing a 40-mile long stretch of pristine sandy beach, a variety of historic structures, including lighthouses, a lifesaving station, and Cape Cod style houses

Wellfleet and Chatham: two fishing communities set in a scenic and charming area, featuring carefully preserved hamlets

Cape Cod Rail Trail: follows a railroad track from Dennis to Eastham, through cranberry bogs and forests

Hyannis: has the **John F. Kennedy Museum**, showing photographs, news clippings, and film footage

Nantucket Island: features **Nantucket Town**, restored houses and cobblestoned carriageways; a **Whaling Museum**, with artifacts of the trade; the **Peter Foulger Museum**, of island history; and the village of **Siasconset**

Martha's Vineyard: island and chic summer hot spot; Victorian terraced cottages; the old settlement of **Edgartown**; and an ancient lighthouse

Brewster: has the **Cape Cod Museum of Natural History**, located on 80 acres of woodland, salt marsh, and bay shore

WESTERN CONNECTICUT

Appalachian National Scenic Trail
see Baxter State Park, Maine

Wilton
Weir Farm National Historic Site: country retreat of J. Alden Weir; includes the **Historic Painting Sites Trail,** which allows views to specific sites that inspired many of Weir's paintings

CENTRAL CONNECTICUT

Hartford
State Capitol: opened for the General Assembly in 1879; grand structure of New England marble and granite, crowned by a gold leaf dome; houses a small historical museum

Museum of Connecticut History: includes a small collection of armaments and the desk at which Abraham Lincoln signed the paper that emancipated all slaves during the Civil War

Wadsworth Athenaeum: established 1842; the nation's oldest continuously operating public art museum; holds c. 45,000 pieces, many fine and decorative arts, and Old Masters

Nook Farm: hilltop community with restored 1880s homes of Mark Twain and Harriet Beecher Stowe

Old State House: designed by Charles Bulfinch, built in 1796; site of the first Amistad trial

New Haven
Yale University: founded in 1701, moved here in 1716

Eli Whitney Museum: housed in an 1816 barn and Whitney's restored gun factory

New Haven Colony Historical Society: traces the history of the New Haven colony from 1638 to the present

102nd Infantry Regiment Museum and National Guard Armory: a collection of rare military items and artifacts

Peabody Museum of Natural History: built in 1866; houses a world-famous collection of dinosaur fossils

Yale University Art Gallery: nation's oldest college art museum, featuring art from ancient Egypt through the present

Shoreline Trolley Museum: features a three-mile ride on a vintage trolley car and a collection of around 100 trolleys from the first half of the twentieth century

Amistad Memorial: stands on the site of the old New Haven jail in which, in 1839, 53 illegally kidnapped Mendi from Sierra Leone were incarcerated while former President John Quincy Adams argued their case in court

Christ Church on Broadway: 1897, English Gothic style

Pardee-Morris House: illustrates the living conditions of a typical well-to-do New Haven family in the 1700s

Essex
Connecticut River Museum: shows the history of the Connecticut River Valley through exhibitions and programs

EASTERN CONNECTICUT

Groton
*USS **Nautilus:*** America's first nuclear-powered submarine, built here; first vessel to sail under the polar ice cap

Submarine Force Museum: exhibits on the history of submersibles, from 1775 to the present

Fort Griswold Battlefield State Park: Revolutionary War battlefield site; includes a museum and monument

Mystic
Downtown: lined with typical New England clapboard structures and many old houses built by wealthy sea captains

Mystic Seaport: reconstructed 17-acre waterfront village, with more than 60 buildings, houses, old-style workshops, stores, and a printing press; a **shipyard** where wooden ships are built, restored, and maintained; and the restored **Charles W Morgan**, an 1841 whaling ship filled with whaling memorabilia

The Denison Homestead Museum: historic homestead built in 1717 by George Denison; displays periods of American history

New London
U.S. Coast Guard Academy: museum of coast guard history

*USS **Eagle:*** tall ship open for visitors

Downtown: walking tours pass along the prosperous Huntington Street, which includes Whale Oil Row

Monte Cristo Cottage: childhood home of Eugene O'Neill

Mashantucket Pequot Indian Reserve
Contains the **Mashantucket Pequot Museum and Research Center,** which is owned and operated by the Mashantucket Pequot Tribal Nation; exhibits include the history and the culture of the Tribe

Stonington Borough
Old fishing village, originally Portuguese, with whitewashed cottages, picket fences and flower gardens; a *Lighthouse Museum* c. 1823 is full of memorabilia, maps and drawings

Putnam
The Quinebaug and Shetucket Rivers Valley National Heritage Corridor: 1,086-square-mile rural region; many small towns, farmlands, forests, and mills; authentic sites represent distinct periods of American history

RHODE ISLAND

Blackstone River Valley National Heritage Corridor: see Central Massachusetts *and* Pawtucket, Rhode Island

Woonsocket
Museum Of Work And Culture: interactive museum presenting the story of the French Canadians who left the farms of Quebec for the factories of New England

Providence
State Capitol: stately white Georgian marble structure, built 1895–1904; houses the original Rhode Island Charter and a historic portrait of George Washington by Gilbert Stuart

John Brown House: 1786 home to prosperous merchant John Brown; now a museum displaying period furniture

Benefit Street's Mile of History: beautifully restored Colonial houses, churches, and museums overlook the city's historic waterfront

Roger Williams National Memorial: commemorates the Rhode Island founder who, banished from Massachusetts for his beliefs, founded Providence in 1636

Blithewold Mansion, Gardens & Arboretum: former summer residence of Pennsylvania coal magnate, Augustus Van Wickle; 45-room turn-of-the-century mansion

Governor Henry Lippitt House Museum: Renaissance revival mansion built in 1865 with lavish period interiors

Pawtucket
Slater Mill Historic Site: contains three buildings—the Sylvus Brown House (1758), the Slater Mill (1793), and the Wilkinson Mill (1810)—which illustrate the progression of textile manufacturing from a hand craft to large scale industrial enterprise

Coventry
General Nathanael Greene Homestead: built in 1770; well preserved interior with period furnishings

Warwick
John Waterman Arnold House: two-story clapboard structure from the late 1700s, with period interiors

Apponaug Village: settled in 1696; one-time seaport now with surviving eighteenth- and nineteenth-century structures, most notably *Warwick City Hall*, a Victorian-era building

Pawtuxet Village: settled in 1642, lays claim to being New England's oldest village; features many colonial and historic homes

Exeter
Tomaquag Indian Memorial Museum: maintains Native American artifacts from across the continent

Bristol
Linden Place: Federal period mansion designed in 1810 for General George DeWolf; has been visited by four U.S. presidents; was home to actress Ethel Barrymore; and was featured in the film, *The Great Gatsby*

Bristol Historical And Preservation Society Museum & Library: Located in an 1828 jail with dungeon cells

Coggeshall Farm Museum: a living restoration project on the life of a late eighteenth-century farm family; craftsmen demonstrate weaving, dyeing, spinning, quilting, and scrimshaw

Haffenreffer Museum Of Anthropology, Brown University: fascinating artifacts from the native peoples of the Americas, Africa, Asia, and the Pacific

East Greenwich
General James Mitchell Varnum House Museum: 1773 Federal mansion with period interior and gardens; contains Colonial and Victorian children's playrooms, and military artifacts

Tiverton
Chase-Cory House: 1730 building, with changing exhibits

Portsmouth
Green Animals Topiary Gardens: 80 sculpted trees and shrubs

Portsmouth Historical Society Museum: former Christian Sabbath Society meeting house, built in 1865; holds collections of colonial farm, household tools, and a monument that sits on the site of the initial skirmish of the Battle of Rhode Island in 1778

Little Compton
Gray's Store: built in 1788 by Samuel Church; one of the oldest continuously operating stores in the country contains the 1804 post office and an original soda fountain

Wilbor House: on land purchased from the Sakonnet in 1673; built by Samuel Wilbore c. 1690 with an original structure of two rooms, a cramped stairway, and attic; today four rooms each portray a different century in the house's history

Middletown
Whitehall Museum House: furnished house built in 1729 by Dean George Berkeley, educator and Anglican bishop

Newport

Old Colony House: pre-Revolutionary brick building; seat of government from 1739 to 1900

Hunter House: 1748 home of ship's captain

Quaker House: oldest religious building in town (1699)

Touro Synagogue National Historic Site: dedicated in 1762, the oldest synagogue in the United States, and the only one surviving from the colonial era

Museum of Newport History: displays the evolution of maritime New England through photographs and artifacts

Trinity Church: 1726 colonial structure based on the Old North Church in Boston and the designs of Sir Christopher Wren

St Mary's Church: oldest Catholic Church in Rhode Island; where Jackie Bouvier married John Kennedy

Newport Art Museum: 1864 medieval-style Griswold House; exhibits New England art from the last two centuries

Beechwood: 1890s summer home of William Backhouse and Mrs. Astor; costumed actors re-create their lifestyles

Marble House: lavish summer house, built 1888–92 at a cost of $11 million for the Vanderbilts; has a golden ballroom and a Chinese teahouse in the grounds; featured in the film *The Great Gatsby*

Rosecliff: beautiful 1902 house of Theresa Fair Oelrichs; modeled after the Grand Trianon at Versailles

Kingscote: an 1839–41 Arts and Crafts cottage; a landmark of the Gothic Revival style, including the earliest known installation of Tiffany glass; displays King family collections

The Breakers: 70-room Italian Renaissance-style house, completed in 1895, built for Cornelius Vanderbilt, includes a 45-foot high central Great Hall; on a 13-acre estate with spectacular views of the Atlantic

Hammersmith Farm: The Kennedy's 28-room summer home and beautiful grounds, where the First Couple's wedding reception was held; includes her childhood bedroom, his "summer White House" office; and other Kennedy memorabilia

Belcourt Castle: French-style castle, built in Louis XIII style; constructed for Oliver Hazard Perry Belmont and finished in 1894; displays a global collection of art and antiques

Chateau-Sur-Mer: 1852 stone mansion in the High Victorian style, with original wallpaper, ceramics and stenciling; noted for its Victorian park

Chepstow: Italianate-style villa designed in 1860; summer residence of the prominent Morris family from New York, which included a signer of the Declaration of Independence; contains the family's art collections

The Elms: modeled after the mid-18th century Parisian chateau d'Asnieres; completed in 1901 at a cost of $1.4 million; elaborate Classical Revival gardens

Hunter House: built in 1748 by the deputy governor of Rhode Island; features eighteenth-century Newport-crafted Goddard-Townsend furniture, period paintings, and Colonial gardens

Isaac Bell House: built in 1883 by the famed architectural firm of McKim, Mead and White; combines Old English and European architecture with colonial American and exotic details

Rose Island Lighthouse: 1869; houses museum of its history

Artillery Company of Newport: outstanding collection of foreign and domestic militaria

Fort Adams State Park: largest coastal fortification in the United States; an engineering and architectural masterpiece constructed 1824–c.1854; offers a wide range of activities and exceptional panoramic views of Newport Harbor and the East Passage of Narragansett Bay

Block Island

Practically unspoiled, the island offers quaint architecture, spectacular vistas, beaches, and biking; features the **Mohegan Bluffs** that rise steeply to a height of 200 feet and stretch along the shore for nearly three miles

Narragansett

South County Museum: collection of over 20,000 artifacts, all donated by local townspeople to display the maritime heritage of the region

Jamestown

Beavertail Lighthouse Museum: site of the third-oldest lighthouse on the Atlantic seacoast; exhibits information and artifacts about the history; gives panoramic view of Narragansett Bay

Beavertail State Park: offers some of the most beautiful views along the New England coastline, with a range of outdoor activities

Jamestown Museum: housed in a nineteenth-century schoolhouse; contains a collection of ferry-system memorabilia, historic photos, maps, and other artifacts

Sydney L. Wright Museum: artifacts from prehistoric and early settlements on Conanicut Island

Kingstown

Museum Of Primitive Art & Culture: exhibits primitive tools, utensils, and weapons from various cultures

Gilbert Stuart Birthplace: wooded homestead on the banks of the Mattatuxet Brook where the famous portrait painter was born; an authentically restored and furnished workingman's home and the site of the first snuff mill in America; also features a partially restored grist mill and fish ladder

Richmond

Bell School House: one room schoolhouse from 1826–1934

Westerly

Babcock-Smith House: early Georgian-style mansion, built c. 1734 for Dr. Joshua Babcock, Westerly's first physician and a Chief Justice of the state

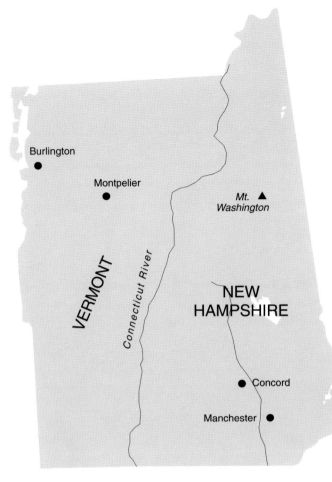

VERMONT AND NEW HAMPSHIRE

NORTHERN VERMONT

Lake Champlain

Champlain Isles: historic islands, reached by Europeans in the seventeenth century; examples of pioneer settlement are set in a landscape of meadows and orchards

Lake Champlain Maritime Museum: displays information on the ***Underwater Historic Preserves***, where divers can observe shipwrecks on the lake floor

Burlington

Shelburne Museum: more than thirty buildings, original and modern, look at everyday life over the past two centuries; includes a general store, apothecary, doctor's office, blacksmith, Shaker barn, schoolhouse, meeting house, covered bridge, railroad station, and even a large steam paddlewheeler from Lake Champlain, the SS *Ticonderoga*

Robert Hull Fleming Museum: a collection of 19,000 artifacts ranging from early Mesopotamia to modern America

Ethan Allen Homestead Museum: home of famed American freedom fighter Ethan Allan, now a museum; includes Allen's restored 1787 farmhouse and an education center

Vergennes

Lake Champlain Maritime Museum: preserves maritime traditions and skills through hands-on and interactive exhibits, including a 54-foot replica of Benedict Arnold's boat

Middlebury

The Henry Sheldon Museum of Vermont History: changing exhibits of fine art and Henry Sheldon's nineteenth-century photographs, objects, and records of Vermont

Long Trail

Hiking trail (predating the Appalachian Trail) along the central ridge of the state, 264 miles from north to south through a beautiful landscape

Barre

Mount Hope Cemetery: burial site of local stoneworkers, from around 1900, with gravestones that they carved themselves

Rock of Ages: world's biggest granite quarry where visitors may watch workers cut huge blocks out of the earth

Montpelier

State Capitol: built in 1859 in the Renaissance Revival style with a gleaming golden dome, leafy gardens, marble floors, and mural-lined hallways

Lake Champlain–Vermont's Underwater Historic Preserves: divers can view relics on the lake bed of ships that fought many maritime battles here

Waterbury

Ben & Jerry's Ice Cream Factory: tours of the famous company feature a short film, an observation platform from which to observe the workforce, and a free scoop!

Stowe

Beautiful nineteenth-century community, with white-spired meeting house and village green; spectacularly set at the foot of Vermont's highest mountain, the 4,393-foot Mount Mansfield; ***Hwy. 108*** leads close to the mountain through the dramatic Smugglers' Notch; ***Toll Road*** leads to the very top; or a gondola leads up to Cliff House, where there is a hiking trail to the top; the ***Trapp Family Lodge*** was established here by the Von Trapp family of *The Sound of Music* fame and is open for visitors

SOUTHERN VERMONT

Appalachian National Scenic Trail

see Baxter State Park, Maine

Orwell

Mount Independence: considered to be the most important bat-

tle site in the Revolutionary War; the American flag was first carried in battle here; a visitor's center has artifacts, interactive displays, and some original buildings

Quechee

Quechee State Park: features the dramatic Quechee Gorge, the 165-foot chasm of the Ottauquechee River, and hiking trails through fir-tree forests

Simon Pearce Glass: housed in a former woolen mill, a waterfall on the river still turns the turbines of this glass-blowing center

White River Junction

Hotel Coolidge: an authentic railroad hotel, still open for guests, with preserved quarters for viewing

Weston

Pretty village that spreads beside a river, where a stone slab commemorates seventeen local soldiers killed on the same day during the Civil War; the nearby *Farrar-Mansur House* is an early tavern, restored to show the lives of early settlers

Plymouth Notch

President Calvin Coolidge State Historic Site: birthplace of the 30th president of the United States; several buildings in the village, including his boyhood home, have been preserved and furnished as in the 1920s

Windsor

The Old Constitution House: site where the constitution of Vermont was originally drafted; the first to prohibit slavery, it also established universal voting rights for men and created the first public school system

Woodstock

Marsh-Billings-Rockefeller National Historical Park: preserves the Marsh-Billings-Rockefeller property—childhood home of George Perkins Marsh, one of the nation's first global environmentalists, and former resident Frederick Billings, an early conservationist who established a progressive dairy farm and professionally managed forest; the *Billings Farm & Museum* is partly maintained as it was on the death of Billings in 1890 and is also a working dairy; tours of the mansion and the surrounding 550-acre forest, and outdoor activities available

Manchester

Hildene: 1902 stately summer home built by Robert Todd Lincoln, son of President Lincoln; the only house occupied by all of Abraham Lincoln's descendants; set on many acres, with large formal gardens

Bennington

Walloomsac River: features three covered bridges

Long Trail: southern end starting point; *see* Long Trail, Northern Vermont

Bennington Battle Monument: 306-foot hilltop obelisk commemorating the Battle of Bennington in August 1777, in which Ethan Allen's Green Mountain Boys were a crucial factor in defeating the British under General Burgoyne

Bennington Museum: collects and preserves artifacts of New England life; has a collection of paintings by Grandma Moses

Brattleboro

Naulakha: shingle style house, designed and built by Rudyard Kipling in 1892–93, in which the author wrote his two *Jungle Books*, among other texts

Old Railroad Station: opened 1849, now the Brattleboro Museum & Art Center, which displays locally made Estey organs and other works of art

NORTHERN NEW HAMPSHIRE

White Mountains

Kancamagus Highway: runs through a high pass discovered by the early pioneers; offers a scenic drive, camping, walking trails, and a half-mile hike to the idyllic Sabbaday Falls

Franconia Notch State Park: a narrow valley between two enormous walls of stone; gives excellent views of the *Old Man of the Mountains*, a startling natural rock formation; visitor center offers two-mile nature trails, various hiking trails to panoramic views, and cable-car rides that look down on the Pemigewasset River, thundering through a narrow gorge

Mount Washington: 6,288-foot-high peak with views from the summit that reach to the Atlantic and right into Canada; winds often exceed hurricane strength, and on the summit buildings are held down with huge chains; there is a scenic drive up Mount Washington Auto Road with hairpin bends; minibuses give narrated tours; and the coal-fired steam train of the Mount Washington Cog Railway gives rides to the top up steep gradients on an 1869 track

Lincoln

Clark's Trading Post: has many museums packed with Americana ranging from antique horse-drawn fire engines to old weapons and household appliances

White Mt. Central Railroad: two and a half mile tour on a classic wood-burning steam Climax Locomotive, one of only three still running in the world, across the scenic Pemigewasset River, through rustic woods, and over the only standing Howe-Truss covered bridge still in use

Appalachian National Scenic Trail
see Baxter State Park, Maine

NEW HAMPSHIRE LAKES

Weirs Beach
Mount Washington: offers cruises through the maze of small channels and islets

Meredith
Winnipesaukee Railroad: operates scenic trips along the Winnipesaukee lakeshore

Holderness
Science Center of New Hampshire: offers educational tours that lead through a largely natural landscape, with animals such as deer, bobcat, otters, bears, and foxes

Laconia
Belknap Mill: claims to be "the oldest unaltered brick textile mill building in the United States"; with machinery still in working order, it is now an arts center

Wolfeboro
Claims to be "the oldest summer resort in America," because Governor Wentworth of New Hampshire built his summer home nearby in 1768; features the *Libby Museum,* the collection of a c. 1900 dentist, focusing on evolution with various stuffed animals and skeletons; also has a mastodon's tooth and other curious items of local history

NEW HAMPSHIRE COAST

Portsmouth
John Paul Jones House: 1758 gambrel-roofed, cream-and-white clapboard house
Moffatt-Ladd House: 1763 three-story mansion with wonderful original furnishings and architecture
St. John's Church: built 1809; George Washington attended services in the original structure in 1789
Warner House: the first brick mansion in New England (1716)
Wentworth-Gardner House: built 1760 as a present for Thomas Wentworth, brother of John Wentworth, the last Royal Governor of the state
Gov. John Langdon House: 1784 colonial mansion and gardens of the governor with period interiors
Rundlet-May House: James Rundlet's Federal-style home, built 1807 and furnished with the wealthy merchant's period pieces
Portsmouth Athenaeum: Federal-style building with a library of over 30,000 volumes, some rare, early Portsmouth memorabilia, and historic portraits

Sheafe Warehouse Museum: fascinating collection of maritime objects and a traditional boat-building exhibit
Odiorne Point State Park: site of the first white settlers landing in 1623; some scattered ruins date from the period
Strawbery Banke: ten preserved acres of the town's original site; a living museum re-created to its former appearance; each building is shown in its most interesting former incarnation; includes the *Drisco House,* where each individual room dates from a different era; the 1766 *Pitt Tavern,* which acted as a meeting place during the Revolution for patriots and loyalists; and the *Dinsmore Shop,* where a cooper manufactures barrels with the tools and methods of 1800

SOUTHERN NEW HAMPSHIRE

Manchester
Currier Gallery of Art: European and American paintings and sculpture dating from the Renaissance to the present, including works by world-renowned artists
Zimmerman House: (1950) the only Frank Lloyd Wright designed house and interior open to the public in the state

Canterbury Shaker Village
The sixth Shaker community to be founded by Ann Lee in the 1780s had grown to 300-strong by 1860; tours demonstrate Shaker crafts and techniques, serve Shaker food, and show buildings from the 1792 meeting house to the syrup shop (1785–1840) and laundry (1795–1907)

Derry
Robert Frost Farm: restored to its early–twentieth-century condition when New England's poet laureate lived here; displays discuss his work, and a half-mile "poetry nature trail" leads past the sites that inspired many of his best-known poems

Hanover
Dartmouth College: founded in 1769 by a congregational minister from Connecticut, "for the instruction of the Youth of Indian tribes…and others"; features the *Hood Museum of Art,* which contains international works from ancient to modern times

Cornish
Saint-Gaudens National Historic Site: 150 acres include the 1885–1907 home, gardens, and studios of Augustus Saint-Gaudens, one of America's foremost sculptors; two hiking trails lead through the park with a range of outdoor activities; offers introductory film presentation and scheduled tours of the buildings

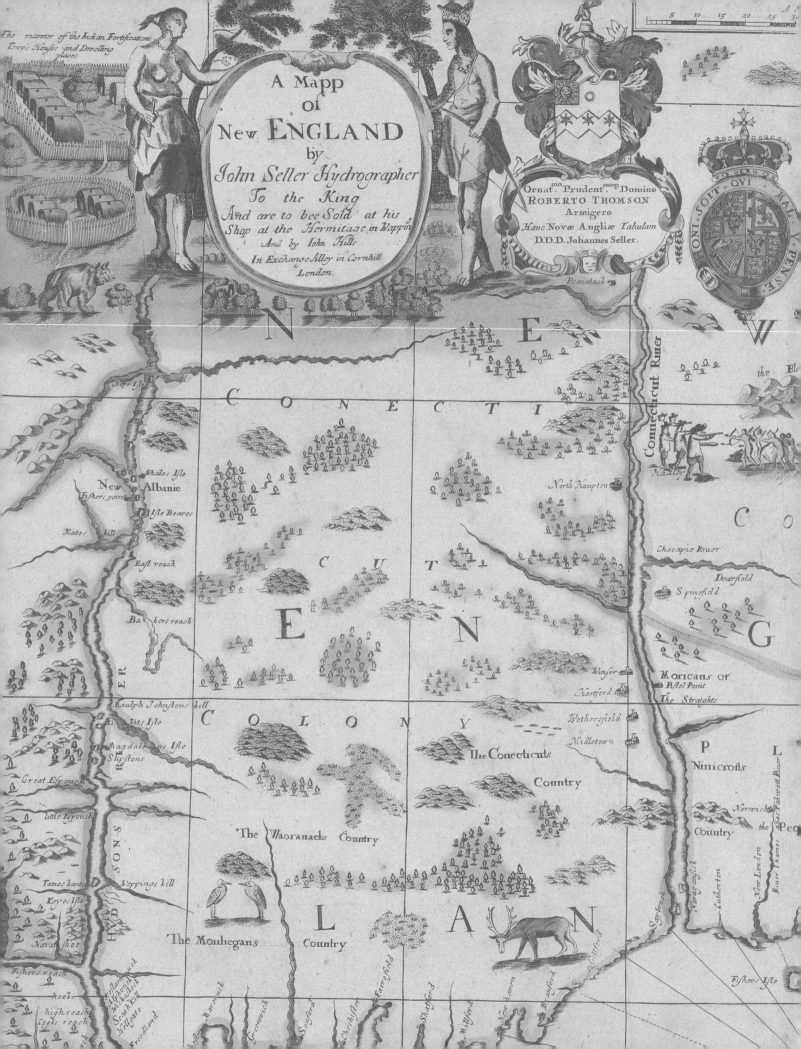

A Mapp of New ENGLAND by John Seller Hydrographer To the King And are to bee Sold at his Shop at the Hermitage in Wappin And by John Hills In Exchange Alley in Cornhill London

The manner of the Indian Fortifications Towne Houses and Dwelling places

Ornat.mo Prudent.moqr Domino ROBERTO THOMSON Armigero Hanc Novæ Angliæ Tabulam D.D.D. Johannes Seller.

HONI SOIT QVI MAL Y PENSE

Poaintack

N E W

C O N E C T I C U T

E N G L A N D

C O L O N Y

C O P L

Hope Isle
Whales Isle
New Albanie
Fishers point
Isle Beares
Kates kill
East reach
Bakers reach

Ralph Johnstons kill
Bats Isle
Magdalens Isle
Shipstons
Great Espous R.
little Espous R.
Tames landen
Keyes Isle
Seppings kill
Narashoe
Fishers reach
hooke
highreach
Cooks reach

H U D S O N S

R I V E R

Friesland

Claverack
Maphock
Wicksell
Seaghkill
Catskate

Tappen
Barrick
Sanford
Greenwich
Stamford
Nachchister
Tarefield
Shatford
Milford
New haven
Branford
Gilford

Connecticut River
Hadley
North Hampton
Chocapie River
Dearsfield
Springfield
Winser
Hartford
Wethersfield
Midletown
Moricans or Pistol Point
The Straights
Ninicrofts Country
Norwich
Cutherton
New London
Saybrook
Naraganfet
Ea: Palmett River
the Peq
Fishers Isle

The Conecticuts Country
The Waoranacks Country
The Mouhegans Country